DONG KINGMAN'S
WATERCOLORS

DONG KINGMAN'S WATERCOLORS

BY DONG KINGMAN AND HELENA KUO KINGMAN

WITH SPECIAL PHOTOGRAPHS BY HELENA KUO KINGMAN

WATSON-GUPTILL PUBLICATIONS/NEW YORK
PITMAN HOUSE/LONDON

First published 1980 in the United States and Canada by Watson-Guptill Publications,
a division of Billboard Publications, Inc.,
1515 Broadway, New York, N.Y. 10036

Library of Congress Cataloging in Publication Data
Dong, Kingman, 1911–
 Dong Kingman's watercolors.
 Includes index.
 1. Dong, Kingman, 1911– 2. Water-color paint-
ing—Technique. 3. Water-colorists—United States—
Interviews. I. Kuo, Helena, joint author. II. Title.
ND1839.D6A4 1980 759.13 80–17381
ISBN 0–8230–2907–7

Published in Great Britain by Pitman House Ltd.,
39 Parker Street, London WC2B 5PB
ISBN 0–273–01624–5

Manufactured in Japan

First Printing, 1980

*This book is dedicated to anyone
who seriously wishes to paint for fun.*

ACKNOWLEDGMENTS

I would like to give special thanks to Helena, whose patience and understanding were most helpful during the writing of this book—and who sometimes stayed up all night to photograph my watercolors for the demonstrations and other portions of the book. I am also grateful to Ed Peterson, who provided additional photographs. And I want to thank Marsha, Betty, and Don for their encouragement and editing. This book would not have been possible without them. Most important of all, I must pay respect and express my gratitude to Someone up there Who always keeps an eye on me.

—Dong Kingman

CONTENTS

INTERVIEW WITH DONG KINGMAN 8

ARTISTIC DEVELOPMENT 10

STUDIO, MATERIALS, AND EQUIPMENT 22

PAINTING METHODS 28

PAINTING A TYPICAL PICTURE 34

ADVICE TO WATERCOLORISTS 42

DEMONSTRATIONS 48

HONG KONG 50

SAN FRANCISCO 56

YOSEMITE 62

NEW ORLEANS 68

HONOLULU 72

PARIS 78

VENICE 84

NEW YORK 90

GALLERY 98

INDEX 142

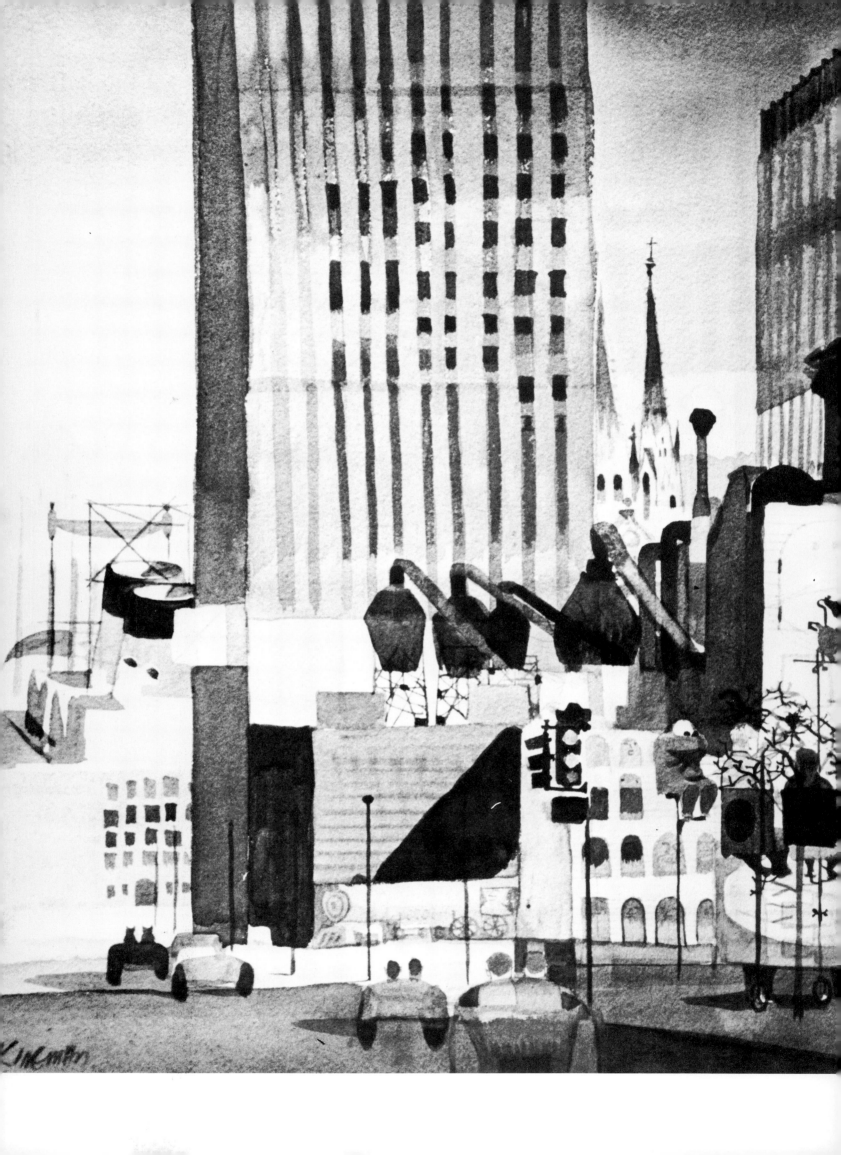

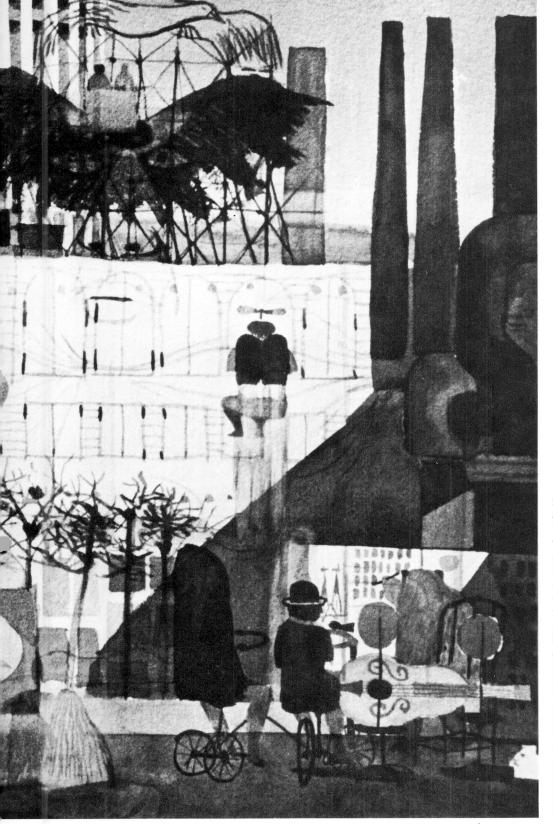

INTERVIEW WITH DONG KINGMAN

In a recent interview, I asked Dong Kingman a series of questions about his artistic development, painting methods, studio set-up, and the materials and equipment he prefers to use. We hope the answers to these questions will help you understand why and how he paints—and perhaps help you improve your own painting techniques, too.

—Helena Kuo Kingman

SELF-PORTRAIT
22 x 30 in. (56 x 76 cm)
Collection, Mr. and Mrs. Earl Wilson

What is a self-portrait? When you think of your individual face among hundreds of millions of others, you always feel that it's different from everyone else's. In this portrait of myself, I included elements of the world I live in. I thought: I'd enjoy having my face painted on a large white wall. I have a smiling face, and I enjoy living among buildings. I eat in a coffee shop when I'm hungry, I travel in subways if I want to go someplace, and if I could have my way, I wouldn't fight the crowds. The only smoke I want to see should be coming from smokestacks; I want to see church steeples in the background and everybody going around on tricycles; and if there's anything flying around in the sky, I'd prefer it to be a large, friendly black bird. That's the kind of world I'd enjoy living in. Do you see my self-portrait in this picture? (If you can't find it, turn to page 12 for a clue.)

9

ARTISTIC DEVELOPMENT

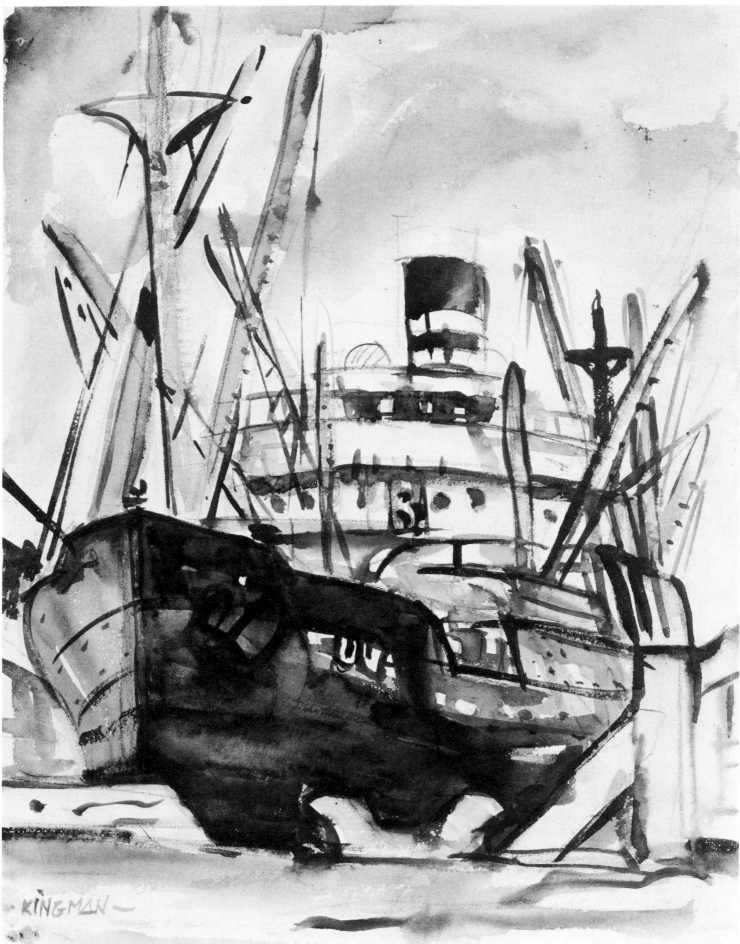

SHIP AT PIER, SAN FRANCISCO, *watercolor, 22 x 15 in. (56 x 38 cm), collection of the artist. This is one of the earliest pictures that I did in San Francisco, back in the thirties, when I would go sketching outdoors on my half-day off.*

When did you first realize that you wanted to be an artist?

I first realized this at an early age—when I was only five years old. Europe was raging with war, and my father, who was running a dry-goods store in Oakland, California, at the time, was afraid America might get involved in the war. So he decided to sell his business and move the entire family to Hong Kong.

We traveled steerage class, which provided the cheapest passenger accommodations. During our thirty-five-day voyage from San Francisco, rumors kept popping up that our ship might be torpedoed by German submarines. Though I was just a child, I could sense the excitement on people's faces and observe their fascinating responses. There were many interesting characters aboard, so I began to sketch them day after day to break the monotony of life aboard ship. It was then that I first realized it would be fun to be an artist.

What was the first really ambitious picture you painted as a child?

I remember a picture I painted for my rich uncle, who was a banker in Hong Kong and whom we called Yee Bark, which means "Second Elder Uncle." He had great confidence in me and predicted that someday I would have a great future as an artist. I was only nine years old at the time.

My uncle was building a huge mansion on Yee Ma Lo (Second Boulevard), and he asked me to paint a picture of it. I was too young to understand how to use color, so I did a large black-and-white charcoal painting for him. He was so happy and so proud of me that when he gave a large banquet for the opening, he placed my painting in the center of the hall and introduced me to all his rich friends.

Did you begin your art training by studying traditional Chinese brush techniques?

In my early years in Hong Kong, I went to the Chan Sun-Wen School, where I especially enjoyed the painting and calligraphy classes. I must confess I was not a good academic student. I was lucky to get an average grade in most subjects, except when it came to watercolor painting and calligraphy. Then I was always at the top of the class. Sometimes I wanted to paint all night to improve myself.

I remember my teacher demonstrating in watercolor how to paint a bird, a tree, or an animal. Then we would all copy his pictures. In calligraphy class, we had to do various brush exercises for an hour at a time every day. This added up to many hours of practice, since it was generally understood that it took as long as ten years for a calligrapher to be any good.

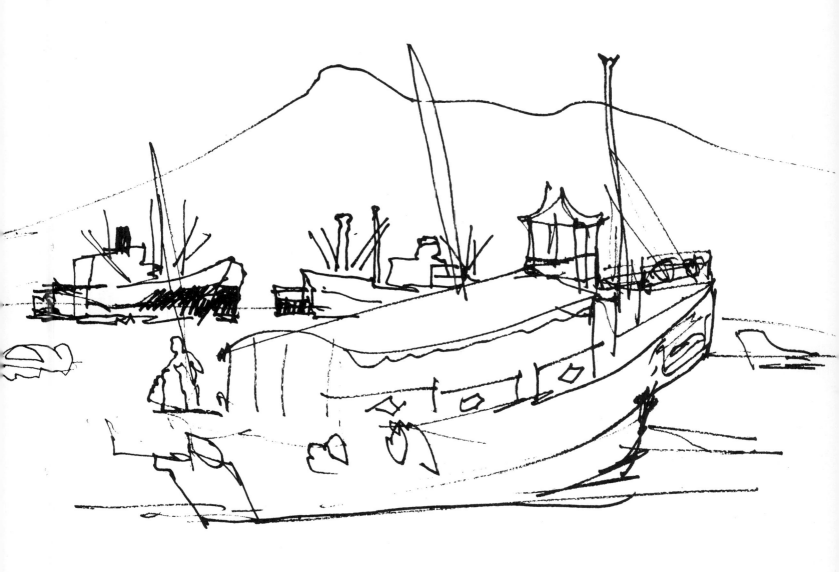

Whenever I travel, I carry along a sketchbook and make numerous drawings of scenes and people that interest me. This sketch of a pleasure boat in the Hong Kong bay was done in 1970.

Szetu Wei, my teacher in Hong Kong

Who was your first teacher, and what were the most important lessons you learned from him?

The first and only art teacher who had a true influence on me was Szetu Wei, a devout Christian and the kindest, most friendly person you would ever wish to meet. Szetu had studied art in Paris in the early twenties and returned to become headmaster and art teacher of the Lingnan Branch School in Hong Kong.

In 1926, I went to Lingnan not only to study Chinese and English, but specifically to study art under Szetu. When he found out how anxious I was to study art, he took me under his wing and became my personal tutor. He took me sketching outdoors during the summer holidays. Our school was located in Happy Valley near the race course, and one day he took me on a long hike up the side of the hill. From there, I could see young men playing soccer in the field down in the valley, and people and vehicles looked like moving toys. It was there that Szetu taught me to do oil painting in the Western style. He taught me how to simplify details as well as many basic theories of composition, brush techniques, rhythm, the use of color, etc.

Years later, when I was teaching at Columbia University, we met again in New York City. Szetu showed me some of his paintings, and I was surprised to find his paintings amateurish. For the first time, I realized he had not just taught me a few basic theories of art—he had also, through his good spirit and human understanding, helped me on my way to becoming an artist and had given me the means to continue on my own through the years.

Were there other teachers besides Szetu who had an important influence on your art?

No—not any that had a direct influence on my art, though I did go to one or two art schools in Oakland when I returned from Hong Kong. I came back to the States in 1929, during the Depression. I left my parents and was on my own for the first time in my life. I didn't know what to do with my future—but in the meantime, I had to eat, so during those first two years in Oakland I worked as a dishwasher, waiter, and newsboy, and found little time for painting.

By 1931, I had saved enough money to buy part ownership of a restaurant for $75. This gave me a little time to paint in the afternoon, and I began to study at the Fox & Morgan Art School, which was only a few blocks away. The school had life-drawing classes every Tuesday morning, and on Friday afternoons our teacher, Mr. Fox, took us out to sketch around the streets and parks of Oakland. It was these outdoor painting classes that I enjoyed the most. I was very happy painting with oil paints until one day Fox called me into his office. "You will never make it as a painter," he told me. "You might as well quit painting and go back to your chop-suey house."

I was very upset, but it is my nature to never say die. Perhaps, I thought, I should change to another medium. I had learned how to work with watercolor in the Chinese schools in Hong Kong. So I put away my oil-painting equipment—and the following Friday, when I went to my outdoor sketch class, I began to paint in watercolor. Fox took one look at my painting and said, "You may make it after all."

So you see, Fox had no *direct* influence on my art. But because of his comment, I made a quick about-face, which was an important turning point in my artistic life.

Who are the artists you admire most, and what have you learned from them?

The Western artists I admire and respect are Van Gogh, Cézanne, Gauguin, and Renoir, to mention a few. In general, I like the French Impressionists, whom I prefer to think of in terms of the overall movement rather than concentrating on individual painters.

But for the most part, because of my heritage and my early training in Chinese art and literature, it is understandable that I prefer Chinese art to that of the West. During my school years in Hong Kong, I studied the rich Chinese literature, including *Gu Wen* ("Ancient Classics"), *Lun Yu* ("Book of Confucius"), and Tang poems. Except for my art lessons, I was not a good academic student, though what I did learn still remains with me. Often, in nostalgic moments, I quietly recite lines from a Tang poem or an ancient classic to entertain myself. No music was taught in the old-fashioned Chinese schools, but I learned it anyhow. From the time I was ten years old, my father had taken me to see the Cantonese opera almost every night, and I knew its sounds and rhythms well. Later on, I also learned to play Chinese musical instruments.

Hong Kong is a British colony, and even though 90 percent of the population was Chinese, English was required in every school. Chan Sun-Wen School, the first school I attended, was basically an old-fashioned school where they taught only Chinese classics, with just one hour of English lessons every day. The teacher would read each of the twenty-six letters of the alphabet out loud, one by one, and the students, some fifty strong, would simultaneously repeat after him. I don't think anyone who came out of that Chinese school in Hong Kong would know anything about English! But although I learned my English in the Chinese way, so to speak, I studied art in the Western manner under Szetu. Having studied art in Hong Kong, it was difficult at first to find my own direction: I didn't know whether to follow the influence of the East or the West.

Would you say, then, that you were mostly self-taught?

For the most part, I was—though I can't say this absolutely, since I did study in art schools, and I believed in the teacher if he was good.

In Hong Kong, I went to a private painting school located on the corner of Hollywood Road and Cat Street. The school had only one teacher, who taught in a tiny classroom only 10 ft (3 m) square. Each day, he told me to copy a Chinese scroll painting; I was asked to do the same thing over and over again, day after day. After a week of this, I quit. Did I learn something from this teacher? Come to think of it, I did. I learned how bad a teacher can be.

When I went to study art at Fox & Morgan in Oakland, I enjoyed my weekly outdoor sketch class, but the teaching was mediocre. Perhaps the students there were as much to blame as the teacher—they seemed more interested in party-going than in studying art.

However, I had studied under Szetu Wei, my most important art teacher. Although I didn't study with him for very long, the little time I did have with him was worth a lifetime of study.

A good teacher can help you get started, but from then on, you have to find your own way. In my experience, after many years of learning and painting, I've come to believe that the best teacher is yourself.

Did any friends or members of your family have an important influence on your painting?

My mother was an amateur painter. She never had the opportunity to receive formal training, but in her youth, she enjoyed copying birds, trees, and still-life subjects from Chinese paintings. One of her most memorable paintings, which hangs in my home, has two ducks swimming among lotus lilies in a pond. She also designed jewelry for her friends.

When I became interested in art, my family was very happy. My parents never particularly encouraged me to continue, but they didn't discourage me either. I had a feeling they always kept an eye on me.

TRINITY COLLEGE CHURCH, *17 x 20 in. (43 x 51 cm)*

Did you consciously decide to move away from traditional Chinese painting techniques and style, or did this happen gradually by itself?

In my early days as an artist, I had a difficult time finding myself and trying to reconcile my Chinese heritage with my American thinking. I wasn't sure what I was going to do. In 1931, when I first began to take up the medium seriously, I was simply determined to work hard, to study, and to improve my watercolor technique. I was working in Oakland at the time, but later on I moved to San Francisco and worked for the Drew family as a servant. On my half-day off every Sunday morning, I would gather up my painting gear and go sketching outdoors, sometimes in the San Francisco streets and at other times along the waterfront. I enjoyed painting the cityscape around me. This included street scenes, waterfronts, parks, and skyscrapers; and of course, there were always people, buses, bicycles, cars, lampposts, and stoplights in these bustling city scenes.

Over the next year I painted enough pictures to give an exhibition at the San Francisco Art Center. Some critics who saw the show referred to my paintings as a cross between Oriental and Occidental because of my heritage. And I guess this was partly true: I am Oriental when I paint trees and landscapes, but Occidental when I paint buildings, ships, or three-dimensional subjects with sunlight and shadow.

Today, however, my thinking is different, and I no longer worry about these distinctions. For me, there is no such thing as Oriental or Occidental. There is only *my* way of painting with watercolor, and I hope whoever sees my paintings will enjoy and understand them as such.

Why did you decide watercolor was your medium, and why did you ultimately reject other media?

I've used the medium continually since 1931, when my teacher, Mr. Fox, unwittingly caused me to switch from oil to watercolor painting. At that time, I didn't really know how to handle watercolor very well, though I'd had a few lessons in Chinese painting in Hong Kong. I was searching in the dark, not knowing how to approach the medium or whether I was making mistakes. If I did something right, it was sheer good luck and instinct on my part. It was only after many years of experimentation that my enthusiasm began to overcome my fear, and I started to develop an understanding of watercolor.

Although I initially took up watercolor somewhat by accident, I had always considered it an important medium. In Europe, especially in the early days, artists treated watercolor as a minor medium, using it primarily to make studies for their major oil paintings. But for the Chinese, watercolor is and always has been their most important medium. They've been painting pictures in watercolor for more than four thousand years, having developed the technique simultaneously with calligraphy. I've always felt at home with watercolor, even at times when I was unsure of myself as an artist—and that's why I decided it was my medium.

For an artist, choosing a medium is like selecting an instrument for a musician. Should it be a wind or string instrument? Some people are more at home playing the big horn than the guitar or piano. It's a matter of temperament. The same thing applies to artists.

I find watercolor best for my temperament. It's a quick-drying medium, and you must think fast. I can create light, sensitive tones on my paper as well as rich, dark colors—yet watercolor always retains its transparent quality. I've tried other media, too, but not very successfully. It's possible that I didn't spend enough time on any of them to discover their beauty. In my opinion, both oil and pastel are opaque media. Acrylic and gouache, however, can be treated either opaquely or transparently, depending on how you use them. You can achieve different and interesting effects.

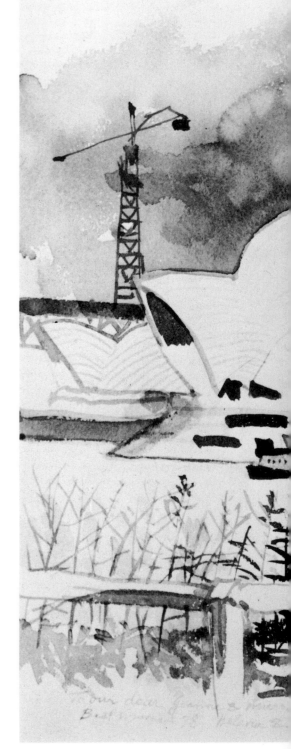

SYDNEY HARBOR
22 x 15 in. (56 x 38 cm)
Collection, Mr. and Mrs. Murray Gart

"Sydney Harbor is the finest I have ever seen," wrote James Michener some thirty years ago. "It is a thing of beauty. . . ." When I first went to sketch the harbor scene in July 1976, the famous Opera House was not quite finished—you can see construction cranes in the background on the left. This sketch was reproduced in the Asian edition of the December 20, 1976 issue of *Time* magazine.

Did you try different styles?

Yes and no. When I first returned to the
United States, I was searching for direc-
tion in my art. The leading water-
colorists at that time were Charles
Burchfield, John Marin, and George
Grosz; I studied all of them at one time
or another, and I tried to copy their
work. But invariably, my feelings kept
returning to my ancestry and my early
training in Chinese art, of which I had a
basic understanding.

A soccer game in Kuala Lumpur, sketched in 1976

Why are you so fascinated by architecture and cityscapes?

I was born, brought up, and have always lived in cities—Oakland, Hong Kong, San Francisco, New York City—and always right in the heart of the asphalt jungle, amid poor people in busy, noisy, congested areas. After many years, I've become familiar with my cities, with their people and animals, and with the ups and downs, ins and outs of their streets, parks, and buildings.

I especially like architecture. When I was seventeen, I wanted to become an architect. Instead of going to a school to study architecture, however, I went to work as an apprentice in an architect's office. Every day, he would tell me to practice my lettering, and I was getting pretty good at it. But after eight weeks of copying the twenty-six letters in the alphabet over and over again, I felt like a naughty schoolboy being punished. I felt that the way things were going, I would never become an architect, so I quit. But I never stopped *painting* architecture.

You have a unique way of painting figures in your cityscapes. How did you arrive at this style?

It took me years to develop the way I paint people. I keep my figures very sketchy, yet they are always carefully planned to fit into the overall pattern of the composition. In the beginning, I was not comfortable with figure drawing. When I painted people, they looked stiff and uncertain. But I kept trying different approaches. Sometimes I painted them simply, with bold strokes, and at other times I would work very meticulously. Through trying many methods and over years of experience, my figures slowly came into focus.

Many types of people appear in my paintings, and often they reflect the times in which I was living when I painted them. During the war years, we were bombarded with news of poison gas and H-bombs. This definitely influenced my work, and I painted many figures walking around wearing gas masks and underwater helmets. Later on, in peacetime, I saw hippies, flower children, not-so-honest policemen, and honorable peddlers. There were grass-smokers and poppy growers. All these characters, and more, have appeared in my paintings at one time or another. On other occasions, my figures seem to have been affected by Chinese opera characters: I would paint them with coolie hats, fishermen's raincoats, or a funny look on their faces. But it seemed to me that whatever people were doing in my paintings, they were happy and they enjoyed doing it.

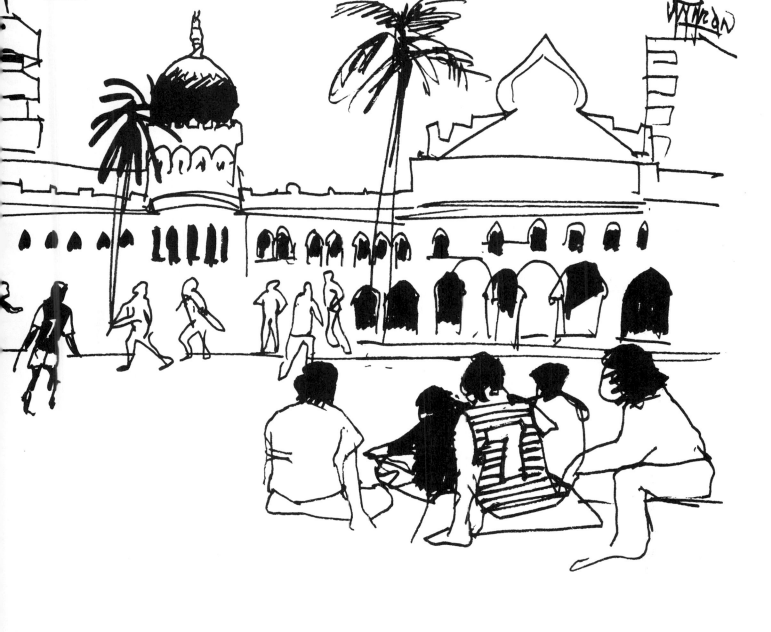

Have you had difficult, discouraging times when you doubted that you were going to make it?

Yes, I have. In the beginning, there were times when I worried, not about how good an artist I might become, but about where my next meal would come from and how I could manage to have time to continue learning. But all along the way, I seem to have always had guardian angels and lucky stars to guide and help me.

Art critics took an interest in my work when I gave my first one-man show at the San Francisco Art Center in 1936, and overnight my name became known in San Francisco art circles. The *Oakland Tribune*'s review stated: "Dong Kingman is a painter we'll have to watch...." A review in the *San Francisco News* described my paintings as "the most satisfying watercolors that have been seen hereabouts in many a day...." The following year I won a First Purchase watercolor prize from the San Francisco Art Association Annual Exhibition. That was quite a nice beginning for me. But I wasn't sure where I would go from there. I was not yet earning a living from my art.

In the meantime, I worked for the Drew family, and so at least I was eating. Then an angel descended on me. I was assigned to the Watercolor Division of the Works Progress Administration (WPA). I gave up my job, and for the next five years, I was able to concentrate on improving my watercolor technique, to think for myself, and to practice and develop my own style. And for the first time in my life, I had a studio of my own.

During this period, other fortunate things began to happen. Albert Bender, a San Francisco art collector, bought some of my paintings and gave them to the permanent collections of several important museums, such as the Museum of Modern Art and the Metropolitan Museum of Art in New York City and the San Francisco Museum.

The WPA Art Project came to an end in 1941, with America's involvement in World War II. I didn't know what I would do next. But my lucky star smiled again: I won a Guggenheim Fellowship—not for just one year, but for two—and it enabled me to travel across the U.S. to study and paint different cities and to come to New York, where I had a most exciting exhibition at the Midtown Gallery in 1942. The show, my first at the gallery, was very well received. Critics for magazines like *Time, Newsweek, The New Yorker, American Artist*, and *Fortune* all praised my work.

I felt I had found my place at long last. After the war I moved to New York, set up a studio, and started teaching watercolor classes at Columbia University and Hunter College. Over the years, I've had some difficult times. But whenever I felt discouraged, I would stop and think of how something had always come along which enabled me to continue learning. I would tell myself to have faith and that with time and persistence I could overcome anything. And I did.

A horse-drawn jitney in the Philippines; this drawing was reproduced in Time *magazine.*

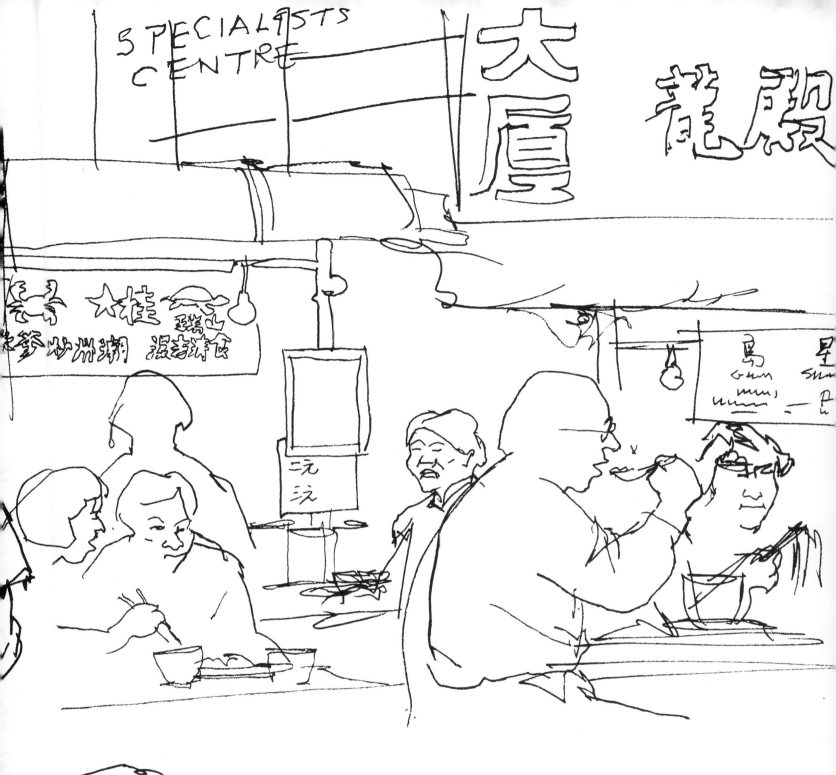

In Singapore, when the car parks, or parking lots, empty out
at night, food vendors set up and sell their wares.

Are there things you dislike in some of your paintings?

There are many things in my art with which I'm not satisfied—such as the design, rhythm, and simplification of my compositions—but with enough time on my side, I'm sure I can improve them. I don't think any painter in the world can honestly say he is satisfied with every piece of work he or she did. Painting requires a lot of hard work and a lot of time. After that, one can only hope for the best. It may take only a day to learn how to use your tools and your medium, but it takes more than a lifetime to become any good.

What aspects of your paintings do you like best, and why?

The thing I most enjoy doing with a subject, especially a street scene, is something like working with a jigsaw puzzle. I break the subject apart (in my mind's eye only, of course), rearrange it, put it together again, and hope it will come out looking and feeling like the same place once again. I like to take a dull subject and make it exciting or to turn a gray, rainy day into a sunny afternoon.

I find I have much more fun painting if I let my imagination go. While having a picnic, I might paint the park scene—people sipping tea or coffee in an outdoor cafe, a sunny sky with kites flying, birds singing on tree branches, a lake with colorful sails and whales swimming around, or every window of a building filled with faces looking out, or stoplights blinking with a rainbow of colors in red, yellow, blue, green, orange, and purple. These are some of my most vivid images and perhaps my best, most expressive paintings.

How would you like to see your work develop in the years ahead, and what new techniques, subjects, or ideas would you like to explore?

Sometimes I think I would like to paint larger paintings, but I have a medium-size studio with a small door opening. Anything larger than 6 ft (1.8 m) square would be difficult to get in or out of my studio.

In terms of subject matter, I'd like to explore figure paintings and perhaps even social commentary, but not portraits. And as for media, I think it might be fun to try acrylic. But the truth is that it's not the tool or medium you use, but how you express yourself on paper or canvas to arrive at your final result that counts.

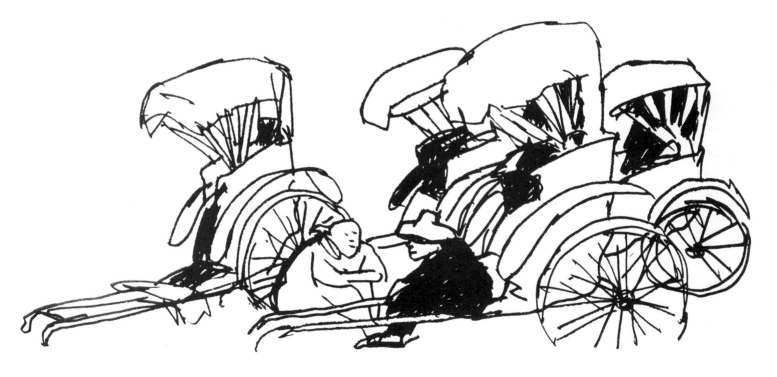

Rickshaw men, Hong Kong

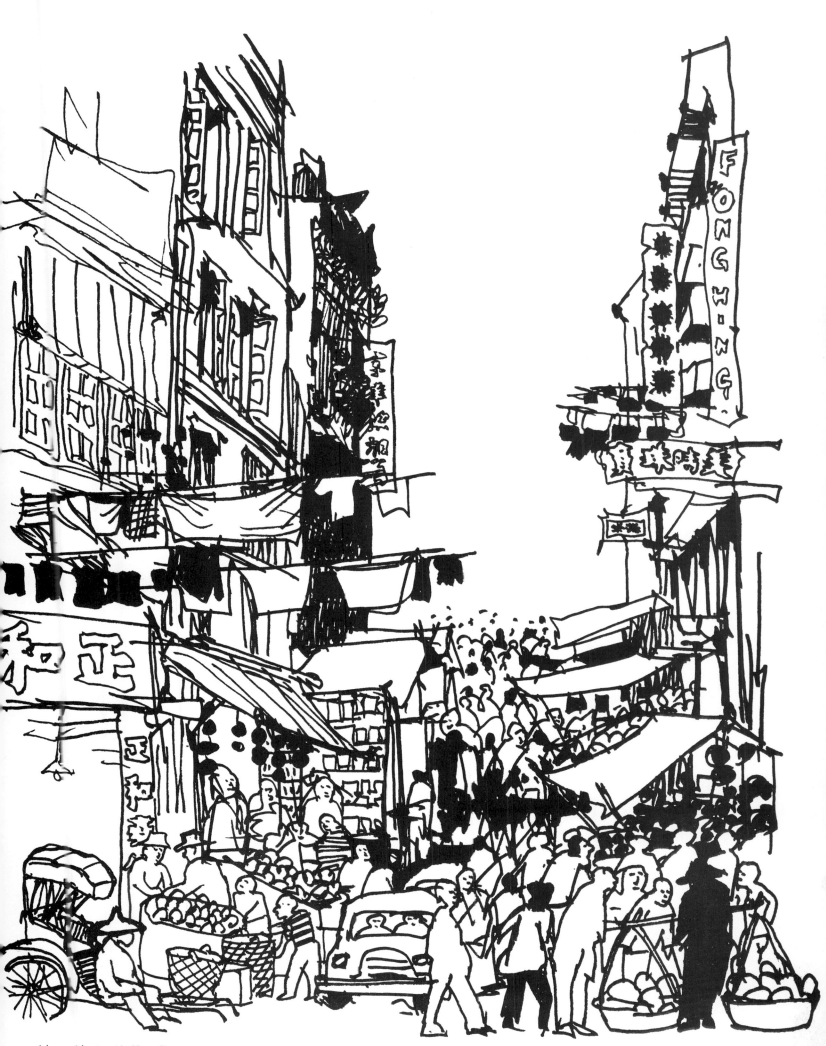

A busy side street in Hong Kong

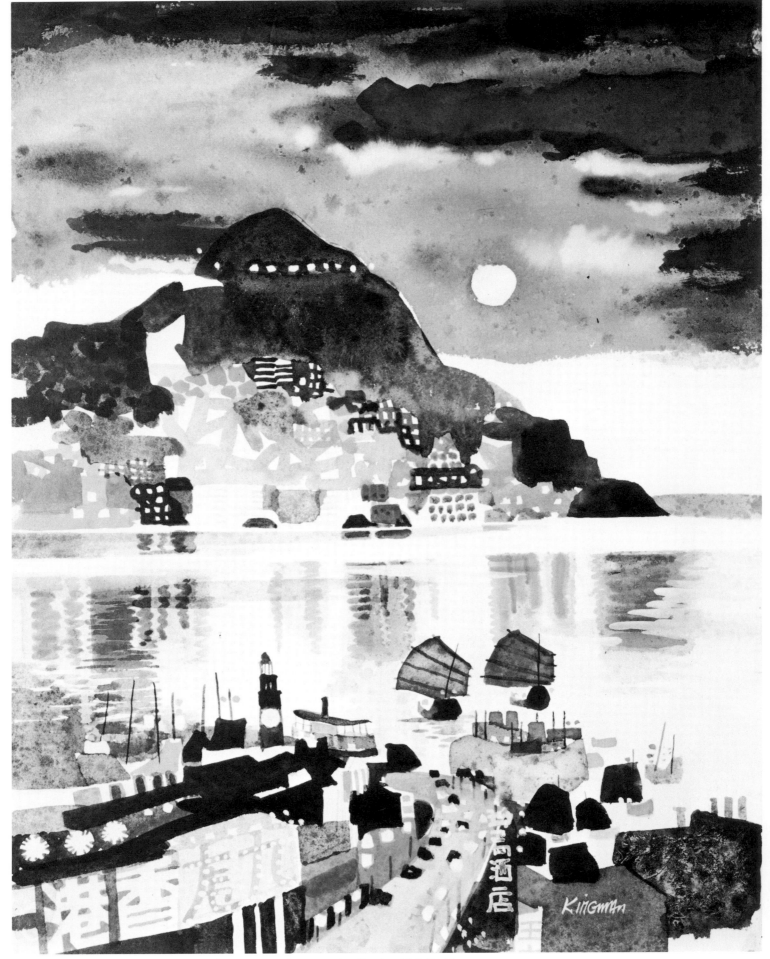

HONG KONG IN MOONLIGHT, *watercolor, 22 x 30 in. (56 x 76 cm); collection, Dick Barkle.*

When you work in your studio, what is your basic painting set-up?

My studio is about 22 x 25 ft (6.5 x 7.5 m), with an 18-ft (5.5-m) high ceiling and a small skylight. On three sides of the room, I have custom-built cabinets for storing my paintings, various art supplies, and reference books. The fourth side is a bank of windows facing south. The specially constructed cabinet units, all suspended from the ceiling and with up-and-down sliding doors, are 20 in. (51 cm) deep and almost 8 ft (2.4 m) tall. Of course, all this cabinetry reduces the amount of actual studio space considerably.

In the studio, I also have a 30-x-40-in. (76-x-102-cm) drawing table; a larger table, measuring 38 x 72 x 28 in. (97 x 183 x 71 cm), with a wooden top; and, besides one of the specially built cabinets which can be opened or closed, a few swivel chairs. With all this equipment, there is not much space left over—and in addition, the doorway to my studio has a small opening and the elevator

in the building is not very large. This limits the size of my work, as any picture larger than 4 x 8 ft (1.2 x 2.4 m) could never be carried in or out of the place.

Although my studio has a small skylight and a bank of windows, I don't rely on natural light for painting, not even during daylight hours. Instead, I've hung a four-tube, 48-in. (122-cm) long "daylight" fluorescent fixture directly above my drawing table, at a height of about 40 in. (102 cm). I always keep the window shades down and the skylight dim so that I can control my light source whenever I paint, day or night. This way I can keep my light consistent as I work—and I know that pictures in exhibitions are always artificially lit anyway.

I paint my watercolors on an adjustable drawing table: its top can be tilted at any angle, from a horizontal position to a vertical one, and the height can be

adjusted from 30 to 45 in. (76 to 114 cm). I added four casters to make the table easier to move around. To the right of my drawing stand is a 30-x-40-in. (76-x-102-cm) table 22 in. (56 cm) high, where I keep my palettes, water jugs, brushes, pigments, sponges, thumbtacks, file cabinets, my favorite little china animals, etc. On the left is a low cabinet of about the same height with drawers full of more paints, colored crayons, pens and pencils, erasers, razor blades, cutting knives, tapes of all kinds, different-sized rulers, etc. I also have several radios sitting atop this and other cabinets around the studio so I can listen to opera, symphonies, the news, and "Mystery Theatre" when I paint. I can work comfortably either standing up or sitting down with this kind of set-up—my drawing board 32 in. (81 cm) high and the side table, cabinet, and chair all 22 in. (56 cm) high. What more do I need than this?

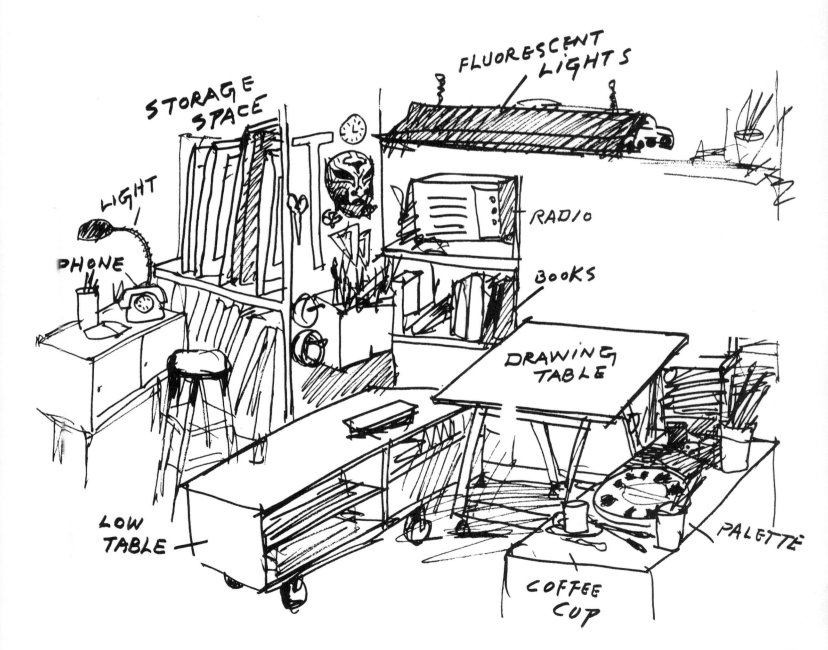

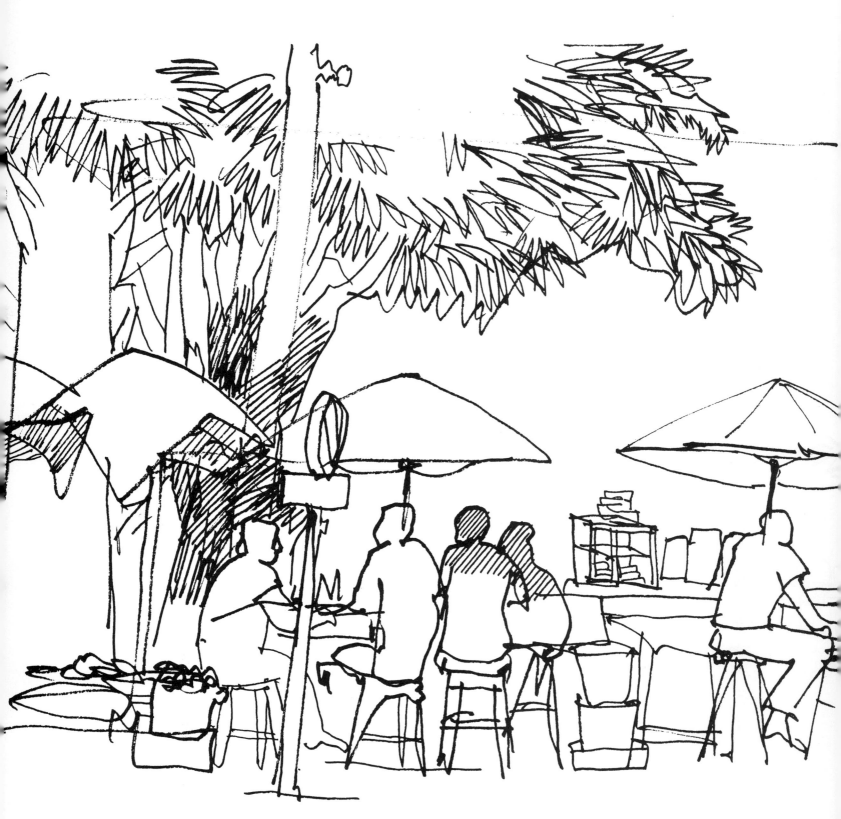

An outdoor cafe in Bangkok

What kind of palette do you use, and why?

For outdoor sketching, I use a small metal watercolor palette with sixteen compartments, or dividers, for my colors. It's black on the outside and white enamel on the inside. It measures 4 x 8¼ in. (10 x 21 cm) when closed and 8 x 8¼ in. (21 cm square) when open, and it has a fingerhold on the lower right-hand corner.

However, I use a different set of palettes for studio painting. Recently I've been using a round plastic palette, 10 in. (25 cm) in diameter, with twelve compartments. I also supplement this with two or three porcelain palettes, each with six compartments, which I use for special colors or media such as ink or designers colors.

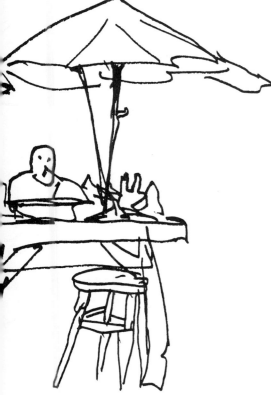

What colors do you use, and how do you arrange them on your palette? Do you try different arrangements for different purposes?

I like the watercolor pigments which come in tubes. For outdoor sketching, I use only nine colors, arranged from right to left: cadmium yellow, cadmium orange, Winsor red, alizarin crimson, burnt sienna, Winsor green, Winsor blue, sepia, and ivory black. I like to place my warm colors at one end of the palette and my cool ones at the other, and I seldom deviate from this arrangement. For indoor studio work, I add a few more colors.

Nature's own colors—whether in landscapes, seascapes, or even town- and cityscapes—may vary from winter to spring, from summer to autumn; though they occasionally turn quite brilliant, usually they are subdued. For this reason, when I paint outdoors I tend to concentrate more on cool and gray color mixtures using black, sepia, blue, brown, and dull green. I try not to use much of my warm yellow, orange, or red hues—and, in fact, I even try to leave most of the white paper unpainted until I can return to the studio and replenish my supply of clean water. This is necessary if I want to keep the warm, delicate colors fresh and bright.

The meeting point of the warm and cool colors on my palette is between burnt sienna and Winsor green. I find that mixing these two hues gives me a neutral tone, usually a cool brown or gray-green, that is especially useful and interesting. Using this basic mixture as a starting point for the colors in my picture, I can add either some alizarin crimson to make it warmer or a little blue to cool it down. If necessary, I can darken and strengthen it by adding sepia or even a small amount of black. At the other end of the value scale, I can dilute this color with water to make lighter, more delicate washes.

What size, texture, and weight of watercolor paper do you use? Do you have a favorite, or do you use different ones for different purposes?

There are many kinds of papers made in different countries—France, England, Italy, Japan, America—and they are all good. You should choose whichever paper works best for you. After years of painting and experimenting with all kinds of papers, I've come to the conclusion that the more expensive papers work better for me because they give me the exceptional quality I need in my painting. The most expensive papers are 100 percent rag, and have a strong painting surface which can withstand repeated working over, washing, and rubbing out. A good paper holds its shape well no matter how many layers of wash I put on it.

Watercolor papers come in smooth, medium, and rough textures. The smooth surface of hot-pressed paper is good for fine brushwork, whereas you can achieve interesting, bold effects with the roughest cold-pressed papers. I prefer to use the one in between, with a medium texture.

Generally, watercolor paper comes in different weights, too: 92-pound, 140-pound, and 300-pound. I use 300-pound paper whenever I use full-size sheets 22 x 30 in. (56 x 76 cm); 140-pound paper for a picture 22 x 15 in. (56 x 38 cm); and a 92-pound weight for sizes smaller than 22 x 15 in. The reason I use heavier paper for larger picture sizes is because large areas of washes often create uncontrollable puddles on lightweight paper. I can control the puddles better with heavier paper.

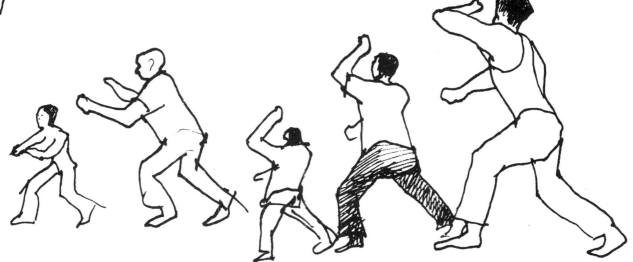

Traveling through Canton, on my way to Hong Kong, I observed many people practicing the slow, dancelike movements of tai-chi.

Do you ever work with opaque media—opaque white, gouache, acrylic, casein?

Because I concentrate mostly on water-base pigments rather than oil, I've experimented at one time or another with gouache, casein, acrylic, and egg tempera. Recently, I did a large mural, 5 ft high and 60 ft long (1.5 x 18 m), for the Lincoln Savings Bank on Canal Street in New York City. I did this mural completely in acrylic on canvas, using an opaque technique, and it came out quite satisfactorily. However, my heart is always with transparent watercolor. I find it the most challenging medium, but it's not easy to learn or understand. It has taken me many years of study and practice to master it.

What brushes do you use? Which ones do you use most frequently and for what purpose?

There are many different types of brushes. Chinese brushes are especially good for calligraphy and for delicate, fine lines. But for watercolor, I generally prefer sable brushes because the hair is strong, yet quite soft, and sable is more resilient than the hair used in Chinese brushes. I like a round brush, and at most I use three or four different sizes for all my work. I especially like the Holbein round sable series 78-K: No. 6 (to which I refer throughout this book as "small"), No. 8 (medium), and No. 12 (large). Occasionally, for very fine lines or for putting my signature on the picture, I use a very small (No. 4) round sable or a small Chinese brush.

Do you ever use other painting tools besides your brushes?

I do use sponges for removing pigment from a picture I've already painted. This doesn't mean I wash off the entire painting, just a small portion of it. Sometimes I use my sponge like a large brush to apply washes of pure water—and sometimes pigment as well—to large areas of the paper. I prefer a natural sponge, and I use both large and small sizes; occasionally, if it's the only kind available at the moment, I'll also use a synthetic sponge.

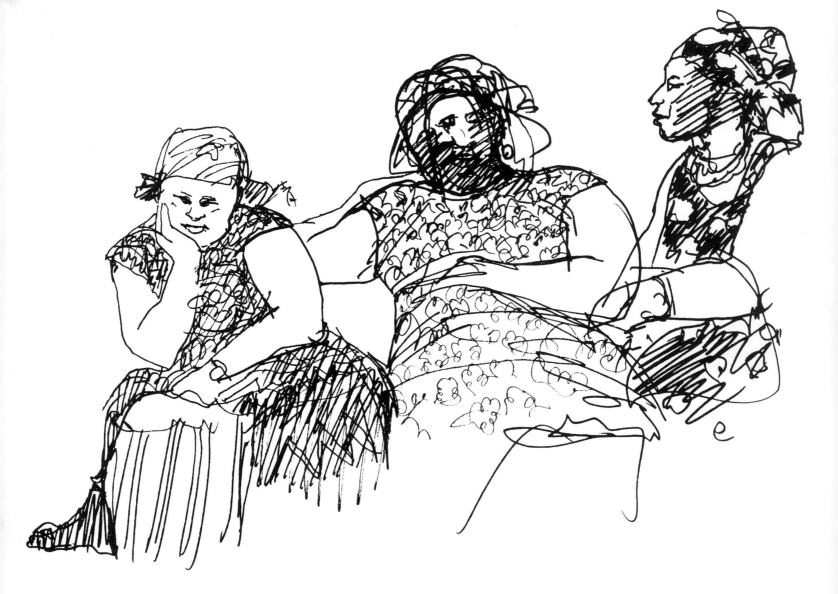

While waiting in an airport on my way to Nairobi, Africa, I sketched some of the other travelers.

What special equipment do you carry for painting outdoors?

Everybody has a different idea of what he or she should take along when sketching outdoors. Some like to have all the comforts of home, so they carry everything—easel, chairs, folding table, umbrella, fly swatter, radio, martini, etc. As for me, I prefer compact, light-weight equipment so I don't have to carry around a heavy load while look-ing for a subject. Lighter equipment also takes up less space in my luggage when I travel.

I like to take the following equipment for outdoor sketching: sketch pads, 11 x 14 in. (28 x 36 cm); watercolor papers; corrugated cardboard, which makes a sturdy, lightweight drawing board; a folding chair; my water container; pal-ettes; tubes of watercolor pigment; brushes; Kleenex, rags, and old news-papers; and a bag of peanuts.

My water container is an empty in-stant coffee jar from my kitchen, the 2-oz. size with a 2-in.-diameter opening. It may contain only 2 oz. of water, but that's enough for my purposes, and if I close it tightly, it doesn't leak.

Instead of carrying an easel, I take along a compact folding stool so I can sit down and paint in comfort. My stool, which I bought years ago, measures about 14½ x 19½ x 14 in. (37 x 50 x 36 cm) when opened, and it folds flat for carrying. This type of folding stool can usually be found in garden-supply stores rather than art stores.

Finally, I always carry old news-papers, rags, and Kleenex when I paint outdoors. I use them to keep my palette and brushes clean and away from the dirty ground, and of course, I also use them for wiping up when I finish my work. No sane watercolor artist should live without Kleenex!

I believe you should carry whatever you feel you need to have for painting outdoors. But most important of all, you should always remember to take your inspiration with you.

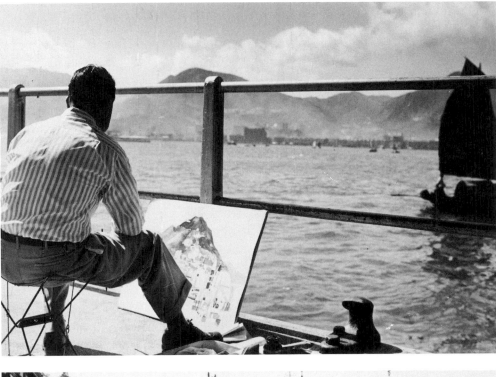

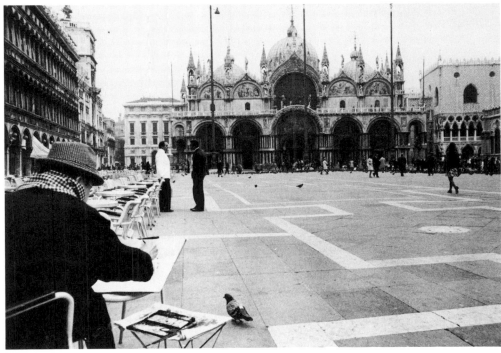

Wherever I travel, I paint on location, weather permitting. Shown above are two of my favorite sites: the Hong Kong waterfront, photographed in the 1960s (top), and the San Marco square, in 1971. The sketches below illustrate some good painting positions—they allow you to move about freely and to see your entire painting surface at a glance.

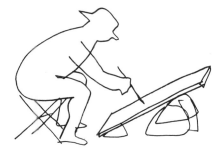
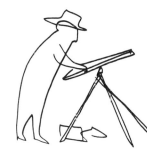

PAINTING METHODS

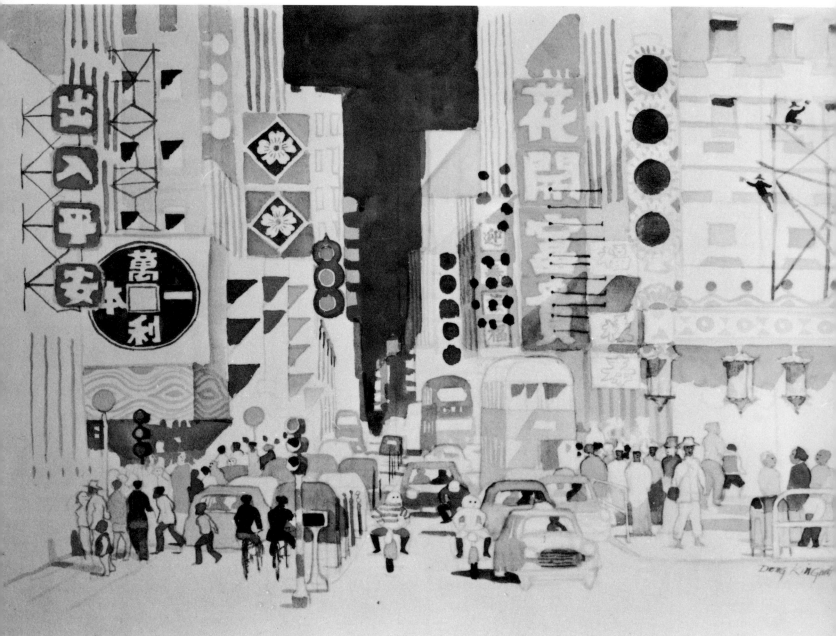

HAPPY NEW YEAR, 1979
22 x 30 in. (56 x 76 cm)
Collection, Mrs. Aw Boon Haw

Nathan Road, Kowloon, is one of the busiest
streets in Hong Kong—full of shops, cafes,
and night clubs. What I tried to do in this
picture was not so much re-create Nathan
Road, but change it and utilize the street
signs for good-wish slogans and New Year
greetings instead. I applied a deep blue
color to the sky and created the impression
of strong sunlight bathing all the buildings
and streets.

Do you use a viewfinder to help you select your subject, or do you ever use your hands to form a kind of natural viewfinder?

An experienced painter doesn't rely on a viewfinder. He uses his eye to select and determine the subject. Then, through his imagination, he transfers the image onto the paper or canvas. After years of outdoor painting, I've come to the conclusion that no matter how interesting the subject, elements of the actual scene always have to be added or subtracted from the composition. Design elements, aspects of the color in the scene—including sunlight and shadow—always have to be worked out so they satisfy the demands of both the painting and the painter.

Do you find a camera helpful for gathering material for paintings? Do you sketch from a photo and then paint from the sketch?

Usually I begin a picture on location by sketching the subject directly onto the paper. I never take a photo of my subject and copy from it. I remember that in 1954, when I was on my first round-the-world sketching tour, I deliberately left my camera home because I was afraid I'd spend less time sketching if I took time out to photograph my subjects. But photos and tear sheets from magazines and newspapers, whether in color or black-and-white, are important reference materials. I think every artist should have a good file of these. Over the years I've collected photographs of cities, street scenes, people, animals, trees, and buildings. It's not necessary to use photographs as references for my actual subject and composition, but I find that studying photos can help me improve the minor details, the textures, and the light and dark patterns.

Do you ever paint purely from memory like the great Chinese landscape painters of the past?

I have great respect for the Chinese painters who worked from memory. However, I try to take their techniques one step further by combining Eastern and Western painting methods. That is, I usually start my watercolor on location and finish it in the studio by recalling the scene and using my imagination to develop it. I find that, for me, this is the best way to create my paintings. It gives me time to think and, hopefully, to develop additional elements in the painting which usually do not appear in the original subject.

However, sometimes I *do* paint completely from memory and imagination. I have done many watercolors from start to finish in the studio, without reference to nature. These too have turned out to be quite successful.

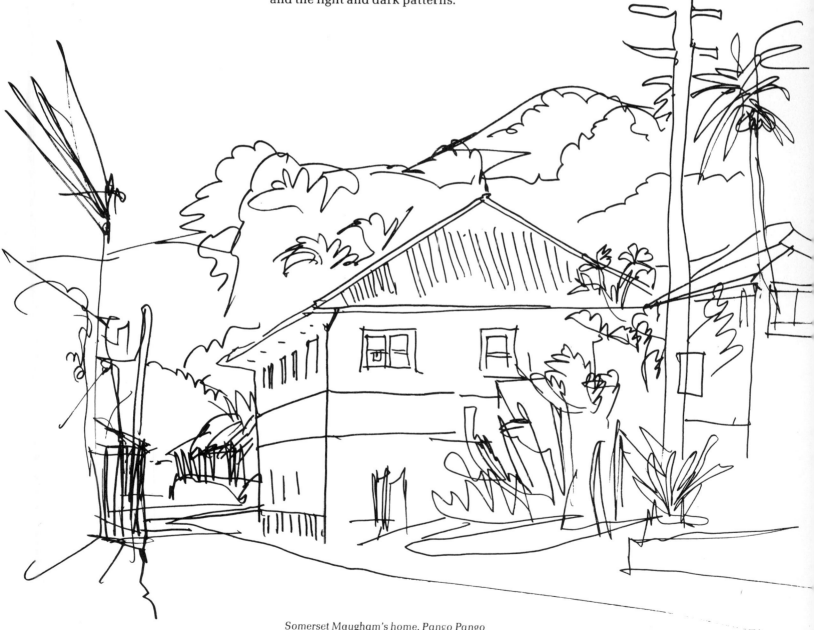

Somerset Maugham's home, Pango Pango

Do you keep your drawing table or easel horizontal, slanted, or vertical when you paint?

Do you wet the surface of your paper before you begin to paint?

Do you sponge, soak, or stretch your paper, or do you simply tape or tack it down without any further preparation?

I always use a drawing board for watercolor painting in my studio, and I keep it in all these positions at one time or another during a painting, depending on my needs. When I apply washes on a large area, there is usually a large amount of water floating on the surface of the paper. During the process of drying, the wet pigments sometimes settle into unexpected puddles; when this happens, I tilt my table upward or downward to change the flow of the wet pigment—and correspondingly, the shape of the puddle.

When I go sketching outdoors, I usually place my watercolor board on the ground and tilt the surface, with the top part of the board raised about 5 or 6 in. (13–15 cm) off the ground.

Usually I start my watercolors on a dry surface. I learned my watercolor lessons from the old Chinese school of painting: most traditional Chinese watercolors were begun on a dry surface, and many ended up without any background colors at all, relying on the white of the paper for a background. I begin my paintings in the traditional manner and worry about the background later. Occasionally, when the subject calls for an overall wet technique, I begin on a wet surface. This is usually the case when I'm painting a foggy or misty scene, such as an early morning in San Francisco.

For outdoor sketching, I just tape down the four corners of the watercolor paper with masking tape on a piece of corrugated cardboard. This is preferable because I keep my equipment as light as possible while working on location. For indoor work, my paper is tacked down on a wooden drawing board. Sometimes I apply a tremendous amount of pigment and water to the paper when I'm painting large areas, and for this reason I place the thumbtacks fairly close together—about ½ in. (1.3 cm) apart—all around the edge of the paper. As the painting dries, the paper becomes smooth again.

The familiar temples of Bangkok, sketched from across the river with a portion of the floating pier shown in the foreground

Do you mix your colors on the palette or on the paper itself?

I always mix my colors on the palette rather than directly on the paper, since I like to be sure of how the colors will look before I use them. When I apply transparent washes on the paper, I always try to arrive at the exact color, tone, and texture I desire before it's completely dry. If it doesn't meet my expectations after the first wash is completed, I try a second wash to make up for what I might have missed in the first. But this method is good only if you work from light to dark in your color values.

Do you apply washes by the traditional method of overlapping strokes on a tilted painting surface, starting at the top and working downward?

Yes, I apply washes on paper the same way any other artist does. I learned early on that if I wanted to apply a big wash on paper, I should prepare a large enough mixture of pigment and water on the palette before applying it to the paper. At this stage, there is usually excess water floating on the surface of the paper, so it's better to keep the paper level and wait till some of the water begins to evaporate. Then, and only then, do I begin to tilt the paper backward or forward to let the wash run and create a soft effect.

Do you use the wet-in-wet technique? The drybrush technique?

I could discuss at length each of the different types of techniques—wet-in-wet, wet-on-dry, dry-on-dry, dry-on-wet, wet brush, drybrush—and whether to use these techniques on smooth, medium, or rough paper surfaces. Generally, wet-in-wet creates a soft edge between colors, and the drybrush technique makes a brush stroke with hard edges between color and paper. On a wet background, a "dry" brush—one with lots of pigment but very little water—will create a hard-edged stroke, though it may flow softly at first. A dry stroke on a dry surface doesn't flow, and it may even appear somewhat grainy, depending on the texture of the paper. A "wet" brush stroke applied to a dry surface contains a tremendous amount of water and pigment, and it may form puddles.

I could go on and on describing different types of techniques, but basically I feel it isn't necessary to limit yourself to a single technique or one type of stroke. It's really better to learn all the techniques and be able to apply them whenever you need them.

Do you ever use special techniques like scraping, scratching, blotting, wetting, lifting, or other less conventional techniques?

Some watercolorists like to scrape or scratch with a razor blade, the end of a brush, or a piece of sandpaper. I don't find these techniques necessary, mostly because they are uncontrollable and I don't like to destroy the surface of the paper if I can help it. But I do use blotting, imprinting, wetting, and lifting techniques in my watercolor paintings. Let's face it, one always makes a certain number of mistakes. So I make corrections by wetting and lifting. I often use blotting and imprinting methods to create a texture. I never use them by accident, but always deliberately to achieve a particular effect.

Do you ever combine ink, acrylic, or other media with watercolor?

Because my medium is transparent watercolor, I try to keep it pure, but on rare occasions I do combine it with other media. Sometimes I experiment by using Pelikan's PLAKA fluorescent watercolors, Pelikan drawing inks, or Winsor & Newton designers gouache to create bright, fresh tones of green, orange, yellow, and light red. But that's just for small areas.

Junks and a ferry in the Hong Kong harbor

Do you ever use additives to alter the behavior of the paint—salt, glycerine, starch, acrylic medium, etc.?

Basically, I just stick to watercolors, except under unusual circumstances, and never use additives of any kind to alter the behavior of my paint. One time, however, I was forced to use an unusual substitute. I was passing through the Big Sur in California and wanted to paint, but I'd forgotten to bring my water bottle. There was nothing around except sea water, so I used Coca Cola instead! There's a saying that a bird in the hand is better than two in the bush. In this case, I already had my Coca Cola in hand. If I'd wanted to get salt water from the sea, I'd have had to roll up my pants, take off my shoes, and get my feet wet. No, thank you. Even now, many years later, the picture of the Big Sur still feels sticky with syrup.

How do you speed or retard the drying process, and do you use any special equipment for this?

I don't do anything special to retard drying, but I do occasionally borrow my wife's hair dryer to speed it up. I feel this serves a useful purpose, and it allows me to create a different kind of texture from the one I get when I dry a watercolor slowly.

What kind of mats and frames do you like best for your watercolors?

I usually prefer to use eggshell-white linen or off-white illustration board to mat my watercolors. If I choose a darker mat, I set it off with a ¼- or ½-in. (.6- or 1.3-cm) white border between the picture and the mat.

When it comes to frame styles, I think they should be as plain and simple as possible. For a picture measuring approximately 22 x 30 in. (56 x 76 cm), I'd recommend a frame no more than 2 or 2½ in. (5 or 6 cm) wide; together with a 3½-in. (9-cm) mat all around, this would create a border of almost 6 in. (15 cm), bringing the total picture size to about 32 x 40 in. (81 x 100 cm).

Of course, this is just my own taste. Everyone has to develop his or her own idea of what style and size should be used to mat and frame watercolors.

THE BUSY BAY OF HONG KONG, *watercolor, 22 x 30 in. (56 x 76 cm), private collection.*

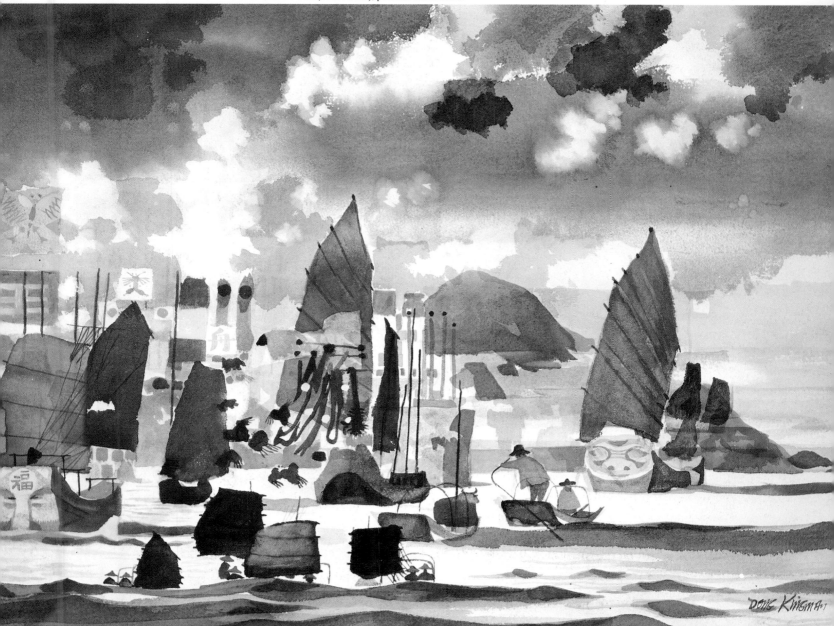

PAINTING A TYPICAL PICTURE

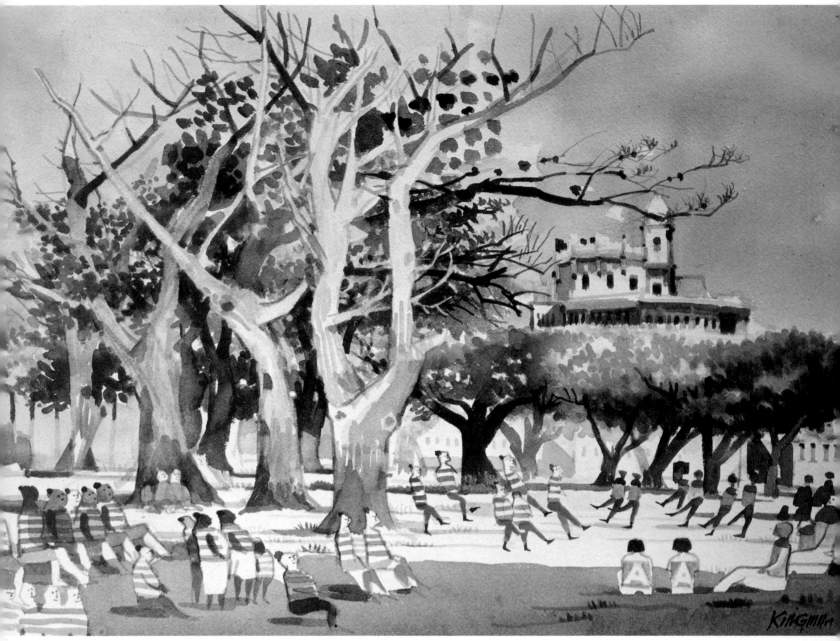

SOCCER IN RIO
22 x 30 in. (56 x 76 cm)
Collection, Sally Aw

When I was conducting a workshop in Rio de Janeiro, I found this scene next to my hotel—a nice city park with beautiful big trees and youngsters playing soccer. I started this watercolor on location, as I always do. I painted most of the big trees in the background first and later, in the studio, finished the foreground and the figures.

What subjects do you like to paint most, and what is it about them that excites you?

Since I've lived in cities all my life, it's only natural that I would be most familiar with busy urban scenes—street scenes, waterfronts, parks and picnic grounds, etc.—and the people, vehicles, and architecture within them. Amid the profusion of telephone poles, traffic signals, bicycles and cars, and new and old buildings is where I find the subjects that interest me the most. In fact, I've been living with these twentieth-century phenomena for so long that I often wonder if I could ever live without them!

Sometimes I do run out of inspiration or ideas. But when this happens, I stop my work and just go for a walk down the street or sit for a while on a bench near Central Park, quietly observing the people and scenery before me. Slowly but surely, I become charged with excitement again, my inspiration returns, and I go back to my studio and continue my work.

How do you plan a composition? Do you make small sketches before you start a picture?

I do make small composition sketches, but most often I do this during a lecture/demonstration or as a teaching technique to show my students how to compare an original idea with the finished watercolor. This is always helpful because it clarifies many of the finer points between the small sketch and the final painting. I make small sketches for myself, too, but I'm more likely to do these in the studio.

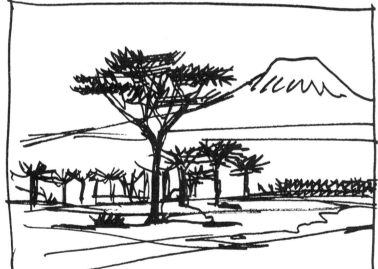

In planning your composition, how much do you alter what you see? How do you decide what to leave out?

Much depends on the situation. I always believe that no matter how good or interesting the subject is, it still requires know-how and experience to improve it in your painting.

Looking for a subject is not always easy. I've heard people say that they've walked millions of miles, yet have not found any interesting subjects to paint. Sometimes I feel the same way. But when finding a subject becomes difficult, I say to myself philosophically, "Maybe it's not that the subject isn't interesting, but rather that the patterns of sunlight and shadow, or perhaps other design elements, have fallen in the wrong places." When elements have gone wrong, they can be corrected—but you must know what to do.

There is an old Chinese saying: Success depends on all three harmonious elements of heaven, earth, and man. This is called *San Ho*, or "the Three Harmonies." For the artist, there are three harmonies, too: good weather, good scenery, and great inspiration. It's best to have all three on your side when you go out painting.

Studies for a painting of Kilimanjaro

35

Amsterdam, sketched from my hotel window in 1973

Do you make small value sketches to help you plan your values before you start to paint? Do you ever make preliminary drawings of specific details or other aspects of your subject?

When I plan the values for my composition, I am less concerned about how the scene actually looks than with how I should place the values according to my concept. I know from past experience that it's that extra touch which determines whether or not my picture will be a good one. I don't use any particular medium for my value sketch. I just pick up whatever is handy—black marker, crayon, pencils, watercolor pigment, or anything else within reach. I usually make my value sketch in three or four neutral tones gradating from black to white. I seldom use colors for this because I *think* of values as gradating from dark to light, rather than from warm to cool colors. I find I can judge how successful my gradation is by taking a black-and-white photograph of the painting afterward.

The only preliminary drawing I ever make is a compositional sketch to furnish as much information as possible before I start the actual painting. When I need a preliminary study to indicate my idea, the drawing is usually quick, sketchy, and broad, concentrating only on the general outline rather than details and colors. On other occasions I have all my ideas worked out in my mind ahead of time before putting anything down on paper, and a sketch isn't necessary. This lets me concentrate all my creative efforts on the actual watercolor painting.

Do you complete an entire painting on location, or do you start on location and finish in the studio?

I get the best results if I start my watercolor picture on location and finish it in the studio. I usually spend from an hour and a half to two hours working on a picture on location, completing perhaps 25 to 40 percent of it. Then I take it back to the studio, where I do the remainder of the work on it. One reason I work this way is because I like to capture the scene as quickly as possible on location before its light, shade, and general atmosphere change. When I get back to the studio, I can relax and take more time to think about the details. However, studio painting is much more complicated and difficult than outdoor painting. It may require weeks, sometimes months, of work for a picture to be finished satisfactorily. Each new watercolor I create becomes a challenge within itself. There is a tendency to try to do better each time. That's why it's becoming harder and harder for me to finish a painting with total satisfaction.

How do you know how far to carry a picture on location before you take it back to the studio?

One of the ways I know when I've sketched enough is that my legs get tired and my back begins to ache. This happens when I paint outdoors because I always sit down on a small stool and bend over to paint my picture, which is lying on the ground.

When I start a picture outdoors, I first draw the composition in line. Then I apply colors to the center of interest and a few surrounding elements. I don't do too much more at this stage; I almost always leave large areas such as the sky, sea, land, etc., unpainted until I return to the studio. Another reason I don't stay outdoors much longer than this is because I only carry a 2-oz. water jar, which is just about sufficient for a couple hours of painting.

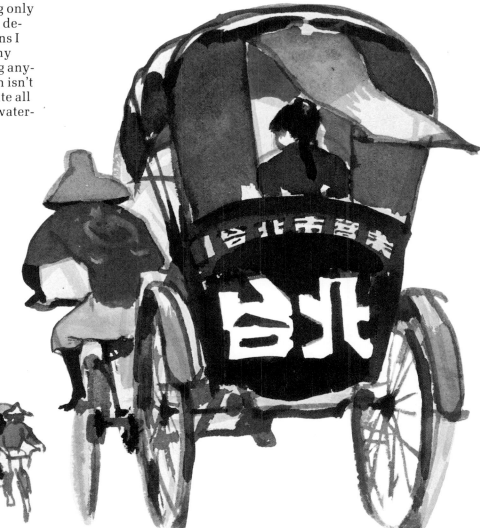

RICKSHAW, TAIWAN
Watercolor, 10 x 15 in. (25 x 38 cm)
Illustration for Time *magazine*
Collection of the artist

37

CELEBRATION, CHINATOWN, *watercolor, 22 x 15 in. (56 x 38 cm), private collection. Painted during the 1950s, this San Francisco street scene was done in a style quite different from my more recent work.*

When you start a painting, how detailed is your line drawing, and do you make it with pencil or brush?

When I first learned to paint in watercolor, I would do an initial outline sketch in pencil. But in later years, I discarded the pencil and now use only a fine brush. My training in calligraphy is most helpful to me in this area. Because I do the entire painting with a brush, both the line drawing and the broad washes are closely related to each other throughout the picture. As the painting progresses, I often continue to draw small details in line before I paint them.

When you've completed your outline drawing, do you then cover the entire sheet of paper with broad washes of color? What kind of brushes do you use at this stage?

No, I almost never try to do this. To me, the white of the paper is most valuable, and I must preserve it as long as I can. I develop my center of interest and certain other elements, but usually I wait till I return to the studio to paint the larger areas. I think it over very carefully before I paint them, and I cover up the paper only if I have to. This helps preserve the fresh sparkle of my colors.

I use three or four different sizes of brushes. Of course, it's always more comfortable to use the right size brush for any given area, but I have a tendency to rely on my medium-size brushes the most, because they can do almost all the work which the larger and smaller brushes can do.

When you start laying-in your colors, do you follow the traditional method of starting with the lightest tones and then moving toward the darks, or vice versa?

My method may seem unorthodox compared with the traditional way of starting a watercolor picture with light tones and gradually applying layers of color to build darker tones. I learned to paint from a Chinese teacher who taught me to begin working from the main area of interest, without any background colors. Today, I still begin with my center of interest, but I often start with the darker colors, perhaps with a gray-blue shadow on my main subject. I use these dark colors as a key to determine the other color values. I don't work from top to bottom or from background to foreground—I still start painting from my center of interest and finish with the least important elements.

In the studio, do you sometimes make compositional or color studies to try out possible changes in a picture?

Yes, I do make small studies to experiment with possible changes. I also make sketches on overlay tissue, which I place directly over my watercolor to try out changes in the composition. At this stage, I refine some of the details as well, utilizing my files of reference photos to complete minor elements such as people in the streets, lampposts, tugboats, Chinese junks, or whatever. For me, the great fun in art is being able to use my imagination and combine different elements to create an interesting piece of art.

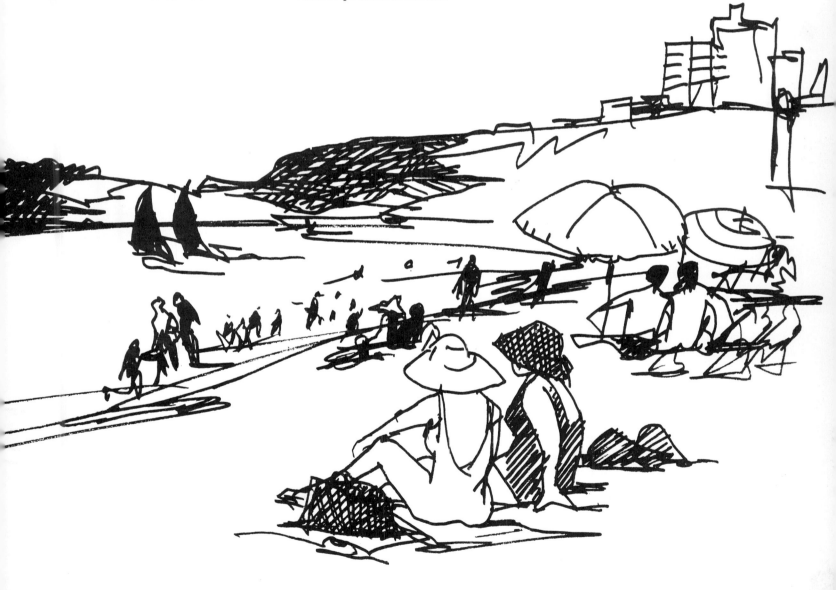

The popular surfing beach in Sydney, Australia

Back in the studio, do you continue working on the picture immediately, or do you put it away for a while and come back to it later?

I don't find it necessary to continue working on a picture as soon as I get back to my studio. In fact, in my experience, only about one out of every three sketches done on location is worth finishing. But as a rule, I feel it's better to cover the broad areas of the picture with color as soon as possible, and I generally go on to this step when I restart the painting in the studio. I then go back and try to improve these areas by going over all the others as well.

In the studio, I carefully plan my overall composition, which includes design and color as well, since these elements are so closely related. In my opinion, design has to do with using dark and light values to balance the composition, whereas I use color to create a mood. This planning usually takes a good deal of time and patience, but it's a necessary step before I can go on to finish the picture.

Every artist employs a different method to paint his pictures. Some artists like to work outdoors and others indoors. I like to utilize both to advantage. Sketching outdoors, I can capture the real mood of my subject. And in my studio, I can create and add my own concept to the same picture. However, what matters is the finished piece of art work. It has to be good.

How do you evaluate a picture while you are working on it? Do you have methods that help you to see it from a fresh viewpoint?

When I run into a problem with a picture, I use all sorts of tricks like turning the picture upside down, looking at it through a reducing glass or in a mirror, and so on. A mat, of course, is always useful, though I can't depend on mats to change my composition. These tricks are helpful only up to a point. Ultimately I must rely on my own judgment.

But I find that when I get stuck and can't continue to paint my picture, the best thing to do is put it away and sleep on it for a few hours, or even a few days. When I get up the next morning and see the picture with a fresh eye, my inspiration usually comes back to me.

THE FRAGRANT HARBOR, *22 x 30 in. (56 x 76 cm); collection, Mr. and Mrs. Jack O'Brian.*

"Fragrant Harbor" is the literal English translation of the Chinese name for Hong Kong. This scene was painted looking uptown from North Point, with Victoria Mountain in the distance. The time was early morning after a violent summer thunderstorm, and the sun was slowly peeking through the city. This picture always brings back my boyhood memories of Hong Kong.

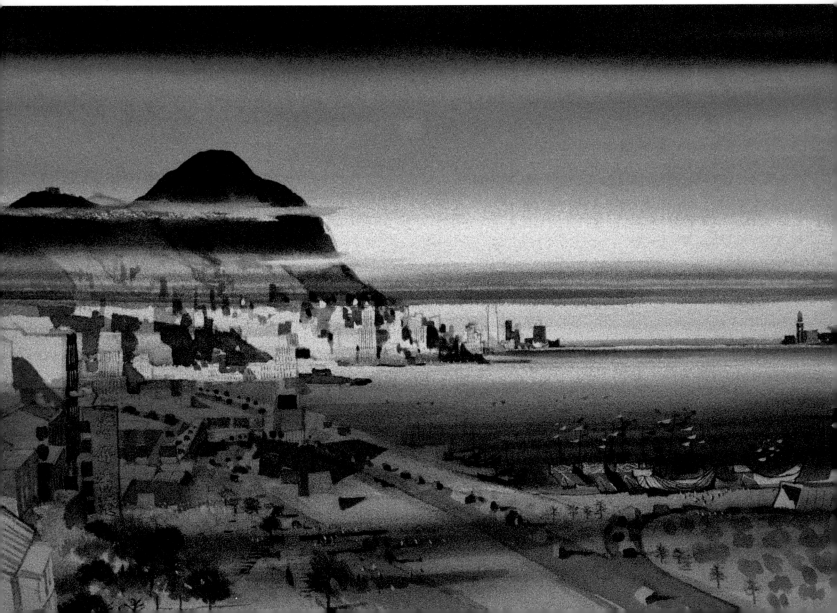

How do you know when to stop painting? Do you sometimes go too far and wish you'd stopped earlier?

To be honest, I have no way of knowing when to stop or when the picture is finished. One thing I have learned is that the longer I work on a picture, the harder it is to decide when to stop, especially toward the end of the painting process.

I find that each new picture presents new problems. No matter how much I have learned, something new and challenging comes along every time I work on a picture.

Do you ever make radical changes, such as overpainting with opaque color, cropping a painting to a different size, or soaking the whole sheet in the bathtub?

I have rarely used opaque color to overpaint on transparent watercolor. One of the basic reasons for doing this is to change colors back from dark to light, but I don't use mixed media if I can help it. My own technique for recovering light tones from dark ones, especially in small areas, is to remove the pigment from the paper as follows: First, I dip a brush in clear water and wet the area from which I want to remove the pigment. I blot it dry with Kleenex and then erase it immediately with a Faber Castell Artgum eraser, rubbing gently. The idea is to rub off only the pigment, not the surface of the paper. If the pigment doesn't come off the first time, I try again, but it must always be rubbed with care and patience. Eventually the pigment will come off—without taking off too much of the watercolor paper. It's important to note that I don't use this method on any area larger than 2 to 3 in. (5 to 8 cm) square.

When I begin a picture, I develop my composition in proportion to the size of the paper. During the process of painting, I may alter the composition slightly, but I almost never change the size of the paper. Also, I'm used to painting my watercolors in only two sizes: full sheets (22 x 30 in., or 56 x 76 cm) and half sheets (22 x 15 in., or 56 x 38 cm). It's easier for me to make frames to fit these two sizes, which is a convenience when preparing for exhibitions.

Do I ever soak the whole sheet in the bathtub? My answer is no. I enjoy straightforward watercolor painting, and I use as few tricks as possible.

The elegant facade of the Hong Kong Club

ADVICE TO WATERCOLORISTS

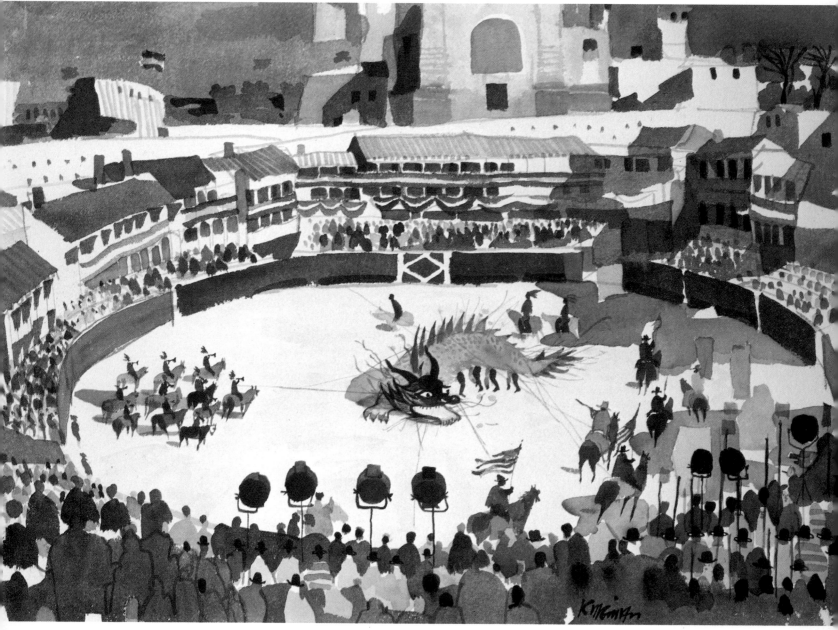

DAY OF THE IGUANA
22 x 30 in. (56 x 76 cm)
Collection, Mr. and Mrs. John Uhr

One time we were invited to watch the film-
ing of a Hollywood Western in Spain. It was
in a town named Chinchón, not far from
Madrid. The paper dragon in the center of
the picture has nothing to do with the
movie—I just put it in the scene to add fun
and fantasy.

Watercolor paper is terribly expensive. What's the best way to economize?

I know many fine painters who use inexpensive machine-made papers for their work, and this is fine if it gives them the results they want. It's all a question of what kind of texture you are used to. I don't think economy should be the only consideration when it comes to buying art materials.

I like to use expensive D'Arches paper: 300-pound for full-sheet paintings, 140-pound for half-sheet paintings. To me, there's a great deal of difference between 100 percent rag and machine-made paper. The rag paper can withstand a tremendous beating, including washing off the pigment to paint something over again, erasing, and scraping off the surface with a razor blade. It also has an inexplicable quality—the way in which colors settle on a 100 percent-rag surface—with which no other paper can compare.

If you could afford just two or three brushes, which ones would you choose? Is it better to buy a few expensive brushes or a wide selection of inexpensive ones?

I am against buying any inexpensive brushes. I know this may be hard when you cannot afford expensive brushes. But in the long run, you will not only paint a better picture, but also save money. A good brush will last a long time if you take care of it. I suggest buying two or three good-quality sable brushes. If you cannot afford two or three, buy only one brush: a No. 8 (medium-size) round sable. I use the No. 8 brush more often than any other size. Whenever you finish using your brushes, wash them off immediately with soap and water and let them dry. This will prolong the life of your brushes.

Is it helpful for a beginner to start out with a very limited palette of colors or with a complete palette?

The question is not how many colors you should have on your palette, but what you want to do with them. I can understand why some painters suggest that beginners start with only a few basic colors and gradually work their way up to a full palette. In a way, that's my own theory, too. Earlier (see page 25), I described my simple nine-color palette. By mixing these basic hues, you can make the color mixtures you need for most purposes.

This sketch was done at the Benihana restaurant in San Diego, California

LADDER STREET, HONG KONG
22 x 30 in. (56 x 76 cm)
Collection of the artist

The famous Ladder Street is located in the old part of the Hong Kong island. There are picture-signs on the walls of the buildings which advertise fortune-telling, palm-reading, pawn shops, food stalls, and singing birds. The street is full of newspaper stands, bar-and-grills, and shops where you can buy *dim-sum* dumplings, wonton noodles, and *jook* (a variety of rice soup). Hidden away in small corners there are always barber shops, herb doctors, tailors, and perhaps a ricksha or two for the tourist. Because Ladder Street is always packed with people, day and night, I find it a fascinating place to sketch.

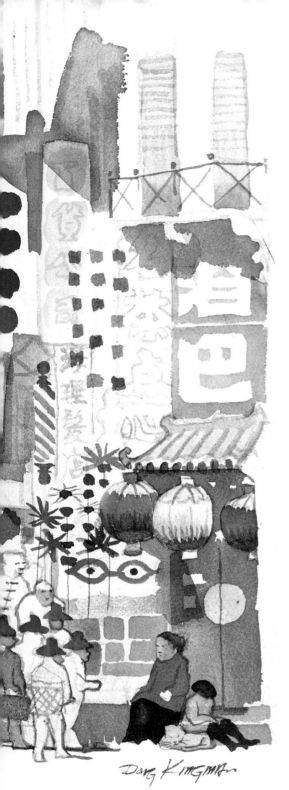

For the beginning watercolorist, is it best to begin working on a small scale and gradually work larger as he or she learns more about the medium?

The size of your painting really is a minor problem, and you should start with any size you prefer. The important thing to remember is that whatever size you choose, you should be far enough from your paper to see the whole sheet at a glance, yet close enough to your art supplies and equipment to paint in comfort. While I'm on the subject, I want to point out that no matter what position you are in while you paint, you must get up and walk away from the painting from time to time to study it at a distance, from another angle, or even upside down.

Should the beginning watercolorist start out by painting still lifes indoors before going outdoors to paint?

There is no reason why you should begin with still lifes or any other particular kind of subject matter. I think you should take into account your own likes and dislikes when it comes to subjects. But whatever subject you choose, my advice is to keep it as simple as possible until you've gained some experience before trying to do more complicated subjects and compositions. Remember this is only a general principle, not an iron-clad rule.

PEKING GATE
Watercolor sketch
22 x 15 in. (56 x 38 cm)
Private collection

This was part of the set for the motion picture *55 Days in Peking*—so skillfully made that, seen from the front, it was almost indistinguishable from the real thing.

Would you advise watercolorists to stick to transparent watercolor and not try opaque color, mixed media, and other unconventional techniques?

The more you can learn from other media, the more it will help you to improve your own, and vice versa. I think it's always important to know not just one or another medium, but as much as you can about all the visual arts—sculpture, lithography, printmaking, and so on.

Although experienced artists often use the camera to gather material for paintings, do you advise the less experienced painter to work from photos?

I'd advise less experienced artists to paint from life rather than copy photographs. I don't start my paintings from photographs, but I do use them for reference to ascertain details, especially after I've begun a painting. But if I had my way, I'd prefer to paint directly from the subject or else create my painting entirely from my imagination. It's a great deal more advantageous to sketch directly from the subject than to copy it from a photograph. One thing is certain: A camera can only catch the mood of the subject for a second. But an artist can capture the mood of the subject for a whole century, if he wishes.

When a painting isn't going well, is it best to keep plugging away and try to solve the problem, or should you discard the picture and start again?

From my own experience, I'd say that if I'm able to keep plugging away with a painting, then I'm not having a major problem with it. But when I do find the going is hard, it's helpful to stop, look, and think. I must then try to continue with the picture and carry on from there. I have to take the plunge because there is no way of telling what is right or wrong until I am willing to experiment with it.

BEHIND THE CATHEDRAL, MEXICO, 22 x 30 in. (56 x 76 cm); collection, Mr. and Mrs. Edwin Singer.

There was an old fountain behind the cathedral in this village which served as a town square. Troopers always stopped there to rest their burros and their own feet, and I felt the whole scene made a picturesque composition.

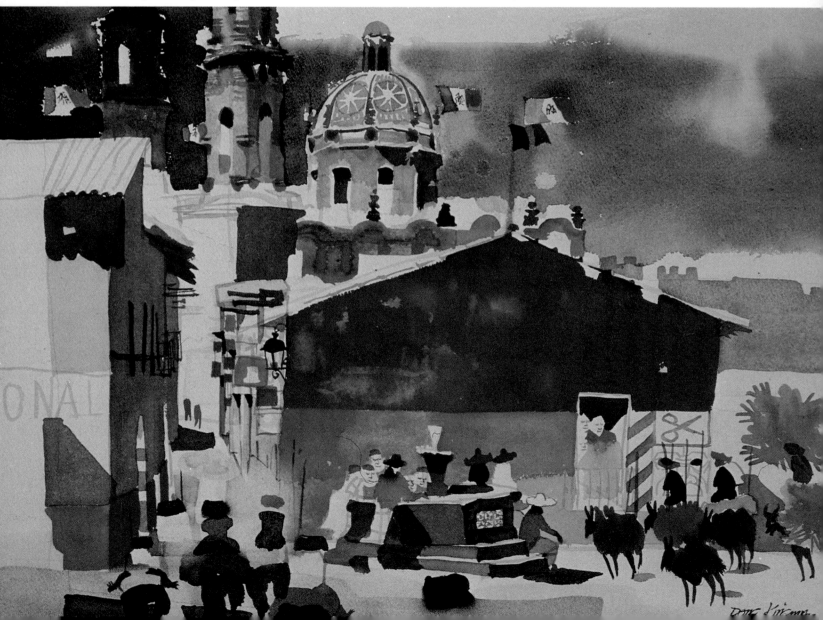

Painters sometimes hit a dry spell when they seem to be repeating themselves instead of growing and improving. What's your advice about getting through these discouraging times?

What is a "dry spell"? I really don't know. If you ask a farmer what a dry spell is, he will say, "Send for the rainmaker." If you ask a drinker, he will probably say, "I'm on the wagon." But for an artist, a dry spell can only be a personal problem. Learning art is constant hard work. It cannot be accomplished overnight, and you must have perseverance as well as talent. There may be disappointing days when you feel you're having a dry spell—but if you continue to paint, you may well be rewarded because you are willing to work through your difficulties.

Should the watercolorist keep everything he or she paints or just save the successful pictures?

In general, it's good to be able to keep everything you create. I am reminded of what happened when I was living in Hong Kong. I kept all my early sketches and watercolors in an old trunk, and when I looked for them years later, they had all been eaten up by bookworms! I often wish I had been able to recover my early pictures so I could compare them with what I'm doing today. When you store your paintings, you must take care to preserve them properly.

How should a would-be watercolorist select a teacher? How do you judge a good teacher?

While you are learning, there is no way you can accurately judge who's a good teacher and who is not. No matter what you are learning from your teacher at the moment, you won't realize the results until years later, if at all. This was certainly true in my case. The best teacher I ever had, Szetu Wei, not only taught me the basic techniques of painting, but also generated in me the spirit to continue learning and painting. A good teacher can give excellent instruction, but after that, it is up to the student to learn.

The center of town, Pango Pango

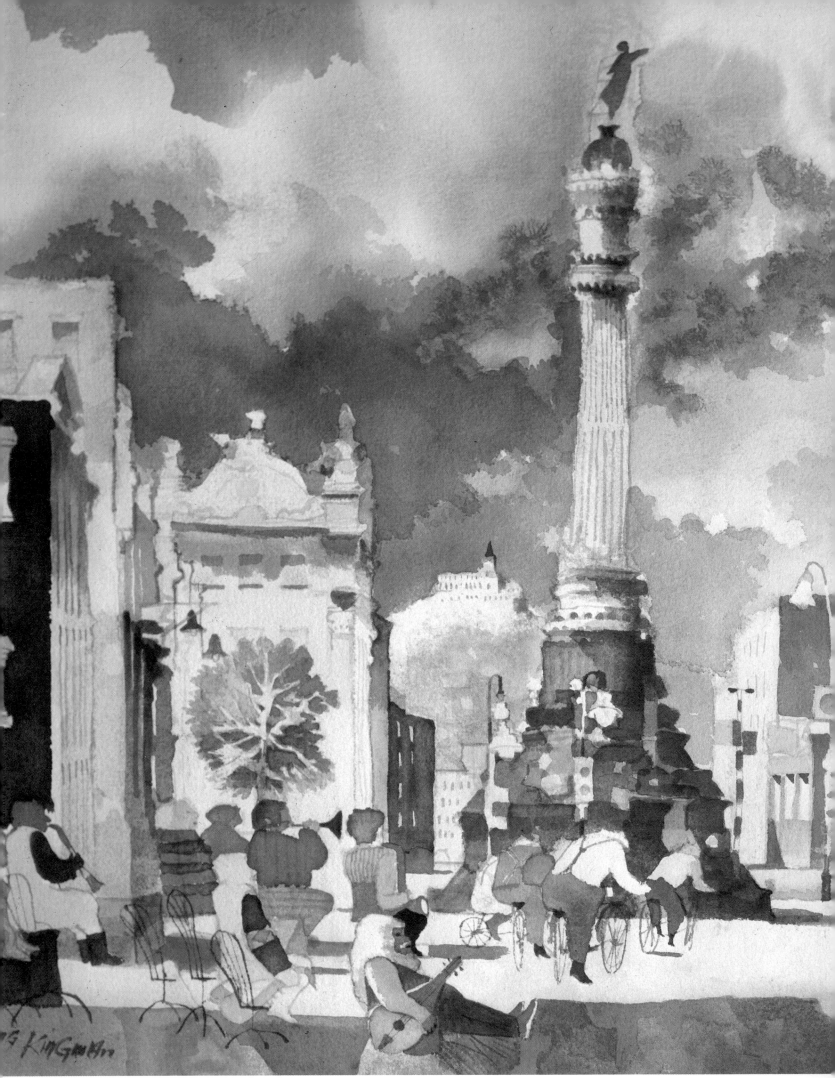

BARCELONA WATERFRONT, SPAIN, *22 x 30 in. (56 x 76 cm), collection of the artist*

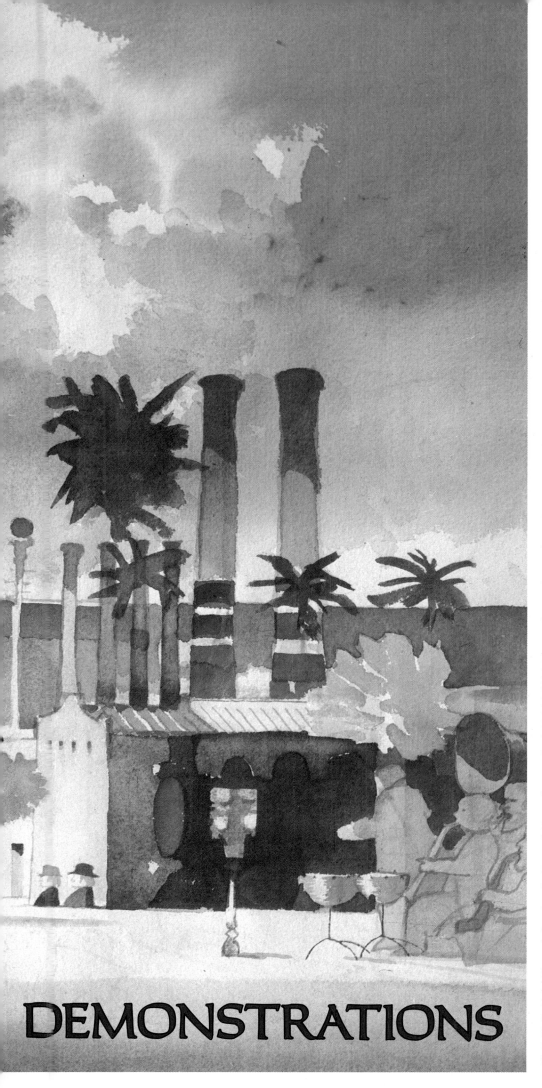

In the following demonstrations, I'll try to show, step by step, how I paint with watercolor. When time permits, I begin by making a small, quick preliminary sketch in black and white to work out the general composition and the overall pattern of light and dark tones. When I start the actual watercolor, whether I'm outdoors or in the studio, I draw the composition in line with a small or medium-size brush and a very light neutral wash. Next I lay-in the different washes, beginning with the most important part of my picture, the center of interest. Instead of painting from light to dark, the traditional method, I begin with one of the darkest areas, such as a rich-toned shadow or the dark side of an object. Then I use this dark color as a key to determine the rest of the color values for my painting. As I develop the overall composition, I make changes or re-arrange colors and values as necessary. When it's time to apply large washes for the sky or for land masses, I prefer to work in the studio, where I can have better control over the washes, rather than outdoors. My last step is to pay attention to final details as well as to the overall design, pattern, and rhythm; at this stage, I try to unify the picture.

My basic palette consists of cadmium yellow, cadmium orange, Winsor red, alizarin crimson, burnt sienna, Winsor green, Winsor blue, sepia, and ivory black. Every artist has his or her own feeling for color relationships. I will try to describe how I mix my colors. Some artists prefer their color spectrum to go from the lightest hues to purple but never as dark as black. I like my colors more down to earth, ranging from very light to sepia and then black. I usually mix burnt sienna and Winsor green to make my basic neutral wash, a tone which is just in between the warm and cool colors on my palette. If I want to make this brown-green mixture *cooler*, I add blue, sepia, or even black. If I want to make it *warmer*, I add alizarin crimson, red, or orange. If I want it to be more transparent, I just add more water to the pigment. Color mixing is like cooking. You must develop an instinct for it, just as a good cook adapts recipes according to his or her experience.

I use three sizes of round sable brushes: small, medium, and large. I don't specify size *numbers*, since these vary from one manufacturer to another.

I hope you will find my methods useful for your own watercolor painting. But please don't be afraid to try out ideas of your own. And if at first you don't understand what I'm trying to say, read the demonstration over again, stop, and think about it. You may find the answer astonishing.

DEMONSTRATIONS

HONG KONG

I learned to sketch and paint in Hong Kong, when I was in my early teens. It's been many years since I've lived there, but my impressions of Hong Kong will always remain fresh in my mind. In those days, there were double decker streetcars running in front of my father's dry goods store. The unpaved streets were rocky and uneven, and there were few automobiles. The best means of transportation were rickshas and bicycles. Street vendors lined up along both sides of the streets, selling everything under the sun—ice cream, Watson's soda pop, hot wonton dumplings and noodles, hot beef-rice soup, fish-rice soup, etc. They were good to eat and good-looking enough to sketch. But despite all its interesting activity, Hong Kong always had frightening elements, too—typhoons, torrential rains, earthquakes, and landslides. I was happy to return to the U.S. in 1929.

I went to Hong Kong again in 1954 and have been back to visit many times since. However, now I check into a beautiful hotel room with modern plumbing, far from the congested, roach-infested areas of the city. But understandably, I'm still influenced by my childhood memories when I paint a picture of Hong Kong.

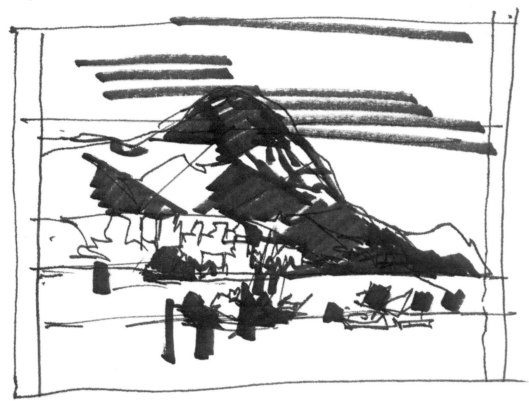

Preliminary Drawing. First I do a quick sketch, using ink line and black marker. I want to work out the placement of the main elements in my composition and also block in the darkest values.

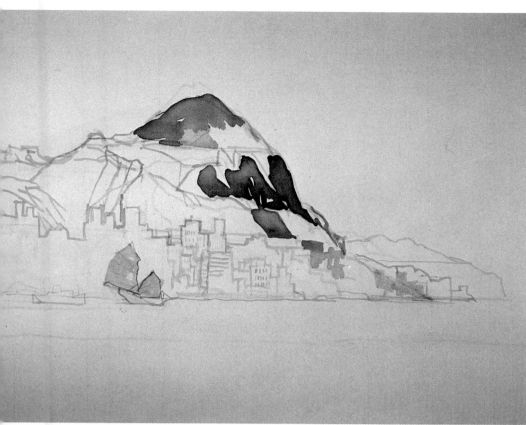

Step 1 (left). While I'm sketching in my basic composition in line—using a small brush and a neutral wash—I'm thinking about the colors of my subject. Hong Kong is a tropical island, and so the overall color of the mountain is a rich green, though the red earth shows through here and there. I begin my lay-in washes with the dark part of the mountain, using a large brush to mix green and blue, to which I then add a little burnt sienna and sepia to get a dark greenish blue. I apply this basic color to the top of the mountain as well as to the shadow side.

Step 2 (below). With this same color on my brush, I sketch in the left side of the mountain. I continue to paint all the way down and across the mountain near the center, but stop short when I get to the top of the buildings.

For the distant hills to the right of the mountain, I mix Winsor blue and sepia together to create a dark grayish blue. With my large brush, I apply this color directly to the dry surface of the paper to suggest the top of the hill. Then I immediately clean all the pigment from my brush and apply clean water to the lower part of the hill to give it a soft-edged look.

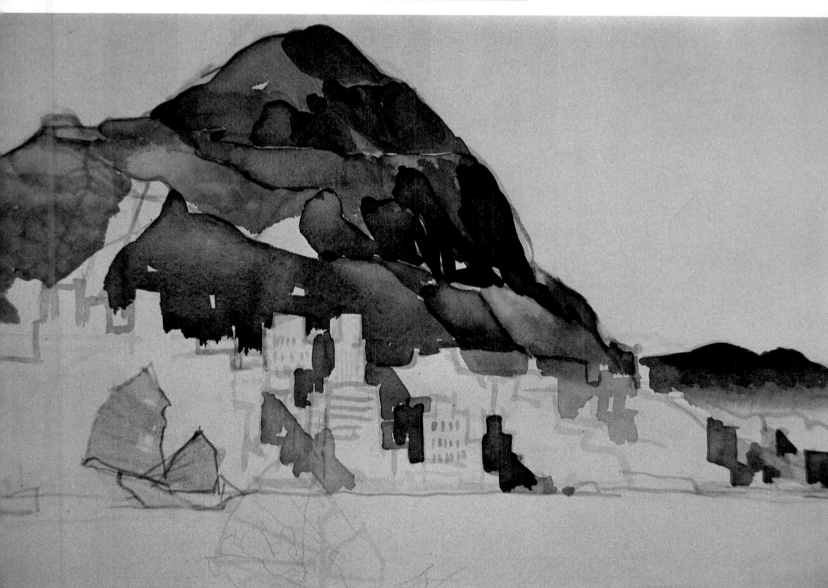

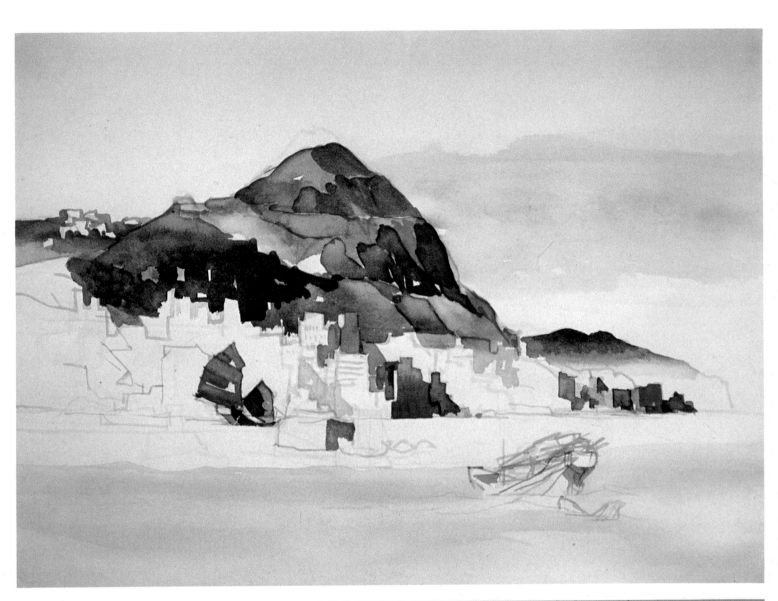

Step 3 (above). With a medium-size brush, I mix blue and sepia to paint the shadow on the building. Then I mix a very light wash of burnt sienna, sepia, and just a touch of blue to get a light brown to paint the junk.

At this stage, I'm ready to paint the large areas of the sea and sky. But now I prefer to return to the studio, where I'll have better control of the different washes I use for these areas. Before I start to paint, I tack down the watercolor paper on the drawing board with four thumbtacks, one at each corner. Then I wet the lower half of the painting with clear water. Sometimes I do this with a natural sponge, but today I am using a large brush. With the same brush, I mix a little burnt sienna with a great deal of water and apply the wash to the wet surface with long, horizontal strokes. Stroking back and forth in a horizontal motion helps to make the sea water look more realistic.

To paint the sky, I use the same technique, wetting the paper first with my large brush and then mixing a light brown wash. However, the movement of the brush strokes is different. This time, I use an up-and-down zigzag stroke, moving from left to right and vice versa, to simulate the effect of clouds.

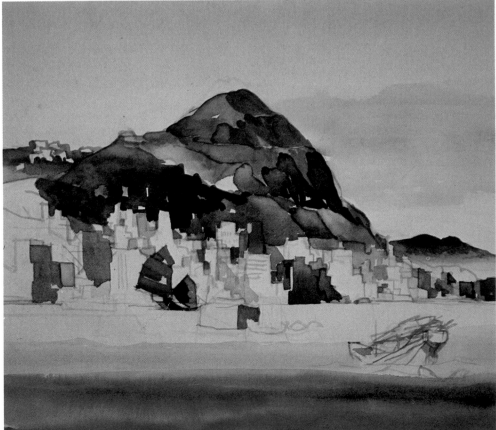

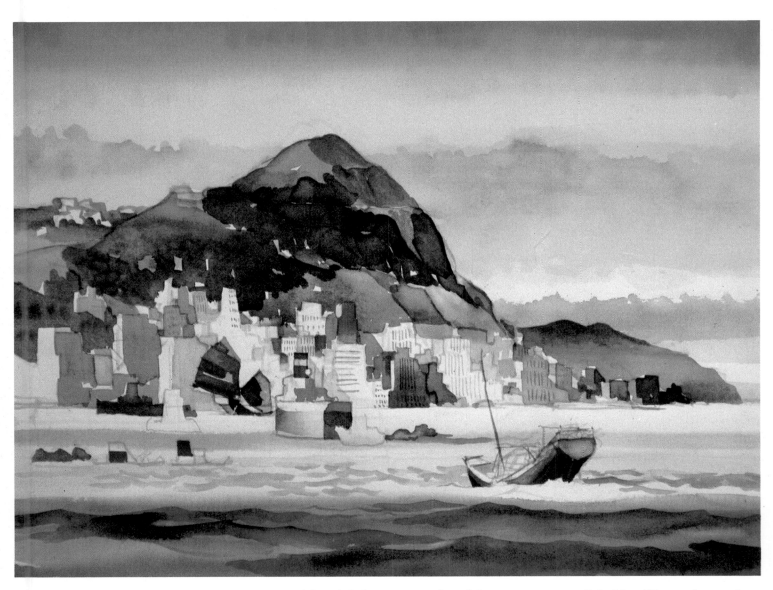

Step 4 (left). When the first light-brown wash is thoroughly dry, it's time to overlay a second color for the sea. First I wet the paper again with clean water and the same large brush; then, using this brush, I mix blue with just a little sepia to obtain a darker blue. With rapid horizontal strokes, I apply this to the lower part of the sea in the foreground.

Step 5 (above). Before my second wash is completely dry, I switch to a smaller brush and rhythmically apply a rich wash of Winsor blue to the top portion of the sea, using wavy strokes.

I continue to paint the sea, using a small brush dipped in a light blue color to make slender but long, wavy strokes in the middleground, to suggest the texture of the water. With the same brush, I add a bright Winsor red accent to the buildings and the smokestack on the steamship. I also apply bright orange, yellow, and light green to different parts of the picture.

I began painting the junk in Step 3, and as I went along I added different colors to it, placing a dark shadow on one of the sails to suggest sunlight. Now I'll put colors on the second junk—the one in the right foreground. I apply a few dark shadows to develop forms and continue to apply more color to the junks.

Now I take time to make a careful study of the overall composition. I realize the colors I have painted on the mountain seem too choppy, and so to unify this area, I use my large brush to mix a dark, cool combination of blue and black. I apply an overlay of this strong color to the left side of the mountain. I also feel the top part of the sky needs a pure blue, and so I wet the background, as before, and stroke the color directly across the sky with a large brush. Now my picture seems complete.

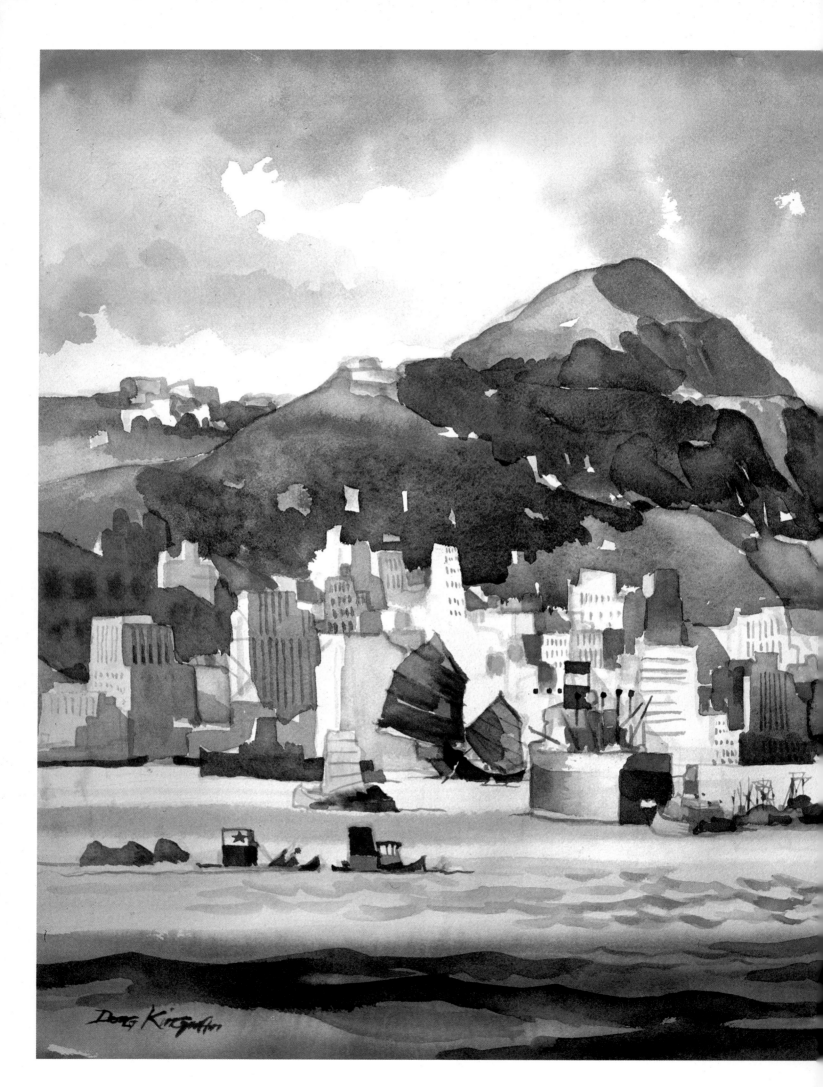

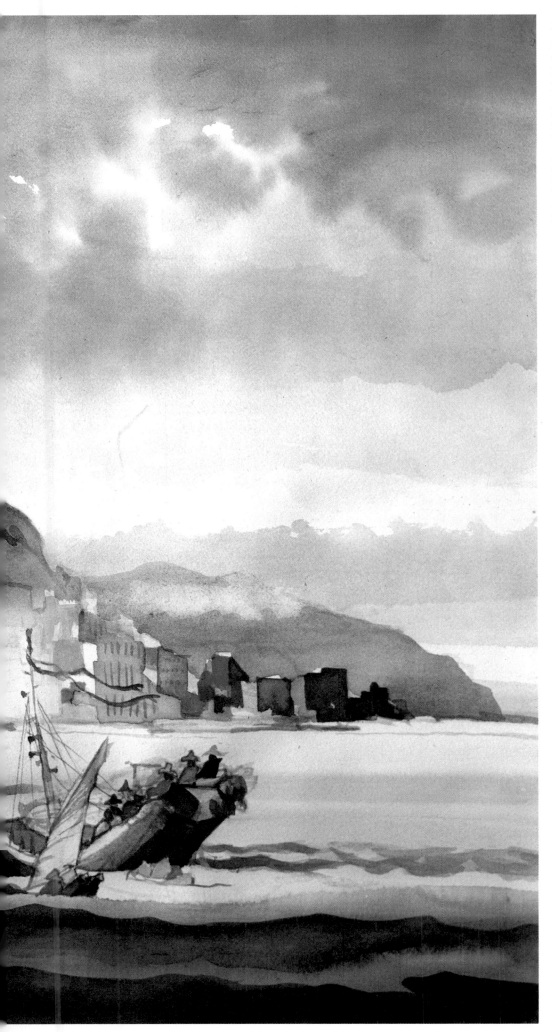

Step 6. After I completed Step 5, I came back to the picture later and looked at it again. Something seemed to be missing, but I didn't know what it was. However, I've learned from long experience that if I'm patient, time will tell.

Now, several weeks later, I begin to realize what's missing. I change a few minor elements here and there, adding a sampan in the foreground near the junk and more clouds among the distant hills on the right-hand side. But most important of all, I add a new sky to the entire top portion of the watercolor. Now the picture is at least 50 percent better than it was in Step 6—and it's finally finished.

VICTORIA MOUNTAIN, HONG KONG
22 x 30 in. (56 x 76 cm)
Collection of the artist

SAN FRANCISCO

San Francisco is one of the most fascinating and beautiful cities in the world, especially its interesting features such as Golden Gate Park, Hunter's Point, the Golden Gate Bridge, and Fisherman's Wharf. When I moved to San Francisco from Oakland, I worked as a servant six and a half days a week. Every morning on Grant Avenue in Chinatown, I took the cable car to work, and this scene became very familiar to me.

On Sunday mornings, my only half-day off, I would go painting. There was one great advantage to painting on Sunday morning: The streets were quiet, few people were around, and even the sunlight and shadows seemed to stand still. In this peaceful atmosphere, I could not help thinking of an old Chinese saying, *Jing che sheng ling*, "Quietude produces inspiration."

San Francisco is built on many hills. The Chinese call it *Gum San*, or "Golden Hill." My good friend Herb Caen, the *San Francisco Chronicle* columnist, has perhaps expressed this idea best. In his book *City on the Golden Hill* (Doubleday), which I illustrated, he wrote: "There is still the aura of gold over the city by the bay—an amber glow over the greatest Chinatown on the American mainland, in the golden light of the bridges, in the topaz glints of the fog that so often film the sky.... San Francisco is indeed the city on the Golden Hill—now and forever."

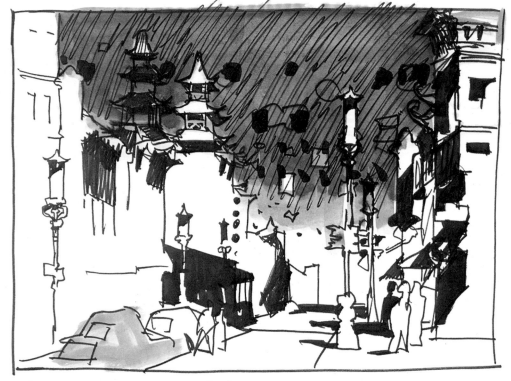

Preliminary Drawing. San Francisco's Chinatown was built on an old, narrow street. It would be easier to make it a vertical composition, but I want it to be a horizontal one. To do this, I open Grant Avenue wider, spread out the buildings on the left a bit more, and place additional activities in the street. In this preliminary drawing I want to establish only the key points of the composition. Finer details will be worked out later when I start to paint.

I always do my preliminary study in black and white. Later, when I begin to paint the actual watercolor, I will establish my colors based on this drawing. To develop my overall color pattern, I use three gradations of values in my drawing: White areas represent the lightest and medium-light tones; I use a medium gray primarily for the color of the sky; and the darkest value is to indicate the shadows of buildings, cars, people, and whatever else may require a dark color.

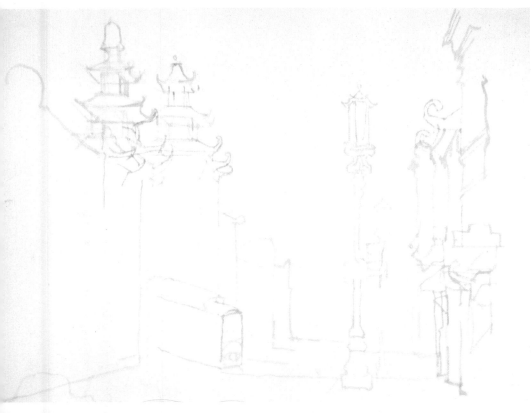

Step 1 (left). I begin my actual painting by sketching in the overall composition with line, using a small brush and delicate washes of blue-gray, green, and a neutral mixture of green and burnt sienna.

Step 2 (below). With a medium brush, I apply lay-in washes to the shadowed buildings on the right. I paint one pagoda a brilliant green and leave the second one unpainted for a while. Next I want to paint the sky, but I must plan my approach carefully because I'll use both hard-edge and soft-edge techniques within the same wash. With a large brush, I wet the paper first with clear water—but only the upper part, because I want a clearly defined edge between the architecture and the sky and a soft edge near the top of the sky. I mix a great deal of alizarin crimson, plus a touch of blue and black, on the palette—more than I can use. Then I carefully stroke on the color, allowing it to bleed softly on the premoistened paper. I leave some white spaces unpainted so that I can come back and add other elements later.

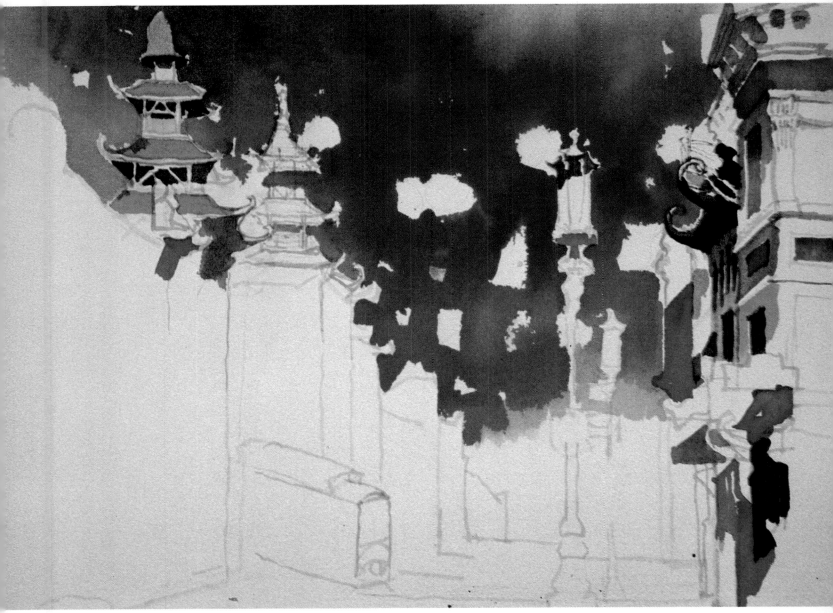

Step 3. Now I turn my attention to the buildings again. I paint the other pagoda dark purple. I continue with the buildings, using a medium-size brush to lay-in a solid yellow color for one of the walls. This yellow also seems a good choice for the sunny side of the commercial signs and lampposts. Then I concentrate on the cable car, painting in various bright colors with a small brush.

Step 4. At this stage I stop, look, and study
the overall composition. Everything seems
to be working well. I move on to the build-
ings on the left side of the painting, devel-
oping details and adding color. Then I
return to the details of the cable car. After
this, I use a medium brush to apply a gray-
blue wash over the street; this is especially
important in the foreground.

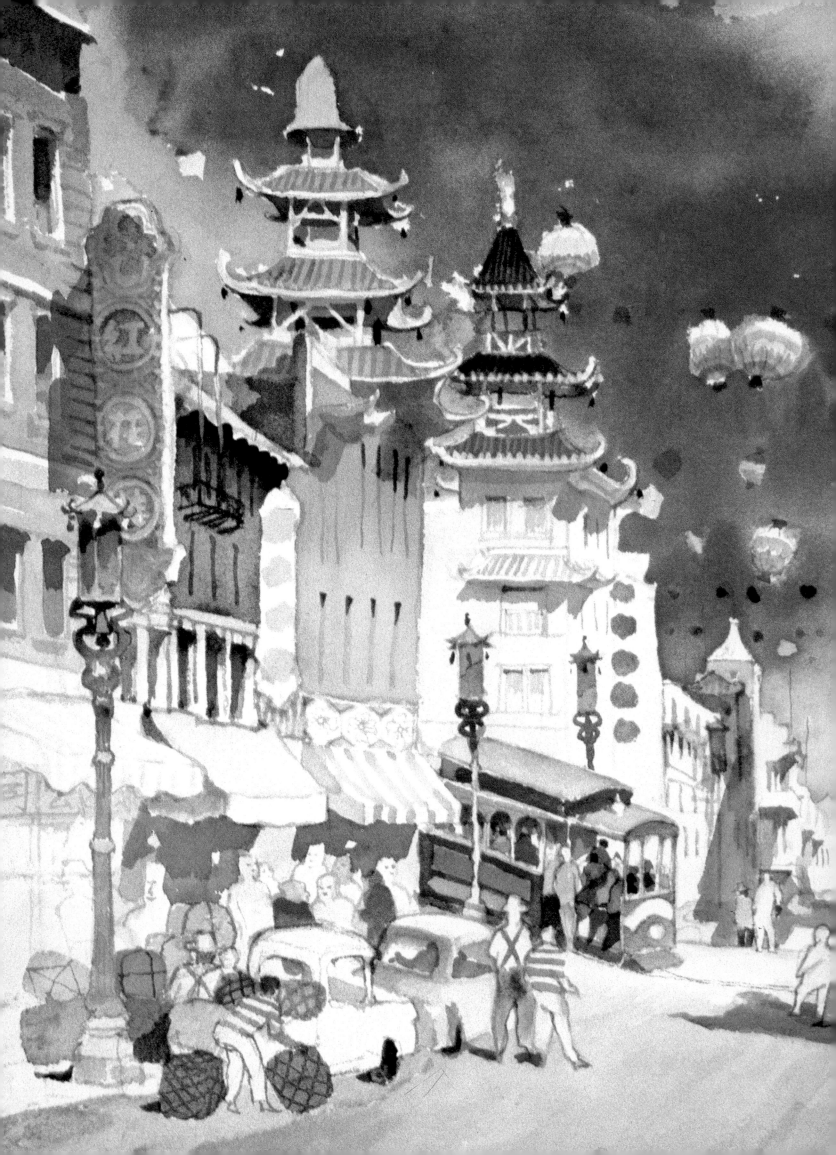

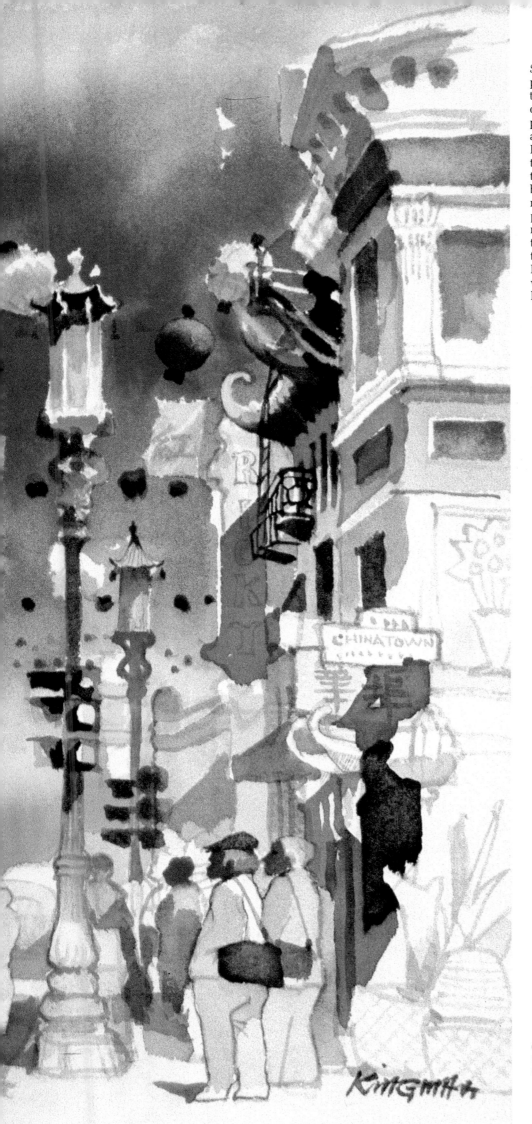

Step 5. Now I return to my studio to complete the painting. I add figures and many of the smaller details that contribute to the overall rhythm and color patterns of the picture. The figures in my paintings are usually created in the studio, rather than when I'm sketching outdoors, so that I can plan them in relation to the rest of my composition. They are often colorful and whimsical, but to me, people play only a minor role in my street scenes; I consider the buildings, parks, stop lights, etc., to be the major elements of my subject. The figures in my pictures may look disorganized at times, but they are actually very carefully composed. If you study them, you'll see that they are always thinking about the same thing and looking in the same direction.

CHINATOWN, SAN FRANCISCO
18 x 22 in. (46 x 56 cm)
Collection, Rocky Aoki

YOSEMITE

Although I paint a great many street scenes and townscapes, I also have a special interest in landscapes and other subjects. I have traveled widely in the United States and painted the Grand Canyon, the Grand Tetons, Death Valley, and Monument Valley, to name a few of my favorite western sites. For this particular demonstration, I've selected Yosemite National Park—an area I've enjoyed painting over the years.

I remember how excited I was, in my younger days in San Francisco, when my friend with a Model T Ford invited me to go painting in Yosemite. We outfitted ourselves with sleeping bags, frying pans, and a good supply of bacon and eggs. We made several trips there in my WPA days. *Life* magazine reported on my painting in Yosemite in its October 27, 1941, issue, in a story about California artists. The caption under my

photograph read: "In Yosemite Park, barefoot Dong Kingman used brush in Chinese lettering style to paint Half Dome Mountain...." So, as you can see, I've been intrigued with this scene for at least forty years. The last time I painted Half Dome Mountain was in September 1976, and I'm sure I'll go back again at the first opportunity.

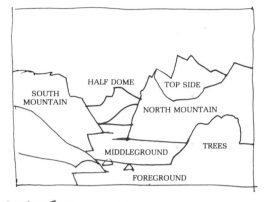

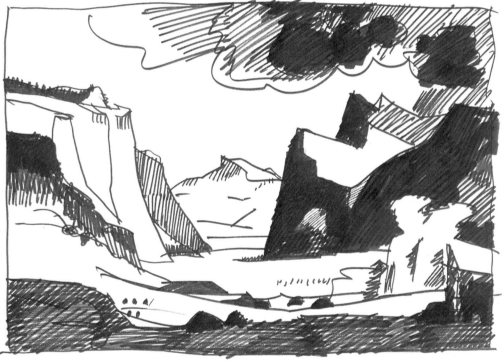

Preliminary Drawing. When Half Dome Mountain comes into view in the distance, I'm overwhelmed by the monumental size of the mountains and the majestic feeling of air and space in this scene. After experimenting with different light-and-dark patterns in a few quick compositional sketches, I decide on this one: to dramatize the power of North Mountain on the right, I'll place the sun fairly high in the sky and to the right so that the mountaintop will be in full sunlight and the faces of the mountain in dark shadow. In my painting, I plan to contrast this strong light-and-dark pattern with the sensitive lighter colors of Half Dome Mountain in the background.

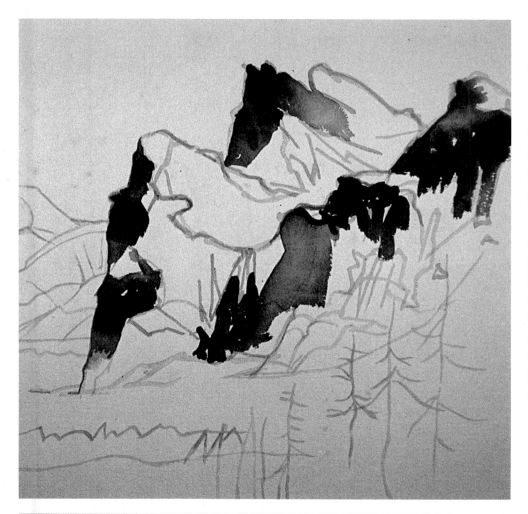

Step 1 (left). I start the painting by sketching the outlines of the major shapes directly onto dry watercolor paper with bold, calligraphic strokes. I use a medium-size brush for this, loading it with lots of water but very little pigment, and mix subtle tones of green, blue, and brown. Once the major shapes are roughed in, I define some of the internal contours of North Mountain on the right, to establish a three-dimensional feeling in my center of interest. Since I plan to make this mountain dark and rich in tone, I begin here with my lay-in washes, putting in the darkest tones first. I use my medium brush and mix blue, brown, black, sepia, and green washes for the shadowed areas.

Step 2 (below). While I'm waiting for my first washes to dry, I move on to South Mountain on the left. Still using the same brush, I continue with the same colors, but now I add more water to the pigment. This creates a slightly lighter tone which will not compete for attention with the more dramatic North Mountain. I establish the mountains in the farthest distance with more browns and blues. I begin to develop the foreground with light green, using a darker green for the bushes.

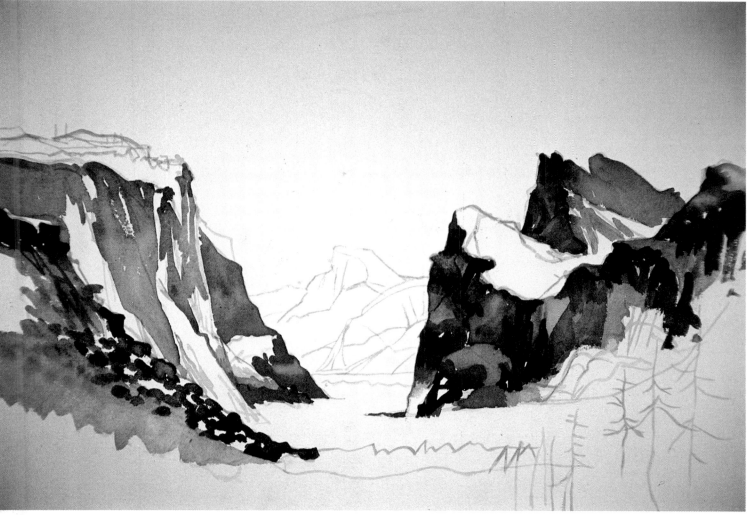

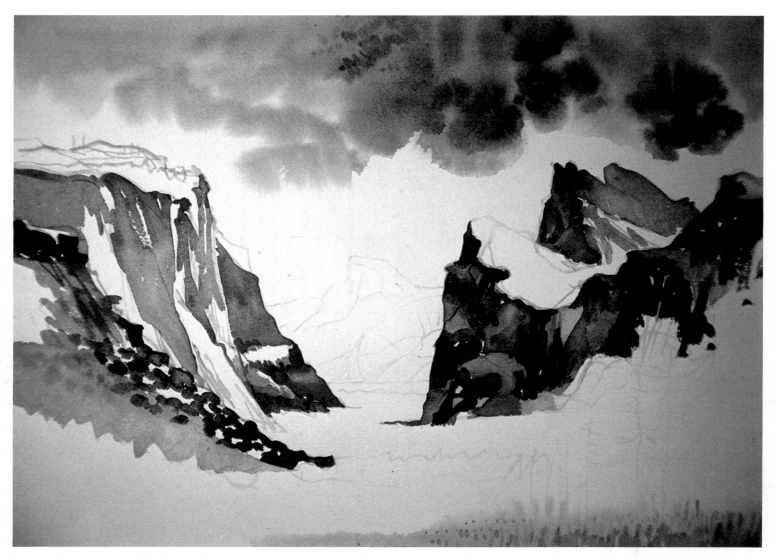

Step 3. (above). Up until this stage, I've been working outdoors, which I find really fun and exciting. However, I want to concentrate now on the overall composition, adding color to all areas of the painting, and so I return to the studio, where I'll have better control over my painting.

After I tack the watercolor paper to my drawing board, I wet the top part of the paper with a large brush and clear water. I bring the water down only as far as the top of the mountain. Still using my large brush, I mix blue with sepia and paint the sky, making small up-and-down strokes as I gradually move the brush across the paper from left to right. This kind of stroke simulates the shapes of the clouds as they move across the sky. I wait till this is partially dry and then paint the dark clouds on the right with a mixture of sepia, black, blue, and red.

Step 4. (right). When the upper part of the sky is dry, I paint the lower section with light blue. To do this, I again wet the background with clear water and then let the pigment flow freely on the surface of the paper to create the beautiful, soft wet-in-wet effect you see in his closeup of the picture. Next I apply a light, warm shadow to one side of Half Dome Mountain, leaving the rest of the mountain white since I'm not sure how light or dark I want it to be. I'll decide that later, when I've completed other parts of the painting.

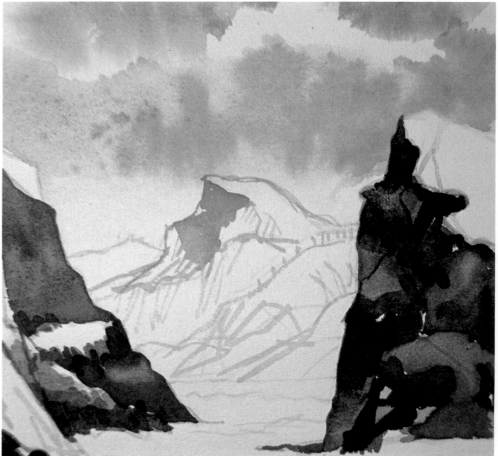

Step 5. With a medium-size brush, I paint the top side of North Mountain with an overall wash of pale green. While this is drying, I stroke on dark green to simulate trees, creating highlights by allowing the white of the paper to show here and there. When it's all dry, I paint the shadow near the top of the peak with a dark sepia-green mixture.

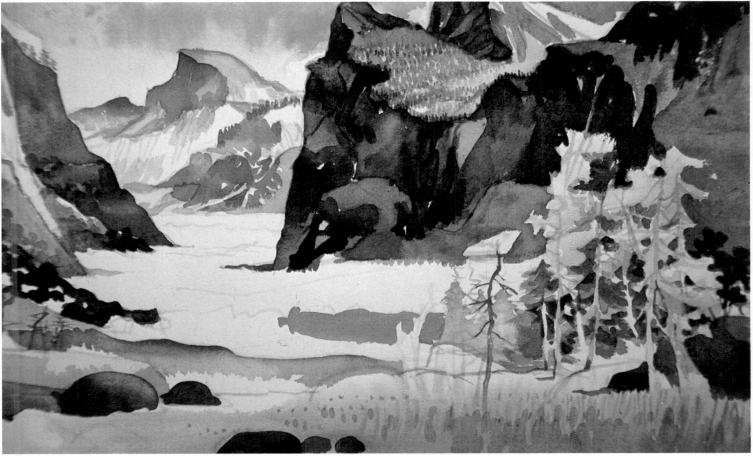

Step 6. Now I turn my attention to the Half Dome and its surrounding mountains, which form the backdrop for the whole scene. Since they're the farthest away, I want to keep the colors light and delicate. With my medium-size brush, I apply pale tones of brown, green, orange, and a little blue. I learned a long time ago that blue always helps to create a feeling of airiness and space.

Next I develop some of the foreground areas. On the right, under the shadow of North Mountain, I had sketched some interesting groups of trees—I remember some

were green and very much alive, while others were almost dead. The colors at the original site were a mixture of both warm and cool shades. There were dark greens among yellow-green trees in brilliant sunlight, and the trees, in turn, cast a long, dull shadow from the sun. Before I begin painting this portion of the picture, I add one or two trees to my basic drawing to improve the composition. Then I paint a gray-blue shadow in the middle foreground. With a medium-size brush, I go on to mix some dark green for the trees, applying the color with small strokes to create the texture of leaves.

To paint the lower foreground, I wet the paper with my medium-size brush and then stroke a pale green wash over the wet surface. Before this is completely dry, I change to a small brush and paint the texture of the grasses, using small up-and-down strokes, with dark gray-green. When the dark green trees are dry, I apply a bright yellowish green for the sunlit trees. Then I come back to the foreground. By now the pale green is completely dry, so I begin to place a few rocks here and there with a medium brush, using sepia and black.

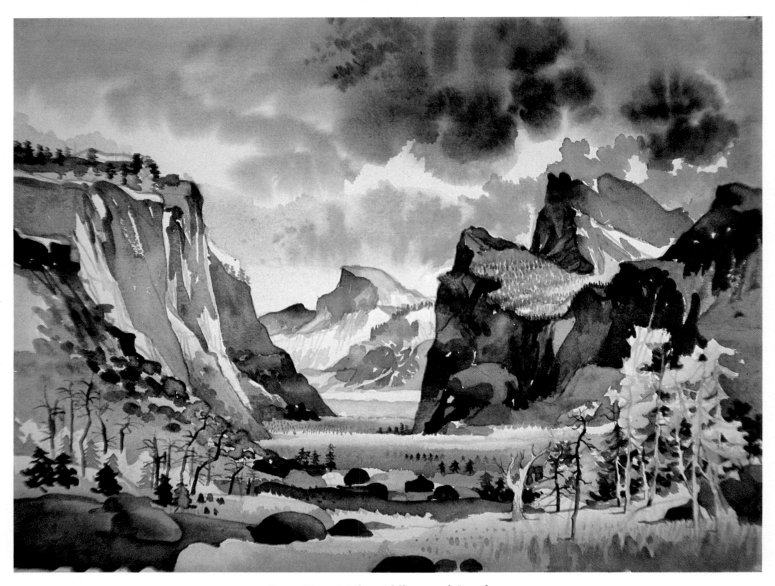

Step 7. To paint the middleground, I apply pure yellow to the center of the picture with a medium-size brush. Before this dries, I change to a small brush and add pure green to the bottom of the yellow area. I allow these colors to blend in order to create a soft edge between them. I develop the middleground further by adding more rocks and some shadowed areas with black and sepia. Next I mix a dark green color with my large brush and paint the left foreground. Then I add small trees, brush, and other details to this area.

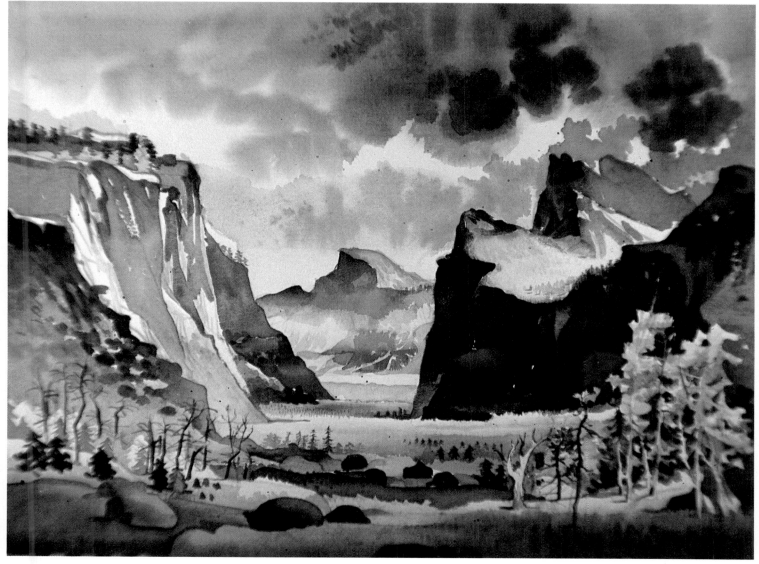

Step 8. When I come to the final stage of my painting, I always try not to overpaint or overwork my picture. Usually I simplify the overall pattern and eliminate some of the minor details. When I compare my painting of Yosemite at this stage with the preliminary sketch (see page 62), I realize I have to simplify the foreground and North Mountain as well as strengthen the dark, stormy clouds in the sky. I paint a dark gray-blue wash over the foreground with my large brush and then add a very dark blue-black tone to North Mountain. I darken the stormy clouds with a black and sepia wash. This ties the whole painting together, and I'm now satisfied that the painting is finished.

NEW ORLEANS

The first time I went to New Orleans was in 1942, when I was on my Guggenheim traveling fellowship. I immediately fell in love with the French Quarter and with its jazz and Latin architecture. The very afternoon I arrived, I walked around looking for a possible location to paint the next day. But when I woke up the following morning, it was raining cats and dogs. As it is my nature not to give up easily, I packed my gear anyway, put on my raincoat, and went out to sit on a covered sidewalk and paint my first watercolor of the old French Quarter. Since then I have returned to New Orleans many times to paint its streets and enjoy its music, and each time, I learn something new about the French Quarter. This demonstration is one of my newest impressions of the subject.

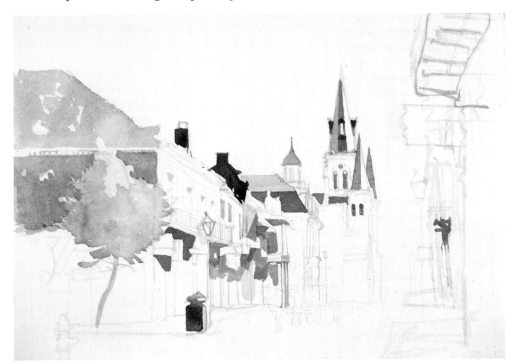

Step 1. I decide not to do a preliminary sketch, as I want to work directly on the watercolor paper before the pattern of light and shade changes. However, I begin this painting, as I do all my pictures, by first sketching my subject lightly in outline, using a neutral wash to establish my basic composition. Then I go on to lay-in some washes. With a large brush, I paint the dark blue-gray shadow on the left-hand building, behind the tree. Next I paint the foliage with a medium brush and a bluish green mixture, and then I change to a small brush and paint the sepia church towers in the background. I continue to apply cool, neutral colors to the other rooftops; these values, which are among the darkest I will use in this painting, will help me determine correct value relationships of other colors as I go along—that's why I put them in at this early stage of the painting.

With my small brush, I continue to paint shadow areas, mixing a medium blue for the shadows on the storefronts in the center. Still using a small brush, I paint details of the street, including a dark gray garbage pail on the left. But I realize I've made a mistake: I am planning on adding a lot of seated figures in that section of the painting, and the dark color of the waste container will detract from them. Immediately I wash it out with a natural sponge.

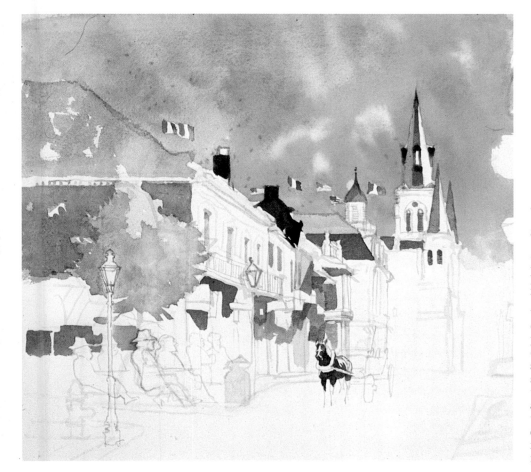

Step 2 (left). With a clean sponge, I apply clear water to the sky area. Then, loading a large brush with plenty of blue pigment, I apply color to the wet paper with free-form strokes, leaving some areas lighter to indicate clouds in the sky and reserving some white spaces near the rooftops. When I add red and blue stripes to them with a small brush, these spaces become flags flying in the breeze. Now I sketch some seated figures on the left and two horse-drawn carriages in the center, using a very light neutral wash and a small brush. With the same brush, I mix sepia and burnt sienna and paint part of the nearest horse.

Step 3 (below). I mix a warm blue with a medium-size brush and paint the shadowed underside of the balcony in the upper right-hand corner; for the side wall of the building, below it, I use a sepia wash. Next I go back to my drawing of the people sitting on the left and begin to apply washes of bright colors to their clothing. At the same time, I paint the red-and-white striped awning and clarify other details of my basic drawing, such as street lamps, fire hydrants, and street signs. Next I paint the front panel of the carriage red, changing to a warm orange-red for its canopy. To depict the figures in shadow under the canopy, I use a cool blue-green. For the other horse and carriage, I use cooler, paler colors that will make them recede.

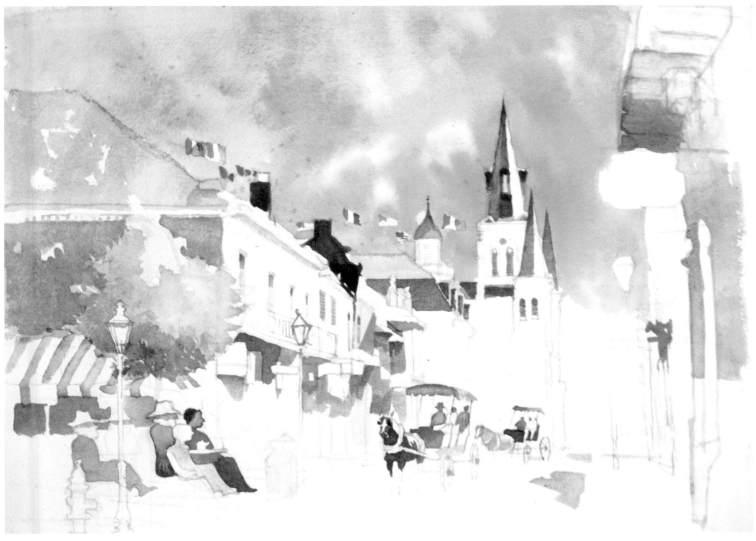

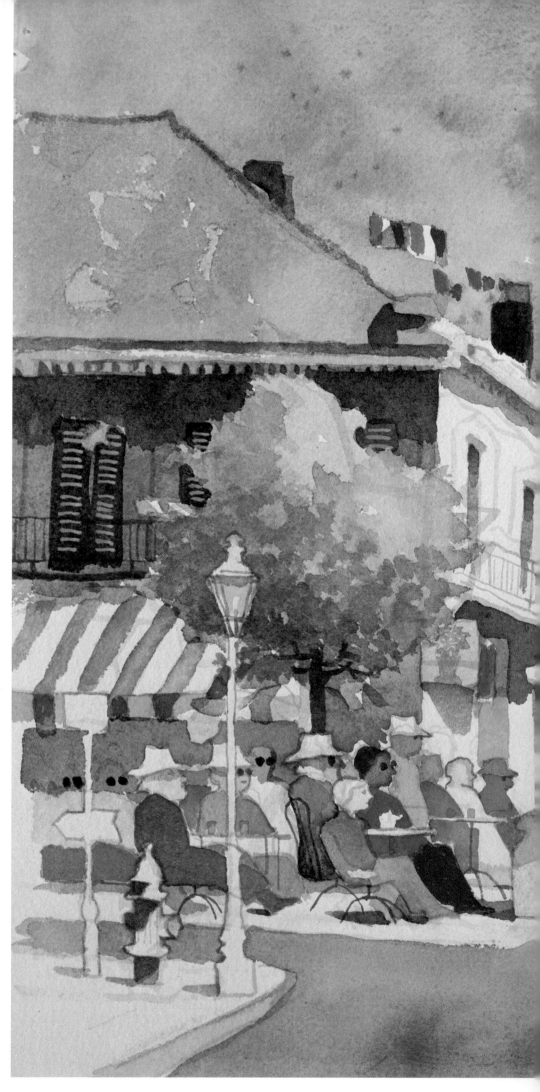

Step 4. In this final stage, my basic composition is already established; now I add detail in order to develop the overall pattern and design, relying on color and movement to unify it. I continue working on the figures in the lower left: Using a small brush and a light neutral wash, I draw more figures, and then I paint them in washes of color—seeing them as an abstract pattern rather than people watching activities in the street.

Returning to the right side of the picture, I paint a triangular shadow across the commercial sign and then darken the wall to its right with burnt sienna. With a small brush I draw the building just behind it, indicating details of the balcony, tourists on the street, the small tree, et cetera. I add a garbage can on the lower right and with gray-blue, paint cast shadows on the street. These shadows help to lead your eye into the painting.

Now I concentrate on the shadowed wall of the large building on the left, painting the oblong second-story windows with a dark blue mixture on my medium brush. When the windows are dry, I go back over them with horizontal strokes of opaque white to indicate shutters; then I deepen the shadow just under the eaves. Finally, to eliminate the stark white of the paper, I brush a delicate wash of burnt sienna over the roadbed and darken the foreground with sepia. After adding touches of lively oranges, reds, yellows, and greens here and there to brighten the composition, my painting is finished.

FRENCH QUARTER, NEW ORLEANS
18 x 22 in. (46 x 56 cm)
Collection, Rocky Aoki

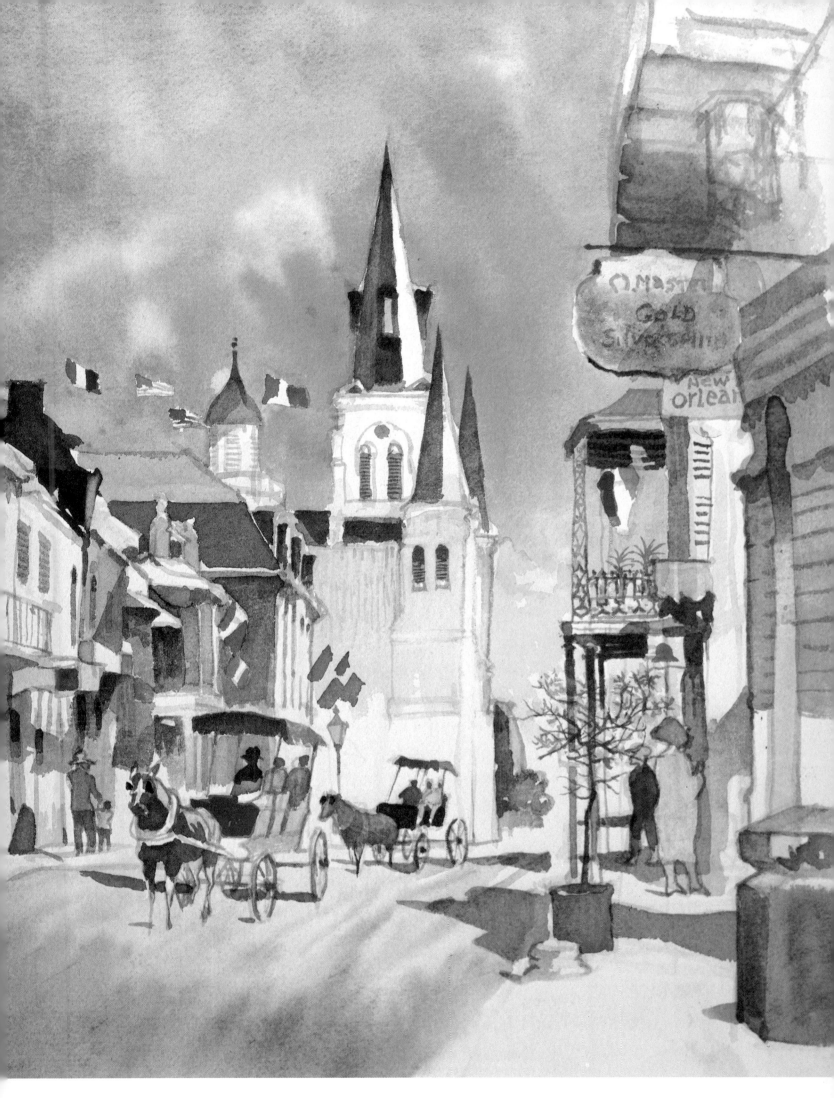

HONOLULU

Honolulu is a fun place for both vacationing and painting watercolors. For this demonstration, I want to paint a beach scene, with Diamond Head Mountain as my center of interest. I'll balance my composition with other elements of the scene that appeal to me—palm trees, white clouds, the blue sky, and the sharp contrast between the deep turquoise sea and the sun-baked, white sandy beaches. Every day in mid-morning, sun worshipers and beachcombers slowly emerge to receive the warm sun. All is as still as a picture, except for a few people who occasionally break the silence by trying their hand at surfing, waterskiing, or swimming.

Preliminary Drawing. When I study this scene, I think in terms of composition, rhythm, design, and color, and try to translate them into a picture language before I even put my brush to the paper. To do this, I make a small composition sketch in black and white, roughing in the main elements of my picture and developing the pattern of lights and darks. Then I'm ready to begin the actual painting.

Step 1 (top, right). Quickly I establish the main elements of my picture in line, with a small brush; then I start to lay-in the first washes. With a medium-size brush, I mix green with a touch of sepia to get a warmer, darker green, and paint the two tree trunks. I let the color sit for a while. Just before it's completely dry, I blot out part of the pigment with a tissue. Then I use a small brush to apply small strokes of dark brown to the big tree trunk.

Next I dip my large brush in clear water and stroke it onto the sky area—not all over, just here and there. Then, using the same brush, I mix a great deal of blue and freely brush it onto the paper with up-and-down zigzag strokes. With the same color on my brush, I add a few darker colors—sepia, burnt sienna, and blue—to the top portion of the sky.

Now I stop, allow the colors to rest on the paper for a few seconds, and look at my painting. I realize that I've made the sky too dark, and so now I take a clean brush and gently apply clear water to the dark areas.

Gradually it turns lighter. At this stage, I am painting only the upper part of the sky, stopping near the hilltop. I'll attend to the lower portion, near the horizon, later.

Step 2 (right). To paint Diamond Head Mountain, I use a medium-size brush to mix burnt sienna with green and black, and then I apply this to all the dark areas of the mountain. I paint the mountaintop one part at a time because I want to make sure the color and texture in each area comes out exactly to my satisfaction before I start on the next part. Still using my medium brush, I apply yellow to the very top of the mountain. Before it's dry, I use a small brush to stroke orange and red over it, along the top edge. For the slope below the mountain, I use yellow with a touch of green on my medium brush. Next I change to a smaller brush and add pure green to the lower edge of the slope.

Now I'll paint the palm leaves. What I want to do here is create an overall impression of palm trees, rather than painting them realistically leaf by leaf. With a medium-size brush, I mix blue and green to get my basic color. I keep changing this color a little during the process of painting the palm trees, adding other colors—such as burnt sienna, sepia, black, or alizarin crimson—to make it warmer or cooler. I create the impression of palm leaves by capturing their basic "gesture" with my brush. When I paint trees, my experience with Chinese calligraphy sure comes in handy!

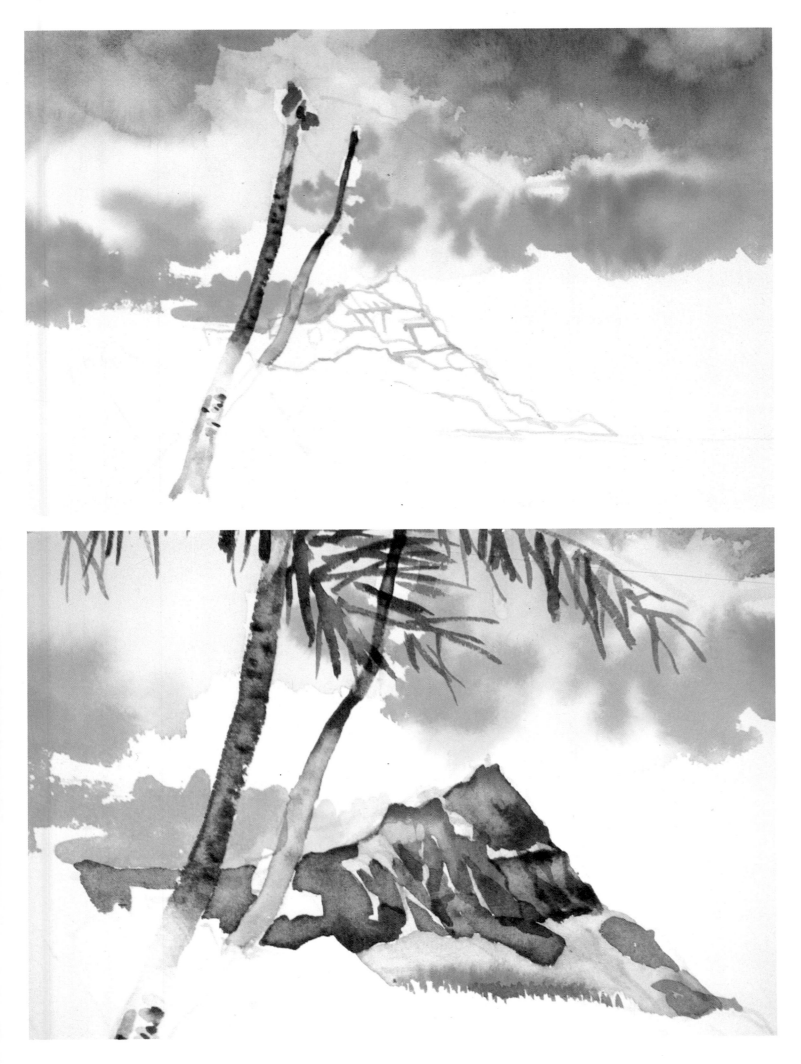

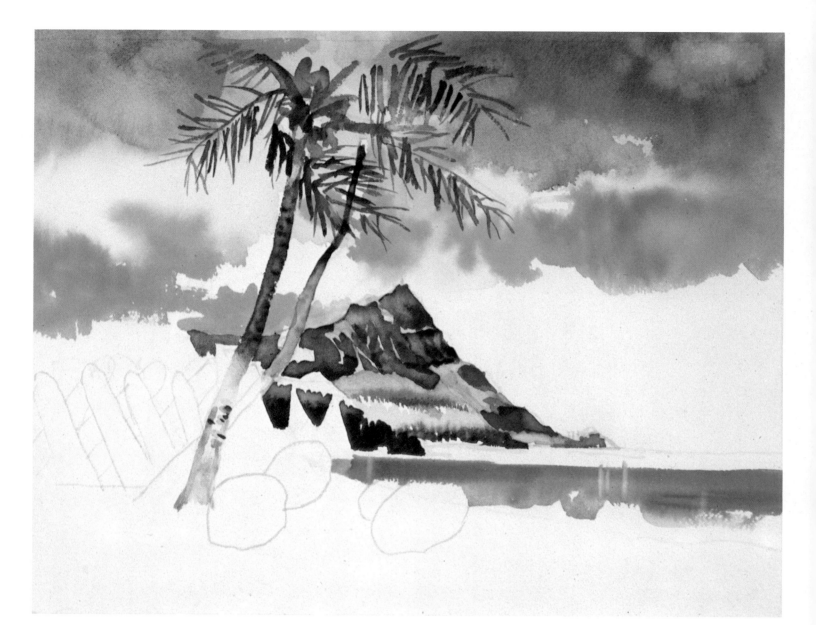

Step 3. I continue to paint the lower area of Diamond Head, near the edge of the sea. With a medium-size brush, I mix a lot of blue and black together with a touch of green, and apply this mixture to areas of the middleground. Then I use a small brush to apply clear water over the top edge of this dark blue; the water dissolves and lightens the color. When the middleground is dry, I paint the land located between it and the mountain, wetting the area first and then applying green near the shoreline.

Before I paint the sea, I must make my basic drawing a little clearer. For this I use a small brush and, with a very light wash of color, indicate some of the activities on the beach. To paint the sea, I switch to a large brush and wet only the *center* part of the sea with clear water. Then I apply a strong blue to the *lower* part of the sea, in the middleground; the distant water is pale, so I leave the white of the paper showing. To suggest a few reflections in the water, I apply pure water over the blue with quick, short vertical strokes.

Step 4 (top, right). In Step 3, I drew only a sketchy indication of the activities on the beach. Now I'm ready to go back and develop the figures. But before I do, I must put some color on the sand. With a large brush, I wet the entire lower portion of the paper with clear water and then quickly brush a light warm wash of burnt sienna and orange over it. I darken the lower section of the sand with a touch of green. While this is drying, I brush more clear water over it and then tip the drawing board to allow the water to run downward. Now I paint the beachcombers with warm, bright colors, using a small brush. (But notice that no matter how warm the colors, I always use a cool tone, such as blue, for the shadows.) For this picture, I depart from my usual methods—

normally I use only pure, transparent watercolor—and add other media to obtain some of the brighter colors. I have an assortment of media—Winsor & Newton Designers Gouache, Pelikan's Plaka colors, Rich Glo Acral acrylic fluorescent poster colors, and Craftint Glo-Brite fluorescent watercolors—and I use them to paint intense reds, greens, and yellows. (Note: many of these colors, particularly the fluorescent ones, are not as permanent as pure watercolor and, in time, may fade. They are manufactured primarily for commercial use.)

By now the sand is dry. With green on my small brush, I make clusters of small vertical strokes to suggest grass growing on the sand.

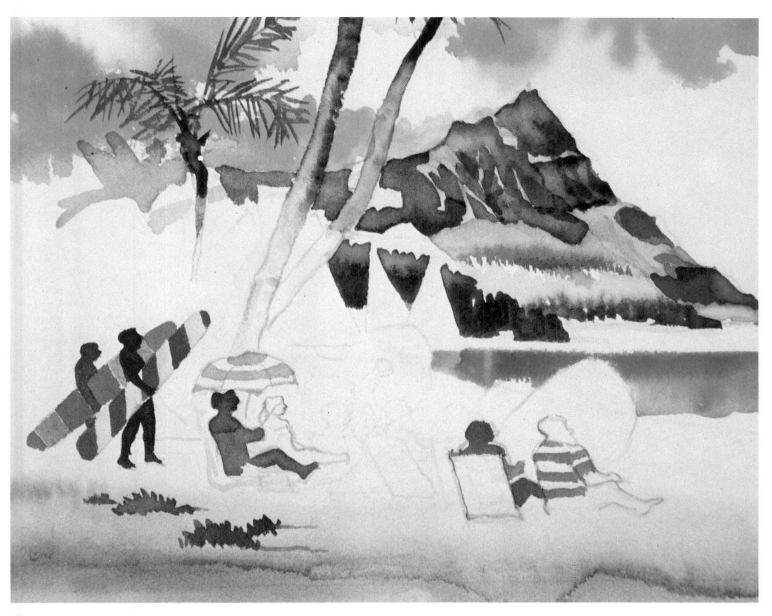

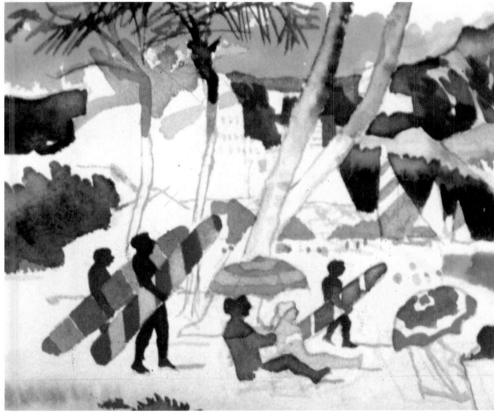

Step 5 (left). Now I concentrate on the left-hand side of the painting. With the same dark brown mixture I used on the Diamond Head—burnt sienna, green, and black—I extend the ridge of the mountain behind the trees and buildings; then I again mix blue and black, which I used for the lower portion of the mountain, to paint the clump of trees in front of the buildings. To paint the two small palm trees, I mix blue-green with a medium brush. Next I change to a small brush and paint the sails to the right of the trees with pure red. I clean my brush and add some small, light blue shadows under the buildings.

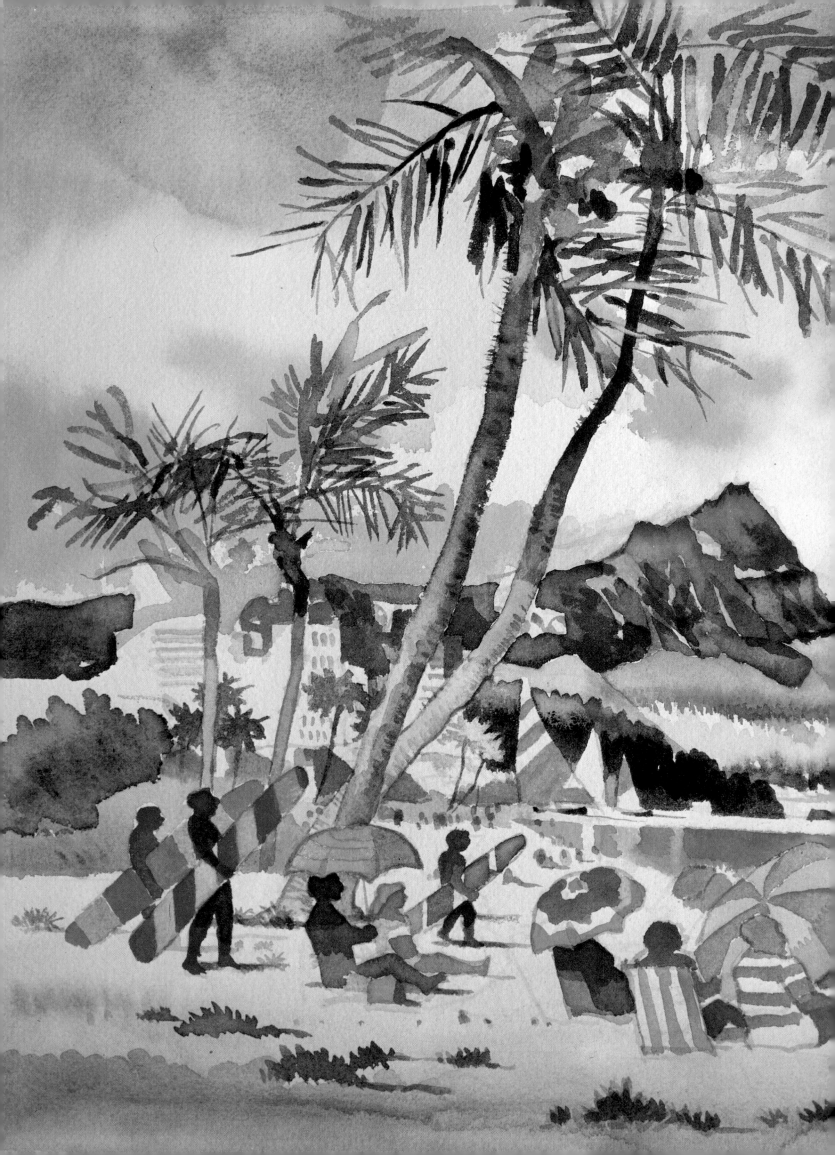

Step 6. Finally I go back and paint more people on the beach, some sitting near the seashore and others in the distance. I use different techniques for painting people, depending on where they're located in the picture—I paint the ones near the shore with simplified strokes and the people in the distance, only with dots of color. In step 3, I began to paint the area where the Diamond Head Mountain meets the sea. Now I go back and add more details to the right-hand side, developing the sky near the horizon. I wet the upper section of the horizon with clear water, brush a light wash of burnt sienna over it, and then add a little light blue to that. For the distant sky, I paint all the way across the horizon with light purple. The painting seems complete now, and I decide it's time to stop.

DIAMOND HEAD, HONOLULU
18 x 22 in. (46 x 56 cm)
Collection, Rocky Aoki

PARIS

On an early spring morning in Paris, I leave my hotel, take a taxi to the corner of Rue Norvins in Montmartre, and immediately set up my equipment in order to be ready to paint as soon as the sun comes out. I wait. The place looks deserted. I pull up my collar against the morning chill.

As soon as the sun shines on the front of the *boulangerie*, which casts a shadow over Rue Norvins, the place is infested with other artists taking up residence all around me. Uniformly and unanimously, they all face the same direction, painting the same subject I am sketching. This has happened twice before when I've come to paint in this location. I thought I was here before anyone else. I cannot help laughing to myself every time I think of it. I often wonder why artists like to paint this subject. Perhaps they, like me, think of this little corner of Montmartre as the artistic center of the world.

Be he an artist or not, no one can help being charged with happy feelings when he walks up this narrow, winding street in Montmartre and the majestic Sacré Coeur suddenly comes into view against the blue sky.

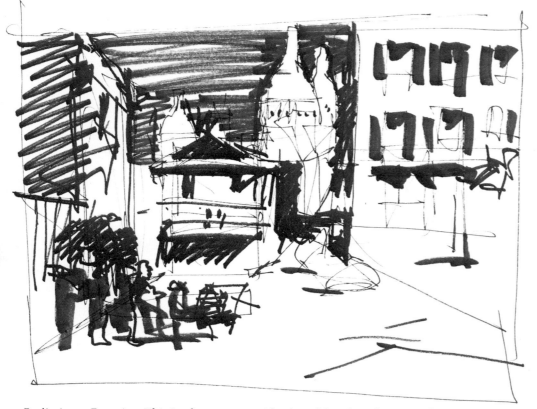

Preliminary Drawing. This is a busy scene with a lot of detail, and so I start by making a small, simple sketch of the most important elements of my picture. At this stage, I am already thinking about the overall pattern of light and shadow.

Step 1. Now I start the painting, using a small brush and a light, neutral wash to sketch in the outlines of my picture. Then I mix Winsor blue and a touch of burnt sienna and paint the small, shadowed windows of the center building. Next, I darken this basic color further with sepia and, with the same small brush, paint the roof of the front building and the smoke stacks on all the rooftops.

I change to a medium-size brush and paint the shadowed front windows of the building on the right-hand side, as well as the shaded, foreshortened side of this building, using Winsor blue. With this same color, I also establish the long shadow which extends from one side of the street all the way across to the other. Notice that within the long shadow, I've left some white spaces. I'm reserving these spaces so that later on, I can use them for highlights on figures and automobiles. Next I go back to my small brush and paint the stop signs and the lower windows in the center building with Winsor red.

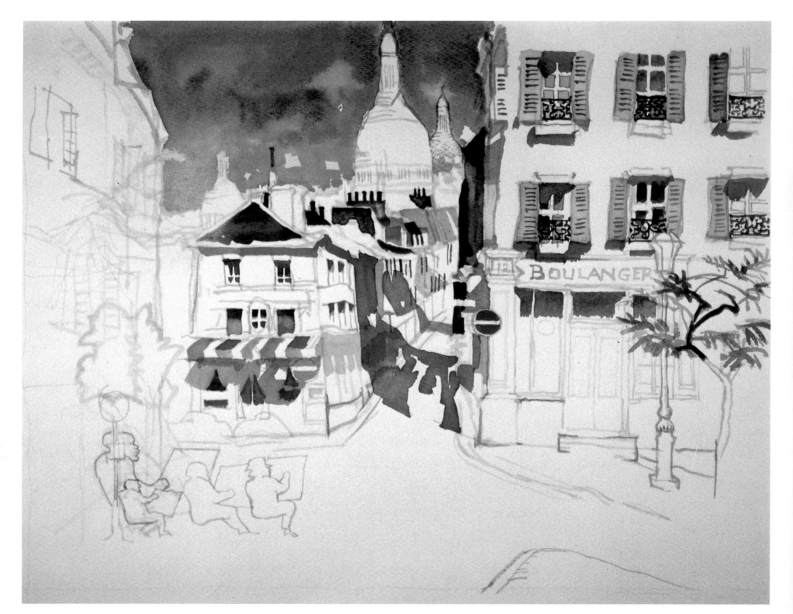

Step 2 (above). In this step, I develop the details of the striped awning in the center and the large building on the right. With my small brush, I lightly sketch in a group of artists. Then I go on to the larger areas.

I often like to paint a dynamic sky to dramatize sunlight and shadow, and in this watercolor, I decide that a strong blue sky will be helpful. First I wet the paper with clear water and a large brush. Then I load my brush with Winsor blue and apply it to the upper portion of the paper in zigzag strokes. In order to create various cloud effects as I paint the sky, I brush on clear water to lighten the color in certain areas, and in others, I add a touch of burnt sienna and alizarin crimson to make it look richer. In the lower part of the sky near the rooftops, I've left some small areas unpainted; later I can use these spaces to paint in small details such as birds, flags flying, and so on.

Step 3 (right). Next I refine the group of artists on the left and create the foliage of two leafy trees above their heads. I add various colors to the seated figures with a small brush. Using my medium-size brush, I develop the foliage with a blue-green mixture, painting one tree at a time so that the color in each tree will not run into the other. Next I draw more people and automobiles.

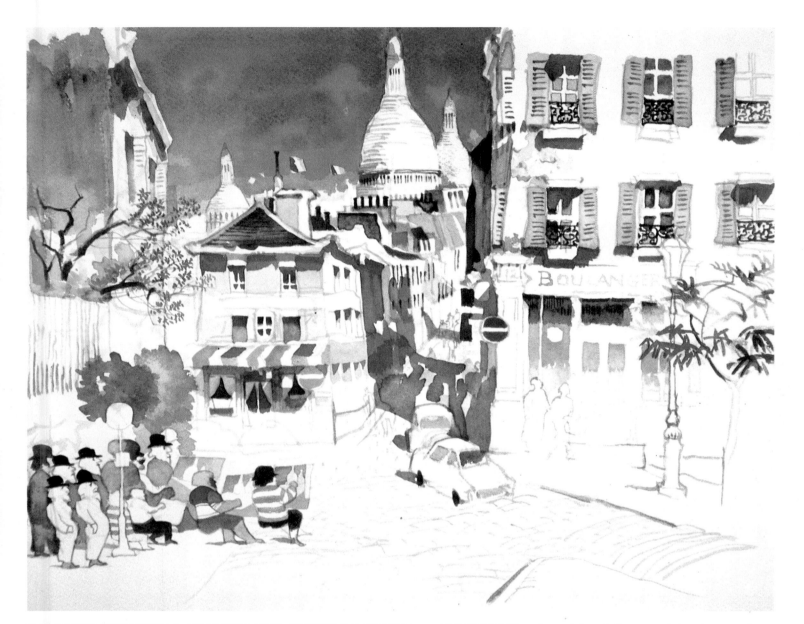

Step 4 (above). Street activity always collects an audience of kibitzers, so to create a happening for my Paris street scene, I add a few onlookers to the group on the left. But no matter what these characters may represent, the most important thing is that I am using them as part of my design, to create rhythm and movement for the whole composition. I continue to develop the left side of my painting, applying a dark gray-blue to the upper left-hand wall with a large brush. I use the same color for the shadows on the window and the top of the building. Changing to a small brush, I paint the tree branches near the same wall with dark sepia and then mix shades of yellow and green for the leaves on the branches to suggest springtime.

With a small brush and a light tan wash, I use fine lines to draw in the texture of the cobblestone street.

Step 5 (left). With a medium-size brush, I add a large triangular shadow behind the lamppost and then mix a blue-gray color for the tree foliage on the right. I develop the figures of the people on the sidewalk, adding color to their clothing.

81

Step 6. The sidewalk in front of the cafe seems to need some activities, so I use a small brush to draw a small group of tourists milling around. But when I reconsider, I don't think I need them after all, so I just leave them there, lightly sketched, without adding more detail.

At the very last stage of my pictures, I usually apply a wash of yellow or another light, bright color such as orange, light red, or green, to tone down the brightness of the white areas of the paper. In this case, I decide to put a yellow wash over some of the people's clothing and on the rooftops. I also tone down the texture of the cobblestone street with gray-brown wash of burnt sienna with a touch of sepia. Now the overall picture looks satisfactory to me, and I consider it finished.

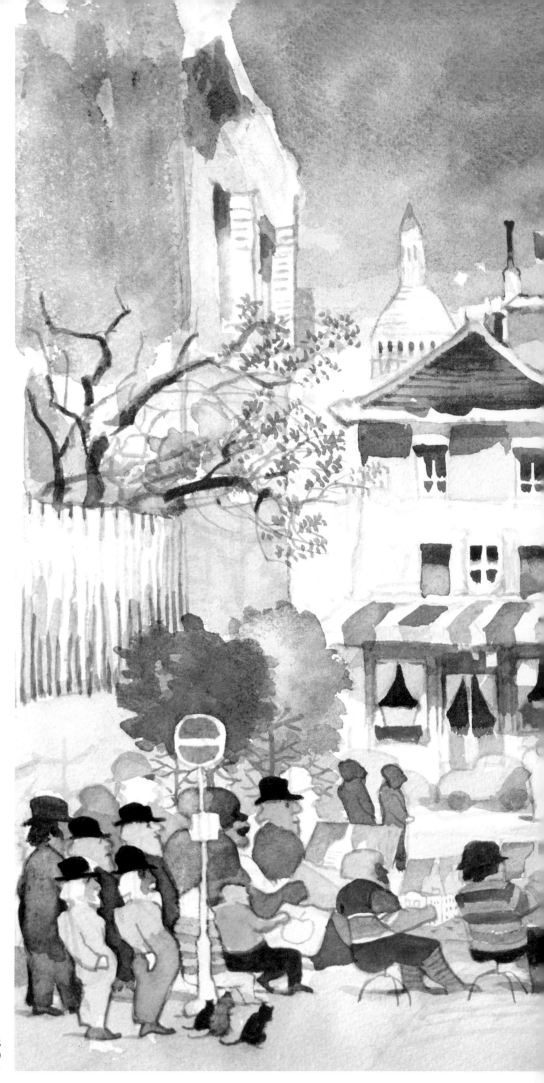

ARTISTS AT WORK, PARIS
17 x 22 in. (43 x 56 cm)
Collection of the artist

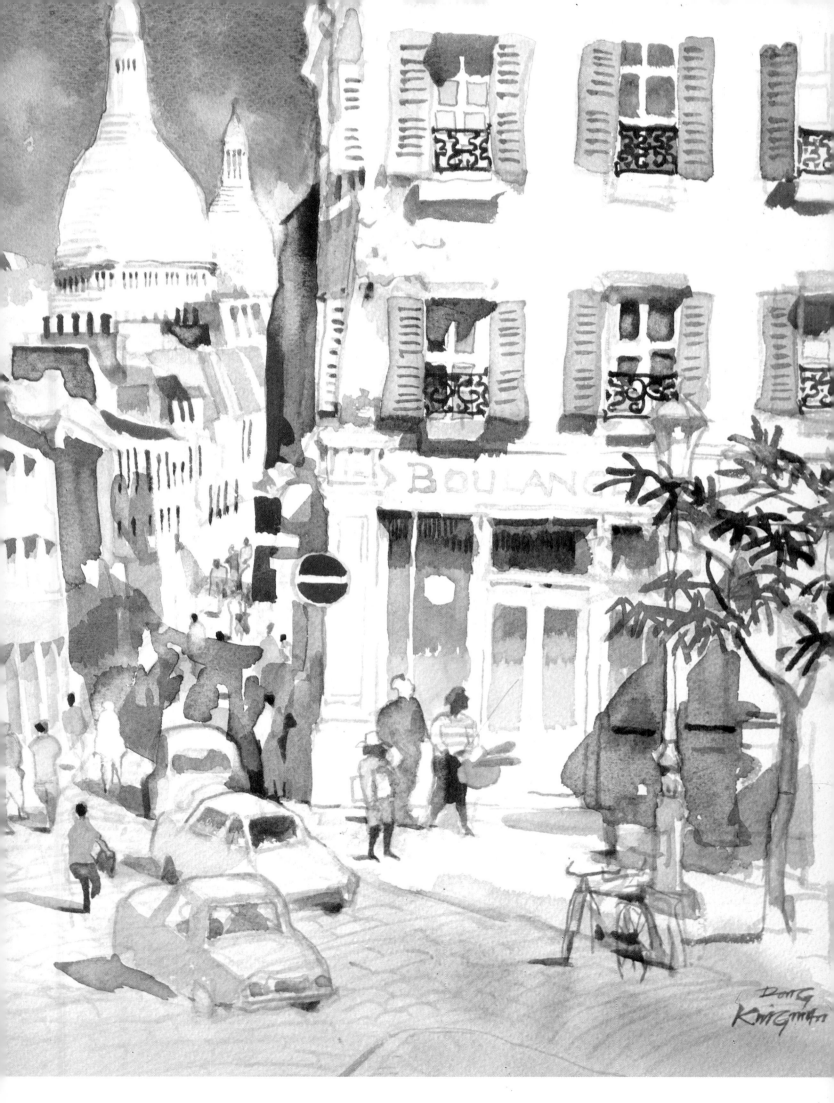

VENICE

When I went to Venice for the first time in 1965, I was so intrigued by the colorful Venetian subjects that I decided the next time I went, I would take along my Thurman Hewitt Painting Workshop. When I did take the group to Venice, in 1971, it was October; most of the tourists had gone home, and the air was getting a little nippy. Most mornings, fog hung low over the canal, and the sun tried hard to break through all day. It reminded me of foggy San Francisco—perfect weather for outdoor sketching because you can see colors and form much better without sunlight and shadow.

I picked the Grand Canal for this demonstration because it's so typical of Venice. Peppermint-candy-striped mooring posts and Gothic architecture line both sides of the canal, and the never-ending traffic on the waterways—motor boats, sightseeing boats, ferries, water taxis, and gondolas—can be seen against the background of the sedately magnificent cathedral of Santa Maria della Salute. The same scene has inspired artists and writers for centuries.

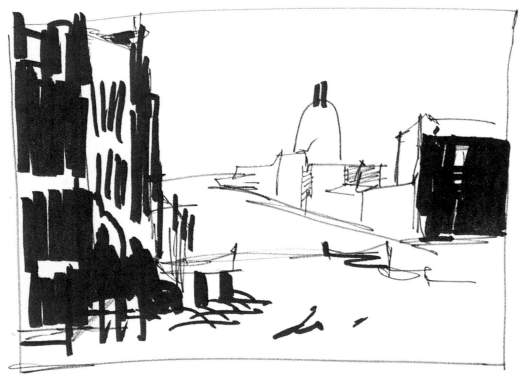

Preliminary Drawing. I make a quick composition sketch in pen and marker, just to map out the placement of the elements I'll want to include in this picture. Then I'm ready to begin working on a sheet of watercolor paper.

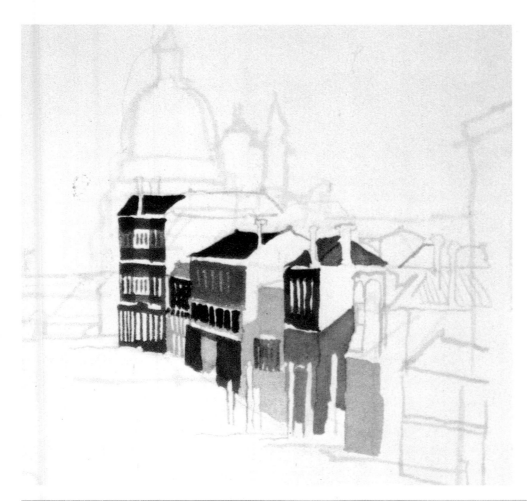

Step 1 (left). First I sketch in the general outlines of my composition, and then I'm ready to apply lay-in washes. Usually I start with neutral gray-blue tones for the cool shadows in my center of interest. However, there is so much color in this scene that it warms the shadows as well. Using a small brush, I mix alizarin crimson and burnt sienna and begin with one of the shadowed buildings in the middle distance—the one right under the dome. Before continuing with the other buildings, I try to improve the basic drawing, adding details such as windows, doorways, and chimneys with a light grayish wash on my small brush. Then I apply more color to the buildings—warm reds and golds, tempered by blue-gray shadows.

Step 2 (below). With a natural sponge, I wet the sky area. Then I load a large brush with a lot of blue, to which I've added just a little alizarin crimson, and stroke it on the paper with up-and-down zigzag movements to simulate clouds. Then I continue to paint the buildings along the sides of the canal.

When I step back and study the overall composition, I discover the white dome in the background is much too high and, unfortunately, it's on the same vertical line as the building below it. I decide to lower the dome and move it about an inch to the right.

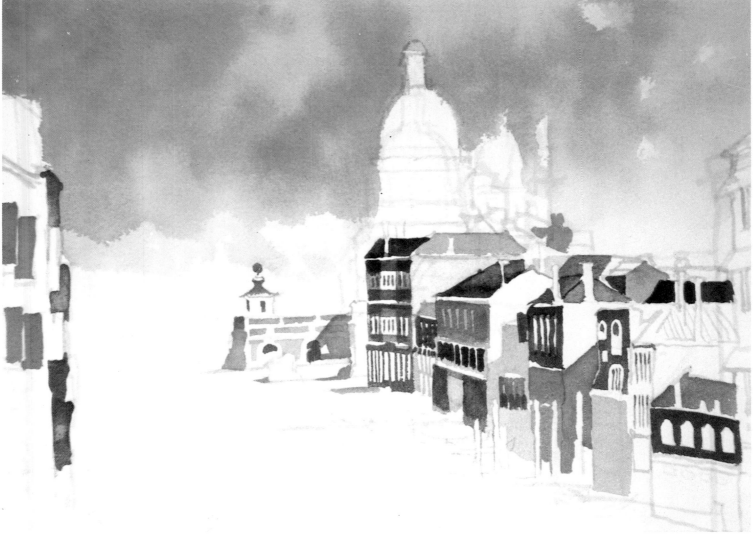

Step 3 (right). Before I can move the dome, I have to wash off the color in the sky. I wet all areas of the sky with a sponge and let the water soak into the pigment a few seconds before trying to rub it off. Then I use a tissue to gently dry the surface, removing paint along with the excess water. Again I soak the paper and then rub off the pigment. With this method, it may take a little time for the color to come off, so I simply repeat the process ever so gently, making sure I am not rubbing too hard or destroying the paper. I have used this technique for a long time. It doesn't always remove *all* the color, but it serves the purpose when I want to make a change. (If you try it, just make sure your paper is tacked to the drawing board, with the tacks at evenly spaced intervals. This will keep the paper from buckling during the rubbing process and while the wet paper is drying.) When I've removed enough color, I reposition the dome. To repaint the sky, I wet the area again with clean, clear water. With a large brush, I mix a great deal of blue with a touch of alizarin crimson and stroke it over the washed-out sky. Changing to a medium-size brush, I also paint a long, delicate blue shadow on the water near the horizon and a shorter shadow in the middleground.

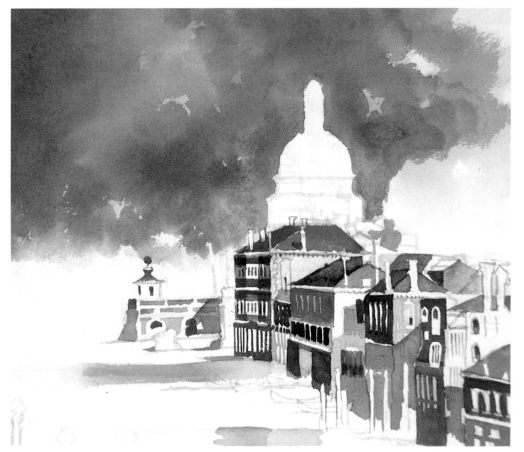

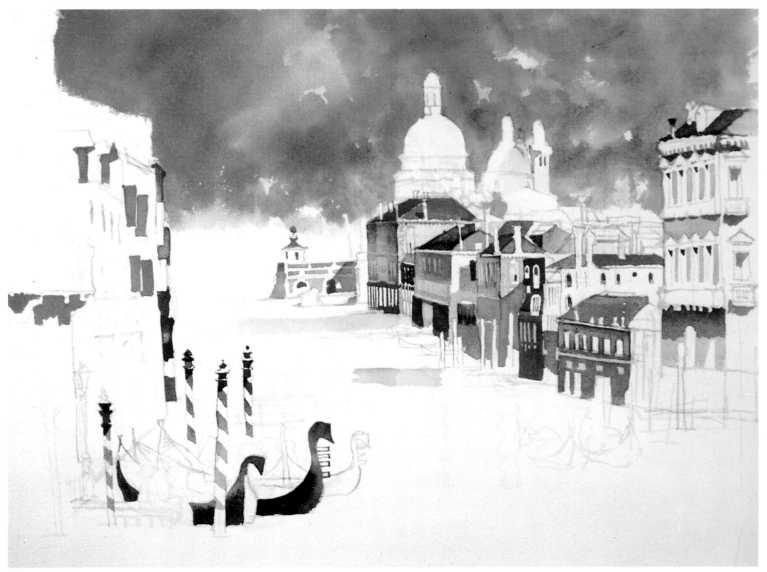

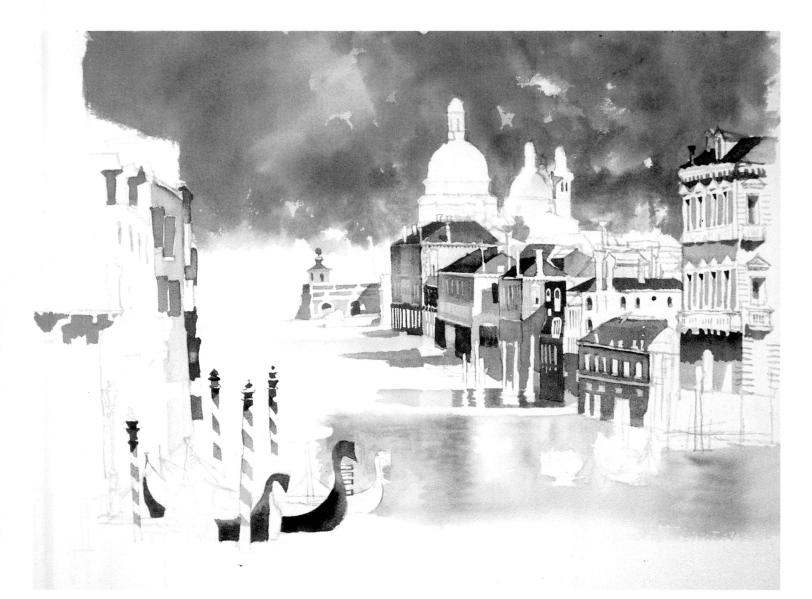

Step 4 (left). I work on the unfinished sky on the right-hand side, first wetting the paper and then brushing on pigment, trying to approximate my original blue as closely as possible. I paint further details on the foreground buildings on both sides of the canal and then turn my attention to the lower left portion of the canal. With my small brush and a light, neutral wash—any color except black will do for this—I finish my basic drawing of the gondolas and the candy-cane mooring posts. (I don't use black for drawing because it doesn't wash off easily if I want to make a change. The same thing is true for heavily pigmented washes of dark green or blue. I prefer to use *lighter* neutral washes—or even "dirty water"—instead.) When I'm satisfied with the drawing, I start applying color, still using a small brush— dark gray-blue for the gondolas and bright red-orange for the mooring posts.

Step 5 (above). To paint the water, I wet the space with clean water on a natural sponge and then paint a light blue wash over it with back-and-forth horizontal strokes. While this is drying, I change to a small brush and mix a darker blue-green, which I brush on in short zigzag strokes to create reflections in the water. To indicate highlights on the ripples, I blot out part of the color with a tissue. When I'm satisfied with the water, I apply a warm yellow-orange to the buildings on the left and a gray-blue, to their windows.

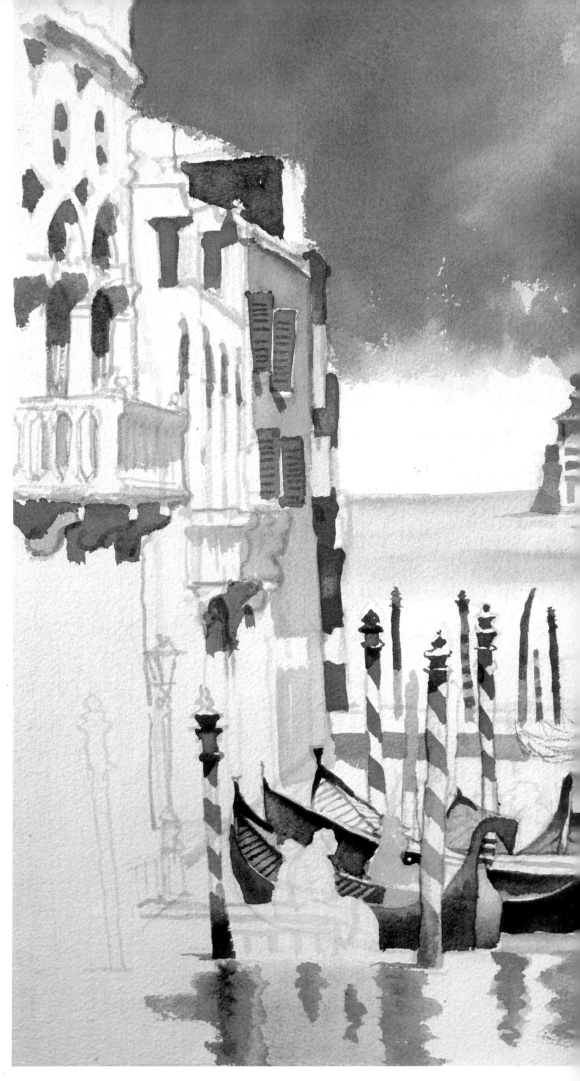

Step 6. Now I add the finishing details, completing the decks of the gondolas on the left with a gray-blue wash and painting upper-story windows on the building in the left foreground. I also finish the domes in the background, taking care to use cool washes and a minimum of detail so that visually they will remain in the distance. Finally, I add two gondolas on the right. They balance the ones moored at left and also create a sense of movement—the only activity in the Grand Canal on a lazy afternoon.

GRAND CANAL, VENICE
22 x30 in. (56 x 76 cm)
Collection of the artist

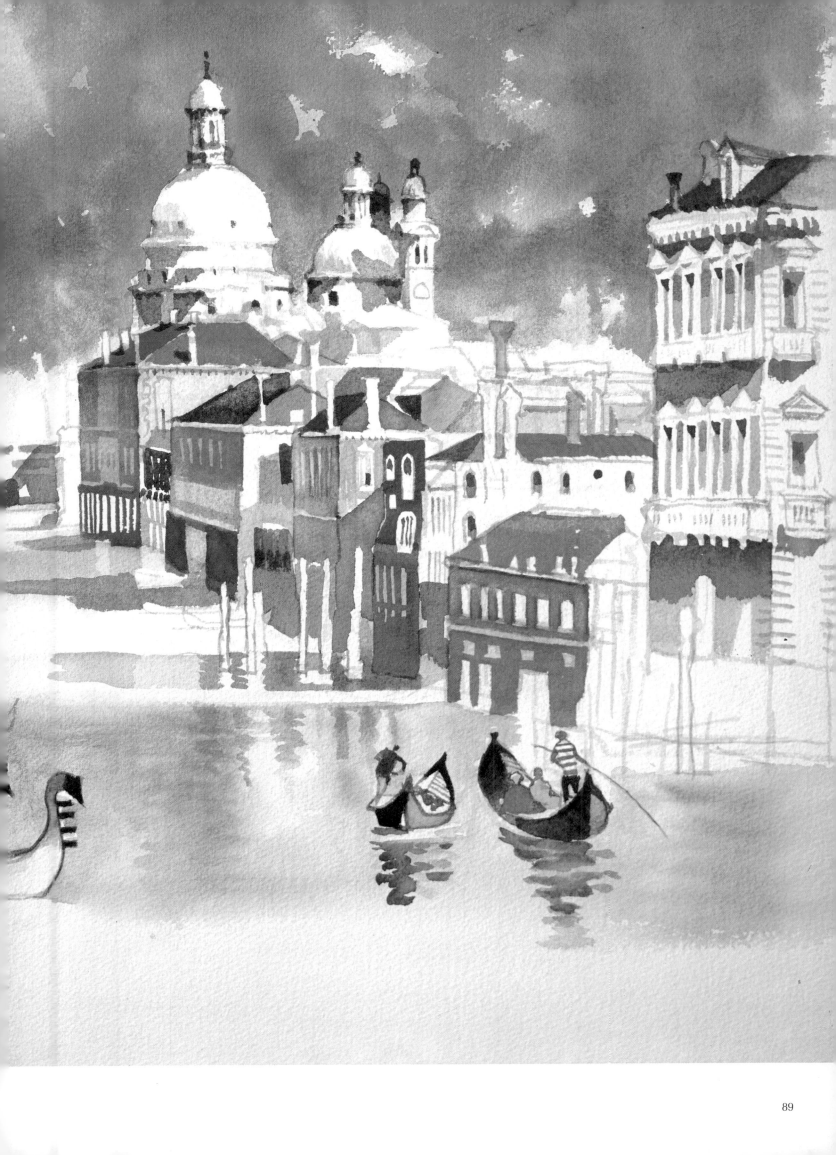

NEW YORK

The first time I ever visited New York was when I came from San Francisco on my Guggenheim Fellowship. I went looking for a subject to paint the first day I arrived. I had my sketching equipment with me, but I didn't know where to go. Suddenly a sign which read "BMT DOWNTOWN" looked appealing, so I took the subway. I rode for a few stations and then, without knowing why, decided I'd better get off when the train stopped at City Hall. When I came out, I was stunned to find myself at the bottom of a canyon surrounded by towering buildings—City Hall, the old Herald Tribune, Woolworth, and Municipal—as well as the Brooklyn Bridge. I was completely overwhelmed by their im-

mense power, which made me feel like a mouse in front of a herd of elephants. I decided then and there that this was my kind of subject.

Since that first visit, of course, I've discovered many other fascinating areas of New York. One of my favorites is the subject of this demonstration— Central Park near the Plaza Hotel. I often go there for inspiration, as my studio is nearby, and I've painted the scene many times (see *Plaza Sitters* and *Plaza in Action*, pages 108–9). In this demonstration, I want my picture to emphasize the action of the people rather than the buildings and streets in the background.

Preliminary Drawing. I start by making a quick, rough sketch of the composition in black and white. This always helps me to determine the basic light-and-dark pattern of my picture before I begin to paint.

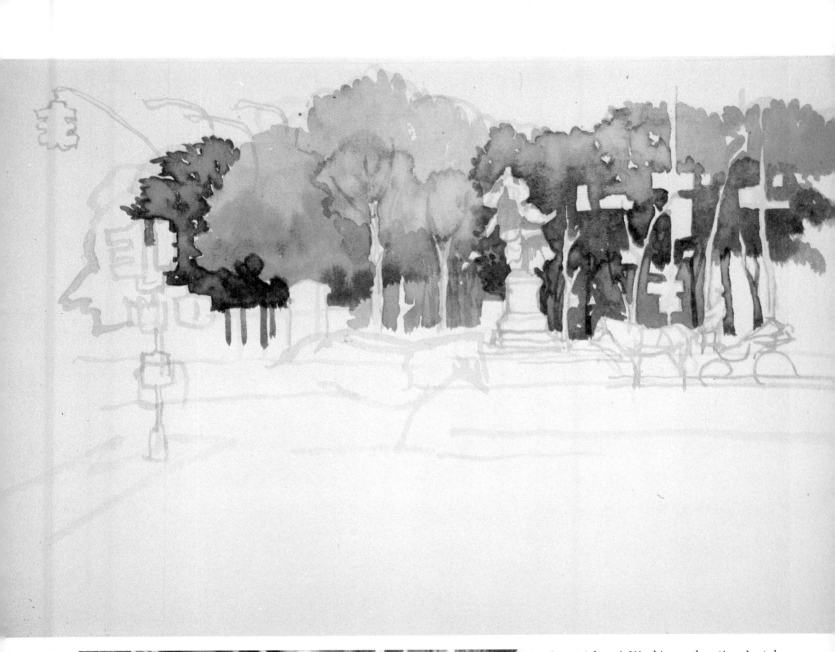

Step 1 (above). Working on location, I establish the outlines of my composition and then start laying-in washes for the trees in the upper part of the picture. Using a medium brush, I mix green, blue, and a little sepia for the foliage behind the white statue. Then I continue painting with the same wash from left to right, leaving small white spaces here and there for later use. With the same color, I paint the dark green tree on the far left side of the picture. When my first washes are dry, I paint the rest of the trees a lighter gray-green.

Step 2 (left). Now I go back to the studio to develop and finish the painting. First I use a small brush to draw a group of people at the lower left and then add color and detail to them. One man in the foreground wears a striped green-and-yellow T-shirt, a bearded man has an orange coat and hat, and for contrast, I put sepia on my brush and add a lady all in dark brown. Next I paint a blue-faced lady with a pink flower in her hair. I don't feel it's necessary to interpret things literally, and I use vivid colors and fanciful characters to add interest to my overall composition. From the point of view of color relationships, I may feel that a blue face goes better with pink, as in this case.

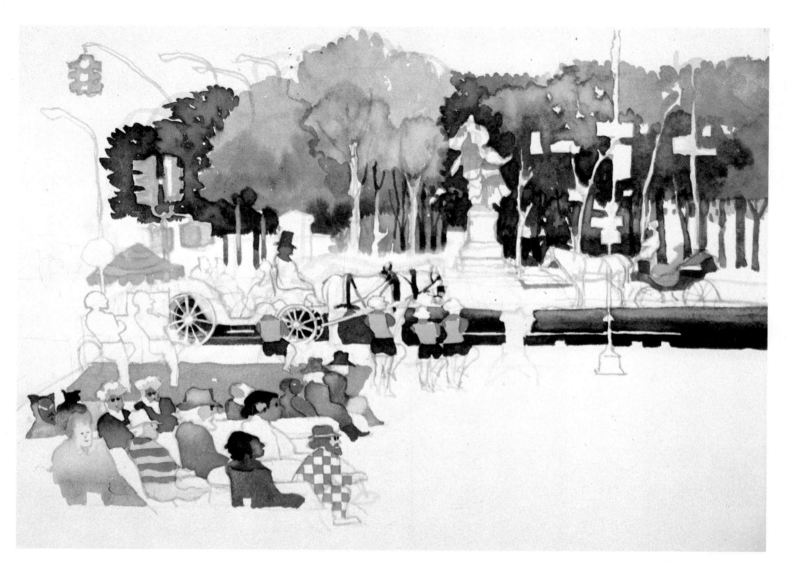

Step 3. Next I paint a dark sepia wash to indicate the roadbed in the middleground, taking special care with the horse-drawn carriage, which I begin to paint in greater detail. Then I sketch some of the bicycle riders, using orange-yellow for their jersey shirts and black for their shorts. I'll complete the figures and draw their bicycles later. I carry the colors of their jerseys over into the umbrella and then go back and add more people to the left foreground. I decide to paint a blue-and-white checked suit on the man with the black beard.

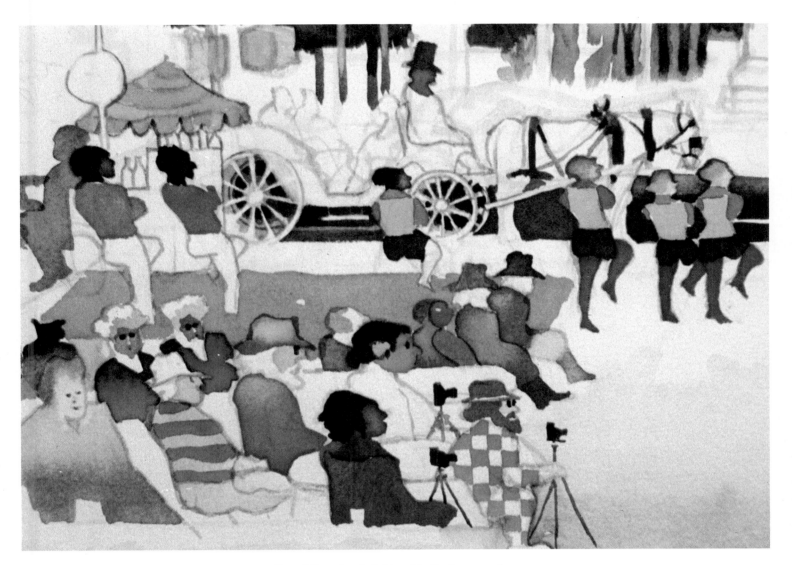

Step 4. I apply a bright red to the jerseys of
the two bicycle riders on the left, in front of
the hot-dog vendor. I paint their faces, using
predominantly burnt sienna and a little
black, and then finish the features and legs
of the other cyclists with the same colors.

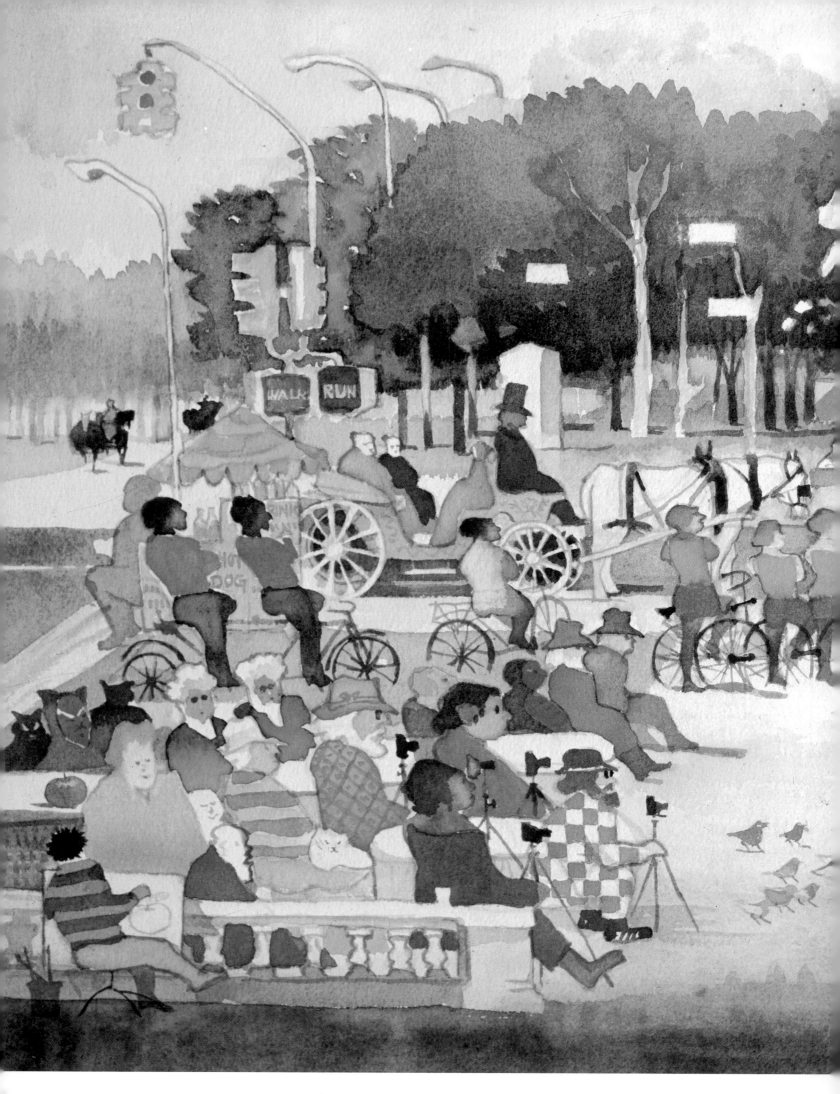

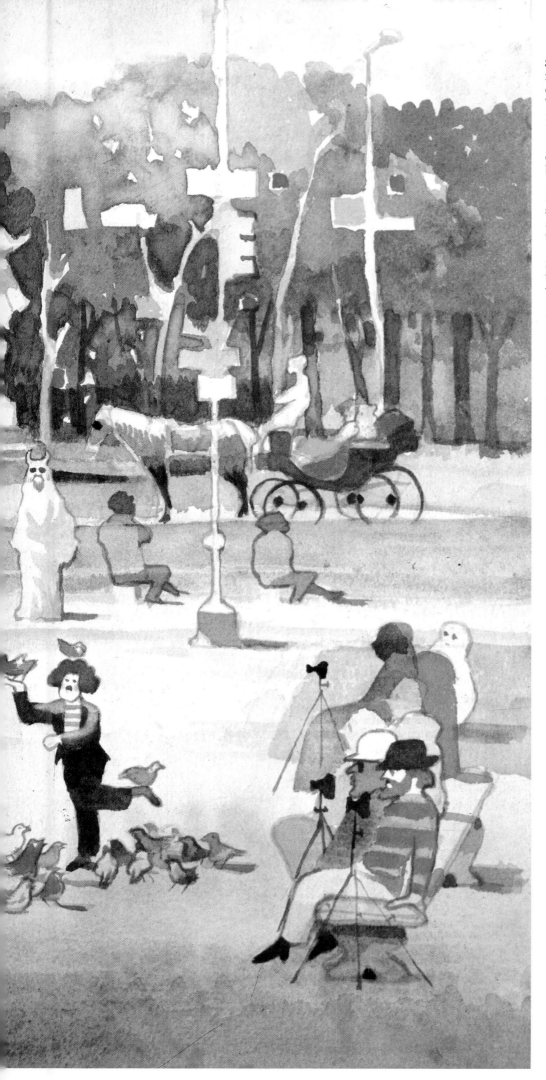

Step 5. To the left foreground I add a stone fence and, sitting in front of it "painting his own thing," an artist in a dark green striped T-shirt. Then I use a small brush to draw in some fine details in dark sepia—such as bicycles for the cyclists and cameras for the camera nuts. I complete the road at the extreme left and add details in the background.

To create the impression that the square is always busy and full of people, I paint a small group of bench-sitters on the right side and a pigeon-lover posing for the photographers.

With a small brush, I add detail to the carriage horse in the right middleground and then complete the figure of the man in a long white robe wearing a horned hat. (This square attracts all kinds of characters.) After refining minor details throughout the picture, it's time to stop and study my painting. It's always difficult to know when a picture is really finished. At this final stage, I usually study the white spaces I've deliberately left unfinished. In this case, I decide to apply a yellow wash here and there, to tone them down and create a more unified picture. When I take another look, I'm satisfied that the painting is truly finished.

THE PLAZA IN CENTRAL PARK, NEW YORK
18 x 22 in. (46 x 56 cm)
Collection, Rocky Aoki

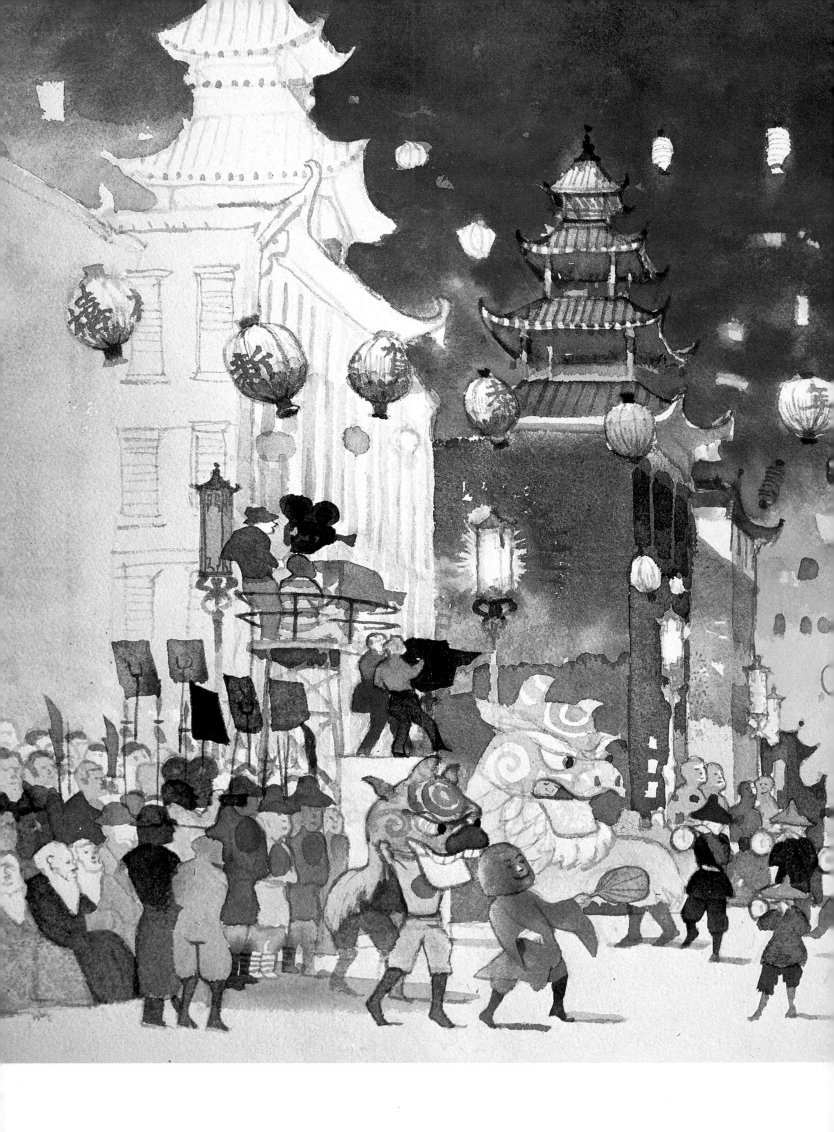

GALLERY

The pictures in this Gallery were painted over a period of many years—some as early as the 1940s. While the selection shown on these pages can't possibly be complete, we have tried to include a representative sampling of subjects and styles which spans a life-long exploration of watercolor.

SAN FRANCISCO FESTIVAL
22 x 30 in. (56 x 76 cm)
Collection, Columbus Museum
of Arts and Sciences,
Columbus, Georgia

Comparable in size and importance with the St. Patrick's Day parade in New York City, the Mardi Gras in New Orleans, and the Rose Bowl in Pasadena, the Chinese New Year parade is one of San Francisco's major annual events. It usually takes place at night, but since I don't like to paint night scenes, in this picture I created a feeling of early evening rather than the dark of night. I believe I can make imaginative changes like this and still be faithful to my subject.

SAN MARCO IN WHITE
15 x 22 in. (38 x 56 cm)
Collection of the artist

When I started this picture on location, my intention was to paint it with a great deal of color. But after I had applied a dark sepia tone to the sky, I changed my mind. Instead, I kept the rest of the picture as light as possible, using light colors and allowing the white paper to show through. Against these light areas, the blue shadow on the church doors stands out strongly. I have also treated the people and the pigeons in very light tones because they are the more transient elements of the scene, whereas the church and the Venetian architecture will be there for a long time.

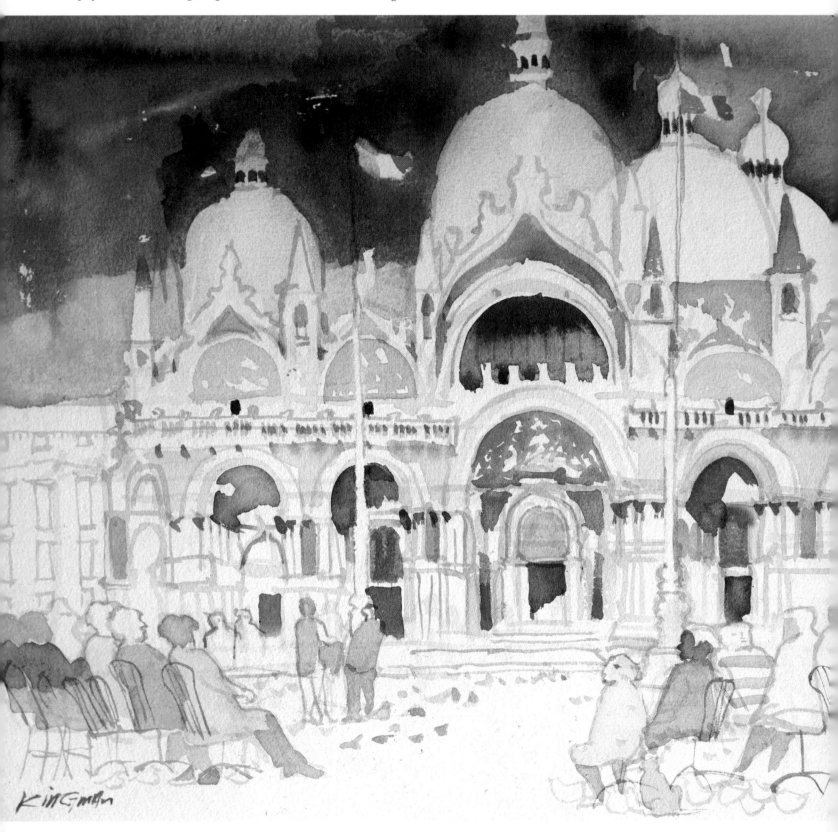

MOCAMBO CAFE, TAORMINA
15 x 22 in. (38 x 56 cm)
Collection, Mr. and Mrs Fred Tatashore
and Freddie Tatashore

One year I held my painting workshop in Taormina, Sicily. Usually I would ask my students to meet me at the square pictured here, because it had many interesting coffee shops and stores to sketch. I wanted to paint this very old outdoor cafe juxtaposed against a piece of architecture which looked almost like a church. Mount Aetna also showed in the background, but I decided I didn't need the mountain for my composition. Most of my compositions are oblong, but this subject seemed to call for a vertical.

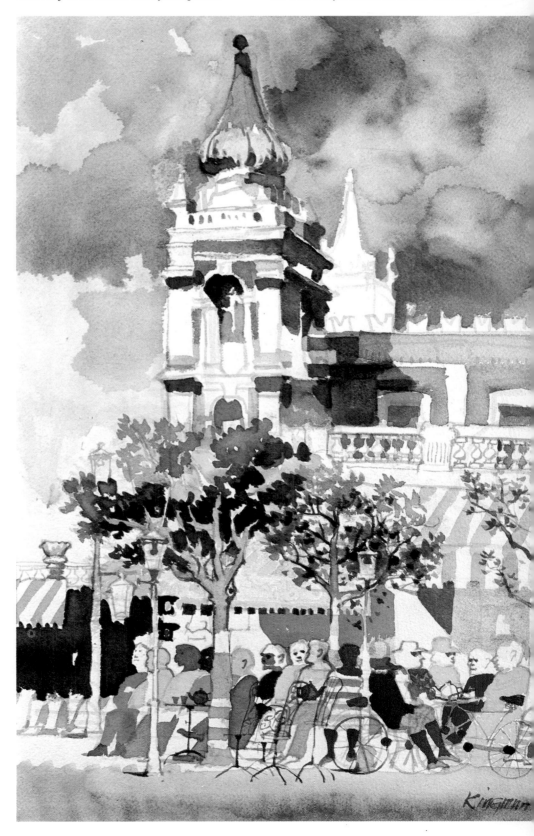

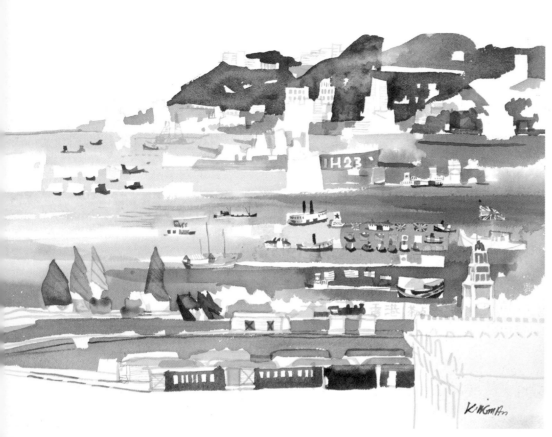

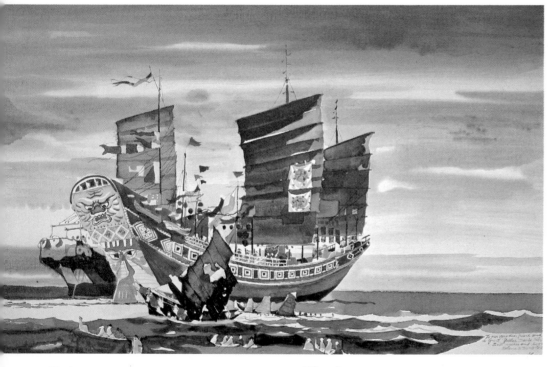

(Top)
HONG KONG HARBOR
22 x 30 in. (56 x 76 cm)
Collection, Mr. and Mrs. Brown L. Whatley

During the 1960s I painted this view of Hong Kong Harbor from the window of my hotel. At that time, on a good day the harbor would be full of junks and sampans waiting for the arrival of large warships and submarines. In the foreground, there would be people arriving by train from the New Territories to connect with the Star Ferry, which would take them to the Hong Kong side of the harbor. Time has caught up with Hong Kong today. Now there are tunnels and subways, and the romance of traveling on the ferry is slowly giving way to modern technology.

(Above)
COLORFUL JUNKS
22 x 30 in. (56 x 76 cm)
Collection, David W. Tebet

These are not just junks sailing at sea. When I painted them, I was trying to create a feeling of celebration—perhaps there's a birthday party or a wedding taking place aboard one of them, with well-wishers congratulating each other and having a good time.

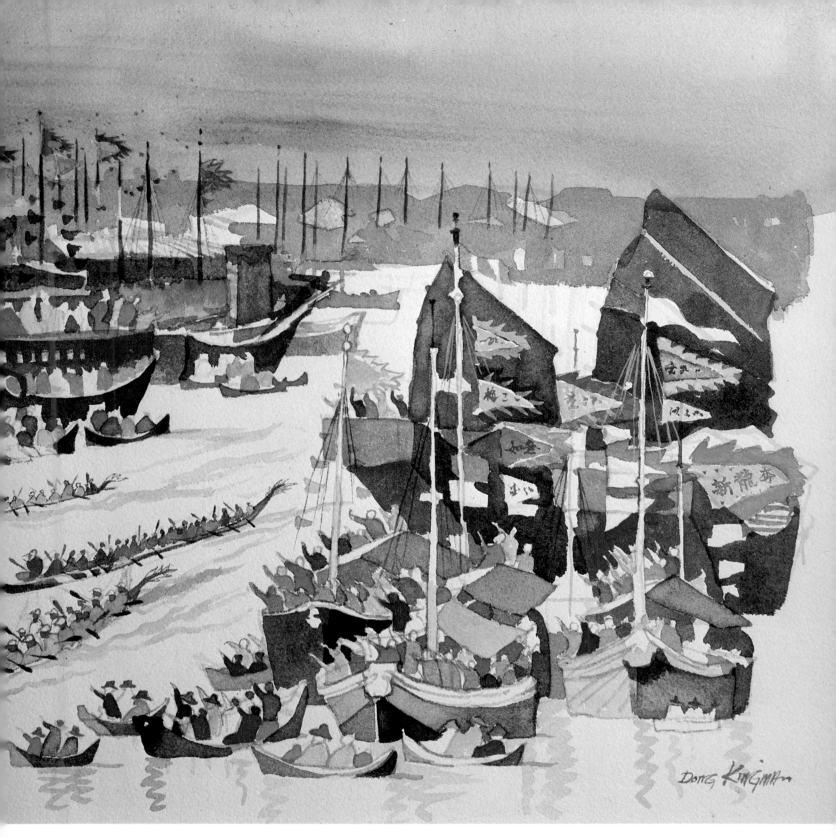

DRAGON BOAT RACE
22 x 30 in. (56 x 76 cm)
Collection, Natalie and Samm Sinclair Baker

Once a year, on the fifth day of the fifth month of the lunar calendar, there is a dragon-boat race in Hong Kong. The local boat people of Aberdeen believe that having the race will chase away evil spirits. In this watercolor I tried to create the overall feeling of this fishing village on the day of the boat race, rather than literally copying every activity of the festival.

EAST END, LONDON
22 x 30 in. (56 x 76 cm)
American Watercolor Society Award, 1958
Collection, Elaine Kingman

I started this picture in a London street and then decided to go to the other side of the river so I could look at the street with Big Ben in the background. One thing which especially caught my attention was the great long building on the left-hand side. The figures I created near the foreground are more or less Londoners—an assortment of bobbies, tourists, and stevedores.

NEAR WESTMINSTER BRIDGE, LONDON
15 x 22 in. (38 x 56 cm)
Collection, Jeff Kriendler

One morning in London, when I was walking toward Big Ben looking for a composition, the view that struck me most was this one, with a row of tall trees along the embankment and Big Ben in the background. Since it was very early in the morning, the streets were practically empty of people except for a couple of bobbies. To paint this picture, I sat down on a sidewalk which was on the edge of a highway, and I was really scared when cars and buses came swishing by me at high speed.

(Overleaf)
MID-AUTUMN FESTIVAL
22 x 30 in. (56 x 76 cm)
Collection of the artist

The Mid-Autumn Festival is one of the most important Chinese festivals in Hong Kong. It's like Christmas here. The gifts exchanged during the festival are only moon cakes—round and perfect like the full moon, which is considered a good omen. The festival takes place on the fifteenth day of the eighth month of the lunar calendar, when the moon is supposed to be at its roundest. In this watercolor, the center of interest is the bright moon rising from the horizon, which is adorned with tens of thousands of twinkling little city lights reflected in the Hong Kong harbor. Shown in the foreground is the clock tower of the ferry building.

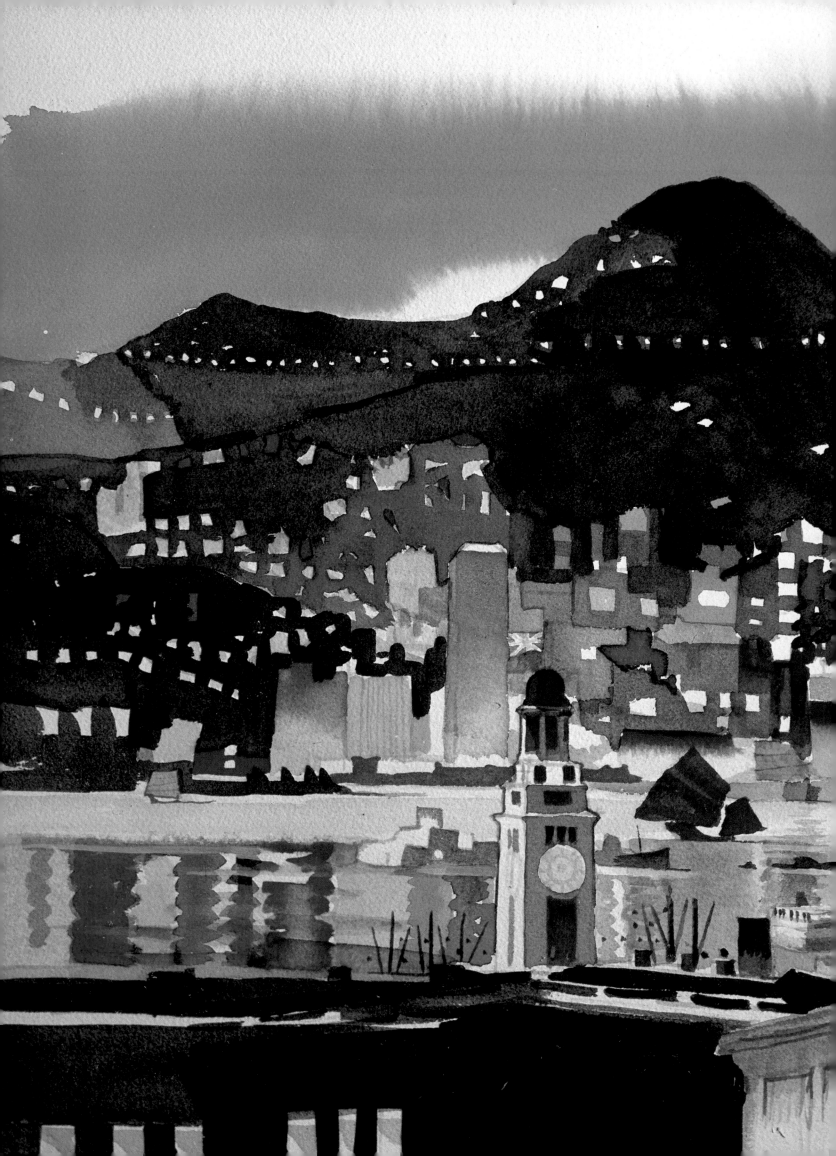

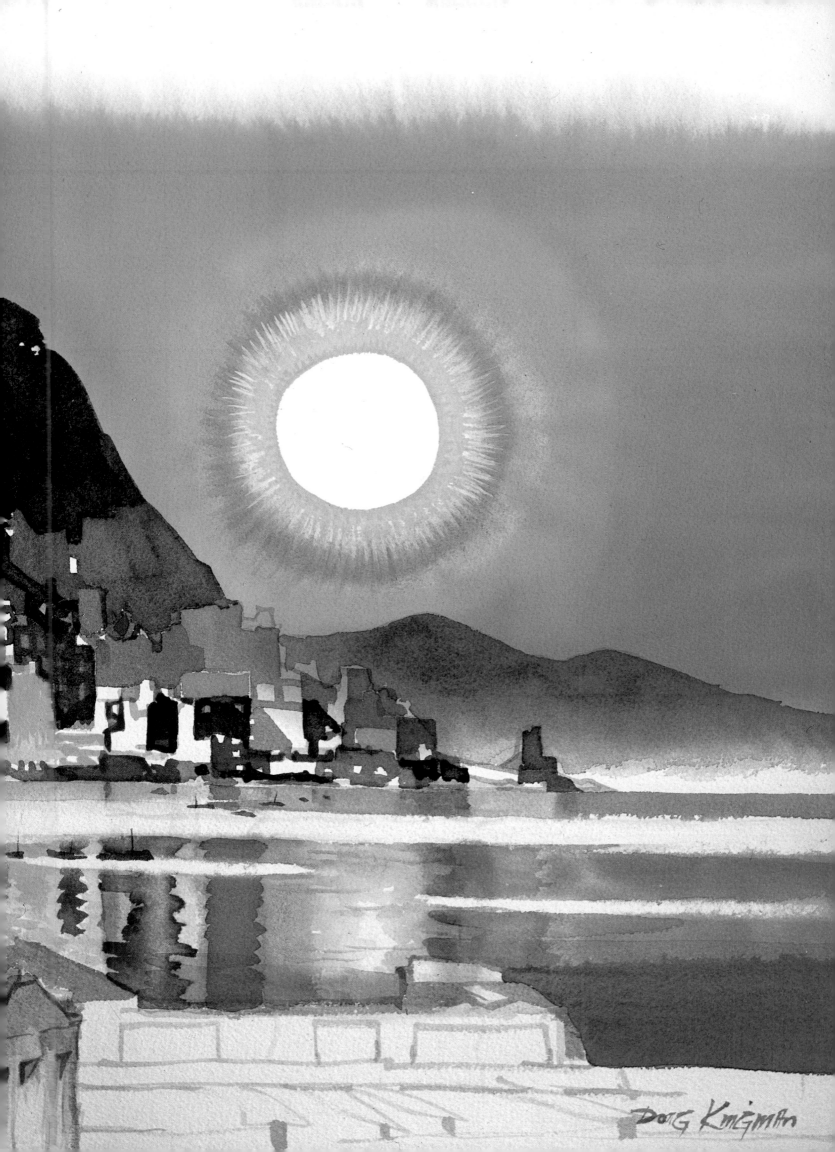

THE GREAT WALL, CHINA
22 x 30 in. (56 x 76 cm)
Collection of the artist

My uncle once took me on an overnight trip to our ancestral village near Canton when I was a child. However, I had not been in mainland China since. In 1978, my wife and I finally made a trip to China for the first time and saw Peking, the Great Wall, Shanghai, Hangchow, Canton, and many other interesting places. The excitement of being there was beyond my expectations.

As soon as we reached the base of the Great Wall, I immediately started sketching and let my wife and friends do the walking up the giant steps. This particular picture, which was reproduced on a menu cover for Pan-Am Airways, is one that I painted directly from memory after this experience. When I sketched in the figures, I was thinking of Rudyard Kipling. While the people of the People's Republic of China look east, all the foreigners look west.

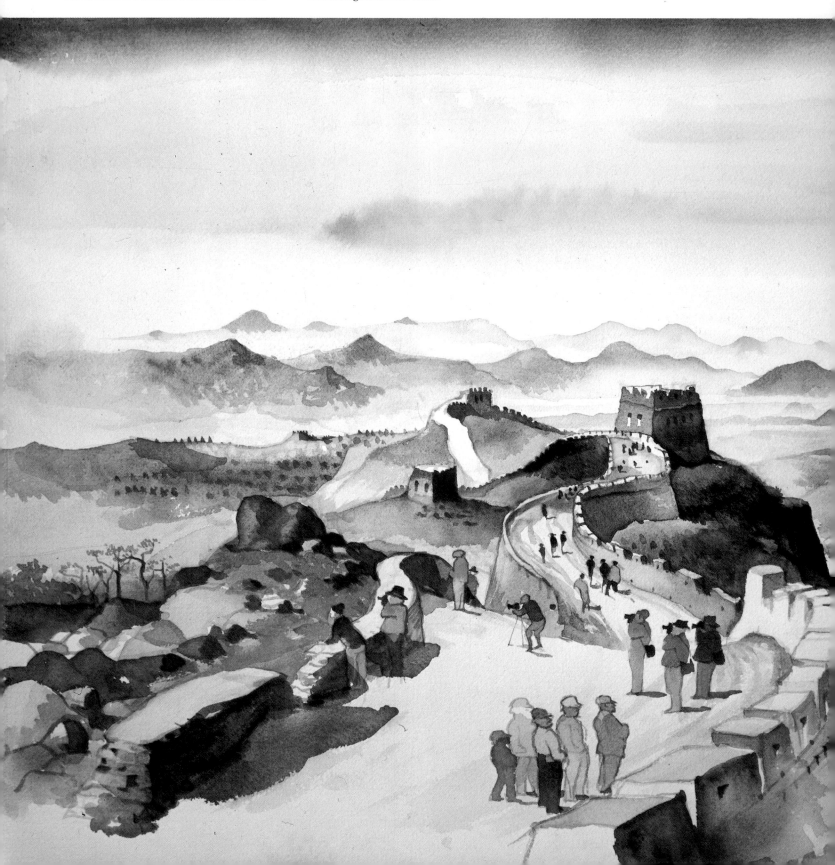

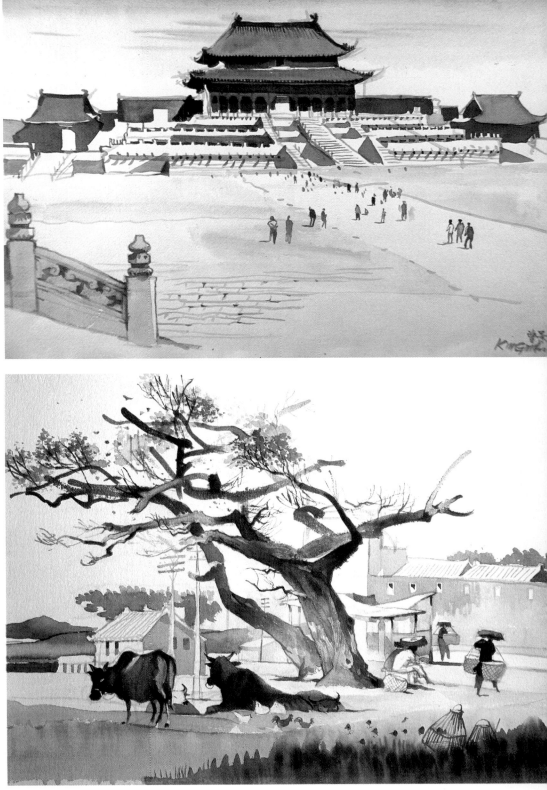

(Top)
IN THE FORBIDDEN CITY
15 x 22 in. (38 x 56 cm)
Collection, Mr. and Mrs. Neil C. Nichols

(Above))
LAZY AFTERNOON, HONG KONG
22 x 30 in. (56 x 76 cm)
Collection of the artist

This picture was done on location in Peking, in May 1978, when I took my painting workshop to the People's Republic of China. That was before the country was officially recognized by the United States, and we were among the first artist groups to visit China. The strong contrasts in the scene were what made me want to paint it. The deep cast shadow on the great pagoda-shaped building, against the glare of the intense sunlight on the ground, makes this subject especially dramatic. This painting was reproduced on the cover of *Clipper* magazine, October 1978.

Hong Kong is a busy city, always congested with people and vehicles, especially in the downtown area. The streets are so jammed with people that pick-pockets have a field day. But not very far away, on the Kowloon side and into the New Territories, there is great open space, with small farmhouses, rice fields, and a peaceful landscape decorated with water buffaloes, funny-looking pigs, and chickens and ducks. Here and there you see tall old trees, short bushes, and walled-in villages. This watercolor was started when I was sketching there one lazy afternoon, and I drew only the large tree in the center. I didn't paint the cows, farmers, or the rest of it until I returned home.

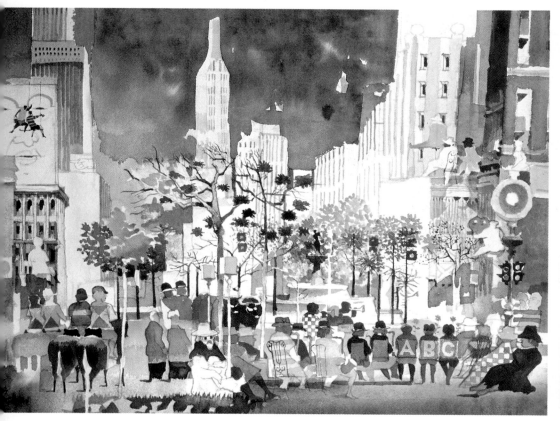

(Above)
PLAZA IN ACTION
22 x 30 in. (56 x 76 cm)
Collection, James K. Wolosoff

All you have to do is sit for a while in front of the Plaza at Fifth Avenue and 59th Street on a nice day, and you'll learn all about what goes on in a city like New York. The Plaza is a gathering place for all kinds of people—small-time musicians, fashion models, movie makers, hot-dog vendors and eaters, et cetera. There are so many different characters that some of them hang from the trees and buildings. But why are there jockeys on horses in this picture? In New York, anything can happen: perhaps they're left over from a parade, or maybe a race is about to start at the Plaza. Gambling is all over town, and as the saying goes, if you can't go to the races, the races will come to you. What I tried to do in this picture was to create a quiet excitement. Somehow, that's the way I react to the city.

(Right)
PLAZA SITTERS
22 x 30 in. (56 x 76 cm)
American Watercolor Society Award, 1979
Collection of the artist

I have been studying and painting the Plaza Hotel for a long time, and I always find something new every time I paint it. If you compare this picture with *Plaza in Action*, above, you'll find that although both were painted at basically the same location, this watercolor is a *Waiting for Godot* kind of story. Everyone seems to be waiting for a parade to take place any moment, with a great deal of anxiety.

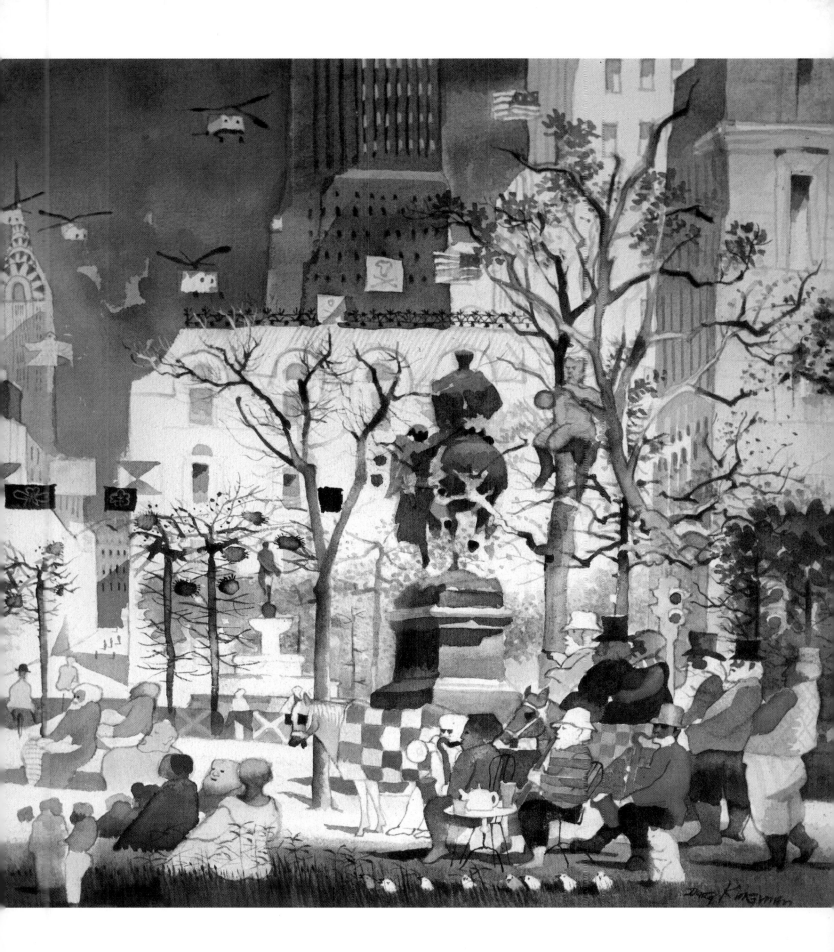

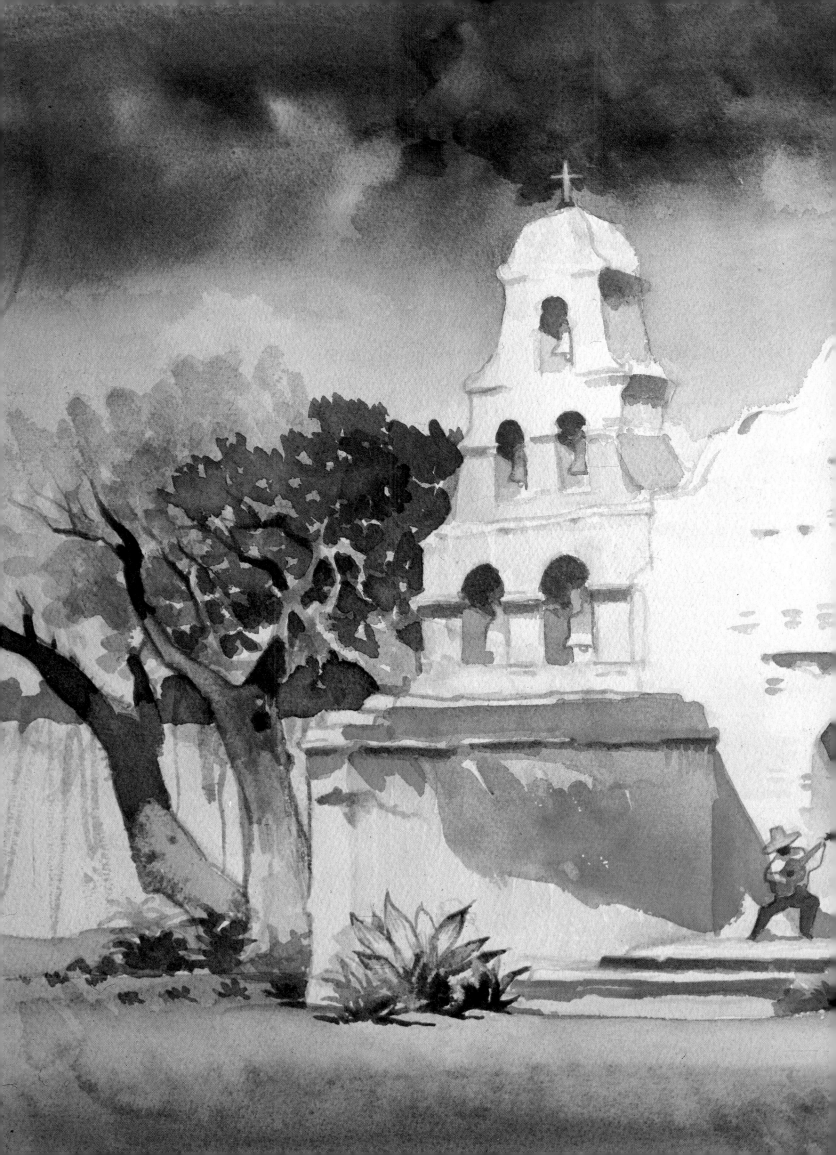

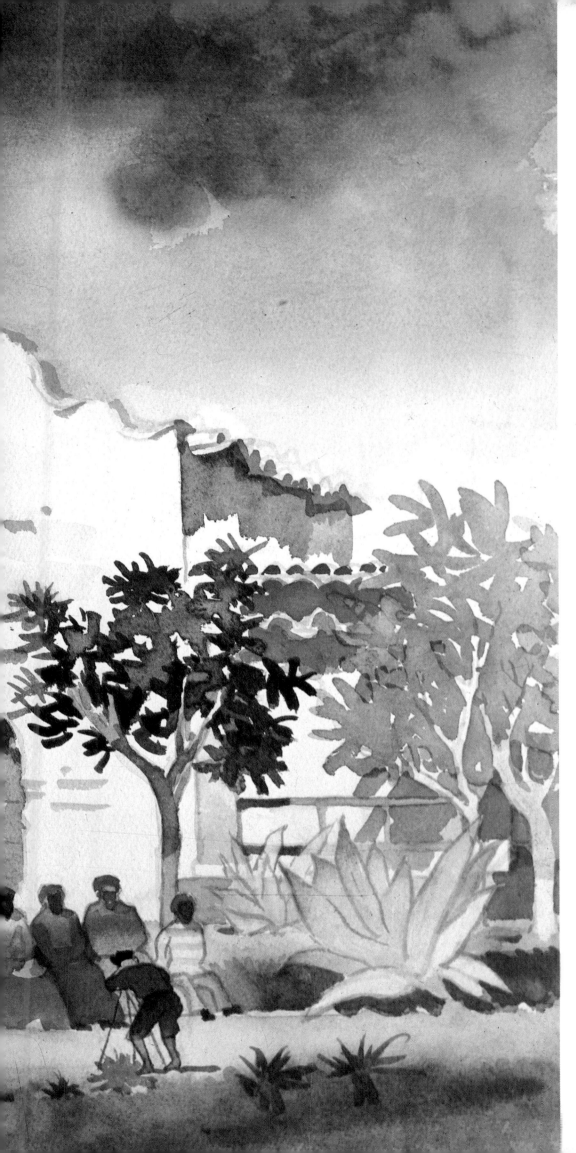

OLD MISSION: SAN DIEGO
21 x 18 in. (53 x 46 cm)
Collection, Rocky Aoki

I have been painting the Mission San Diego de Alcala ever since the 1940s, when I taught at the San Diego Art Gallery and sometimes took my class to paint there. The mission is located about ten miles outside San Diego, so we would go there in the morning, bringing our lunches, and stretch the sketching session into an all-day affair. This watercolor was painted in June 1979.

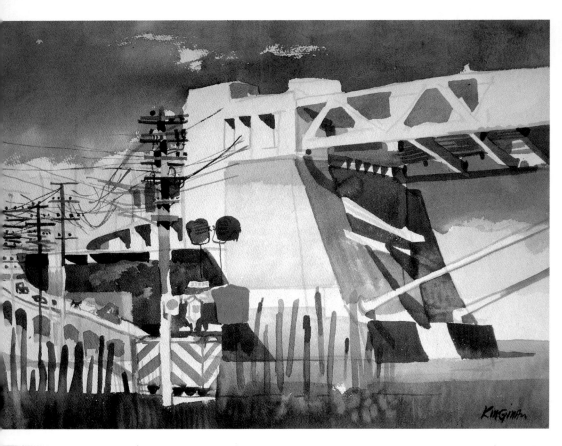

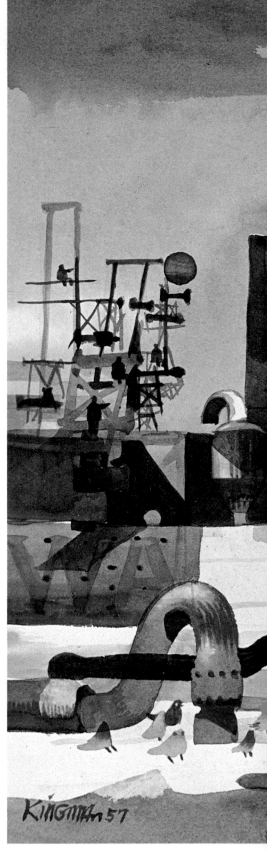

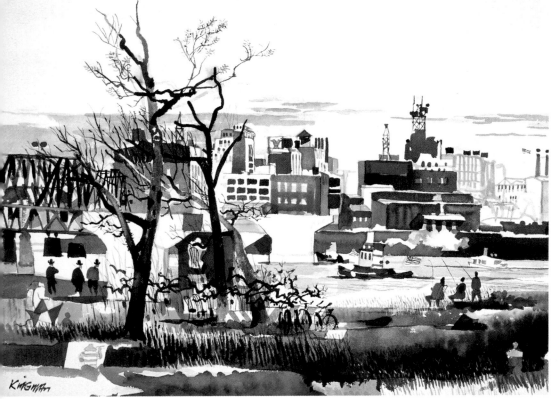

(Top)
BASE OF BAY BRIDGE, SAN FRANCISCO
22 x 30 in. (56 x 76 cm)
Collection of the artist

During my lean but productive period working for the WPA Art Project, I must have painted some five hundred watercolors. Most of the subjects were scenes around the Bay Area in San Francisco. I had sketched the Bay Bridge many times from many different angles, but this is a view that I thought particularly interesting because it has simple forms, monumental shapes, and strong sunlight and shadows.

(Above)
OMAHA, 1966
22 x30 in. (56 x 76 cm)
Collection, Joslyn Art Museum, Omaha, Nebraska

This is one of several watercolors commissioned by the Joslyn Art Museum, which invited me to Omaha especially to paint different scenes of the city. I remember I went across the river on an old iron bridge, looked back at the skyline, and painted this picture. That was in 1966. But Omaha is a growing city, and today, there are many more buildings against the skyline.

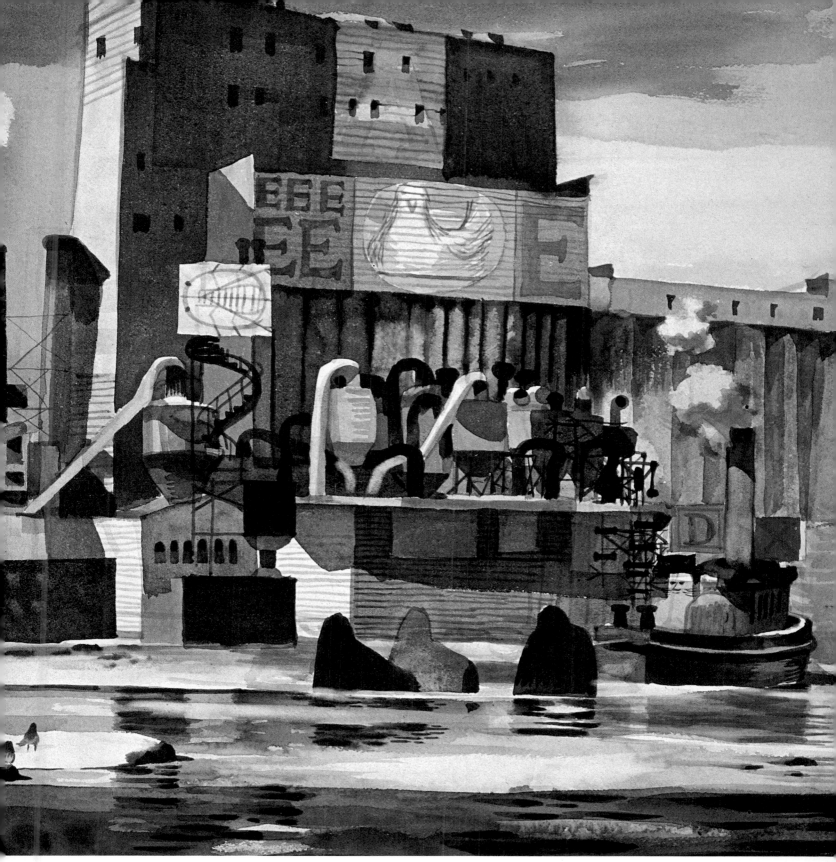

HARBOR STRUCTURE
22 x 30 in. (56 x 76 cm)
Collection, Tweed Museum of Art,
University of Minnesota, Duluth

I painted this picture in 1957, during a summer when I was conducting an art class in Duluth. The city of Duluth is a great seaport which has many good subjects for watercolors, so I did a lot of sketches while I was there. Its terrain reminds me of Hunter Point in San Francisco. The harbor structure looks a lot like a toy set which I wanted as a child, but never had enough money to buy. This painting, like many of my earlier pictures, has strong contrasts and darker, more muted colors than my recent work.

DEMONSTRATION IN THE PARK
22 x 30 in. (56 x 76 cm)
American Watercolor Society Award, 1967
Collection, Melissa Kingman

I began this picture in Central Park at a time
when there were demonstrations of one
kind or another all over the United States,
students were turning campuses upside
down, and hippies and yippies were the
heroes of the day. It was a very disturbing
time. In this watercolor, I worked very
much on the total composition, treating the
strikers and policemen as part of the overall
design and pattern.

TREE ROWS IN MADRID
22 x 30 in. (56 x 76 cm)
American Watercolor Society Award, 1965
Collection, Mr. and Mrs. Herb Steinberg

I painted this picture on a sunny day in front of my hotel in Madrid. There were always mothers with children and sun-lovers sitting on the benches, and anyone willing to pay 25 pesos could sit there on one of the chairs. In this watercolor, I tried to concentrate on the trees in the middleground, simplifying the background and foreground in order to make an interesting composition.

(Overleaf)
A FUNNY ART CLASS
22 x 30 in. (56 x 76 cm)
Collection of the artist

I have been conducting classes in Mexico for many years—in places like San Miguel de Allende, Cuernavaca, Puerto Vallarta, Taxco, Acapulco, and Villahermosa, to mention a few. I enjoy painting the subjects of Mexico, especially its old architecture and variety of costumes. I started this picture at Lake Pátzcuaro a few years ago. I placed the small island with the statue in the background—and in the right foreground, I included my art students. They may look kind of lazy, but they were very busy being happy.

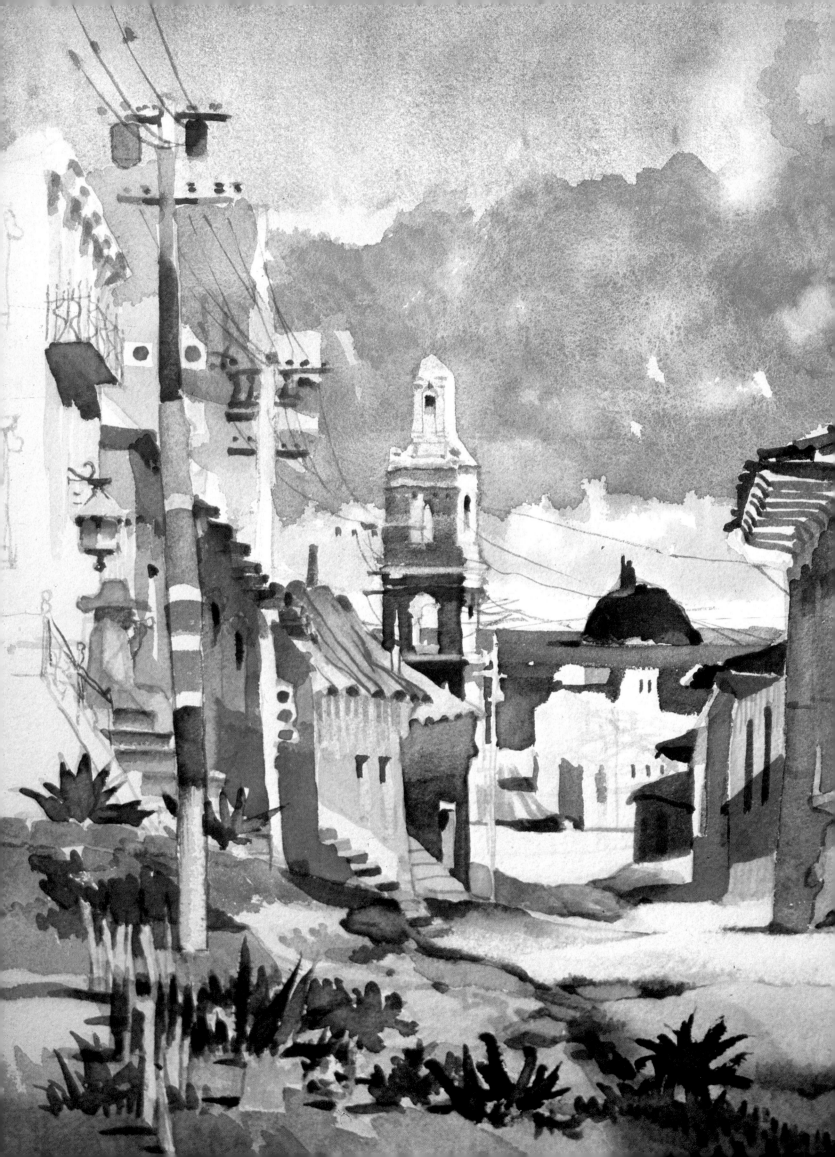

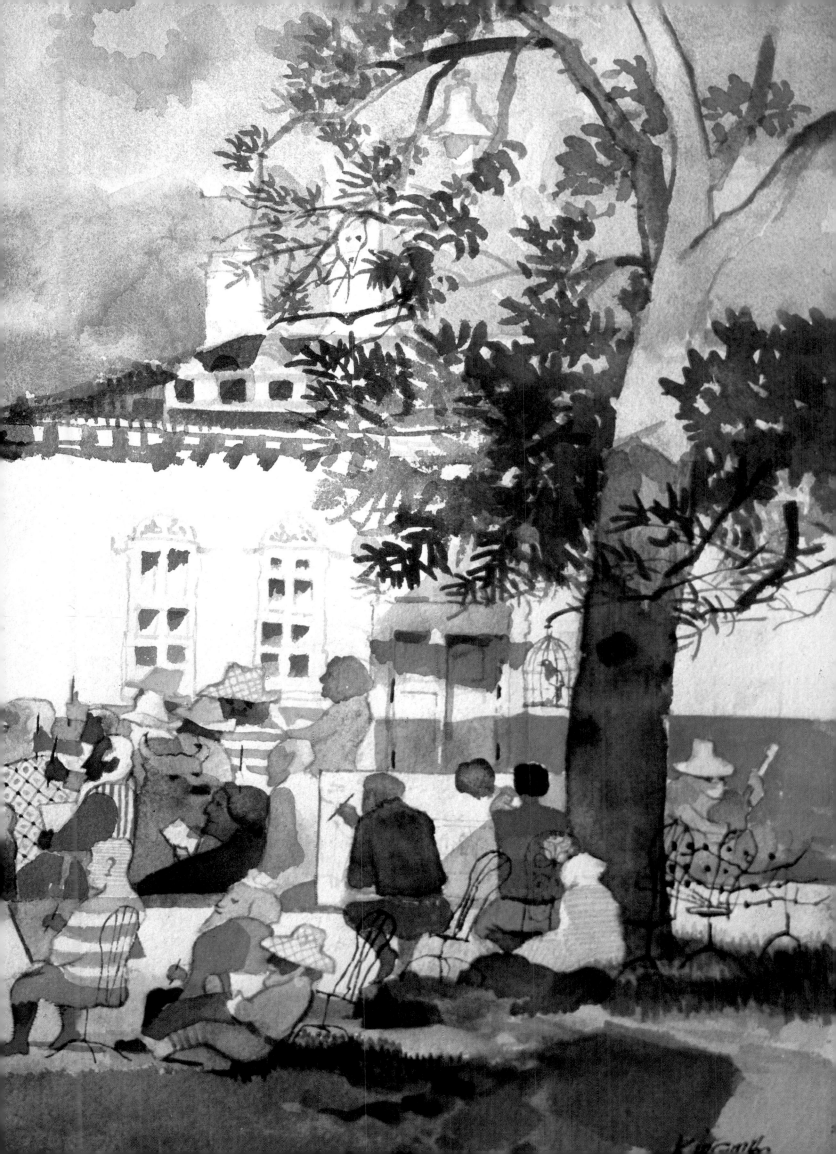

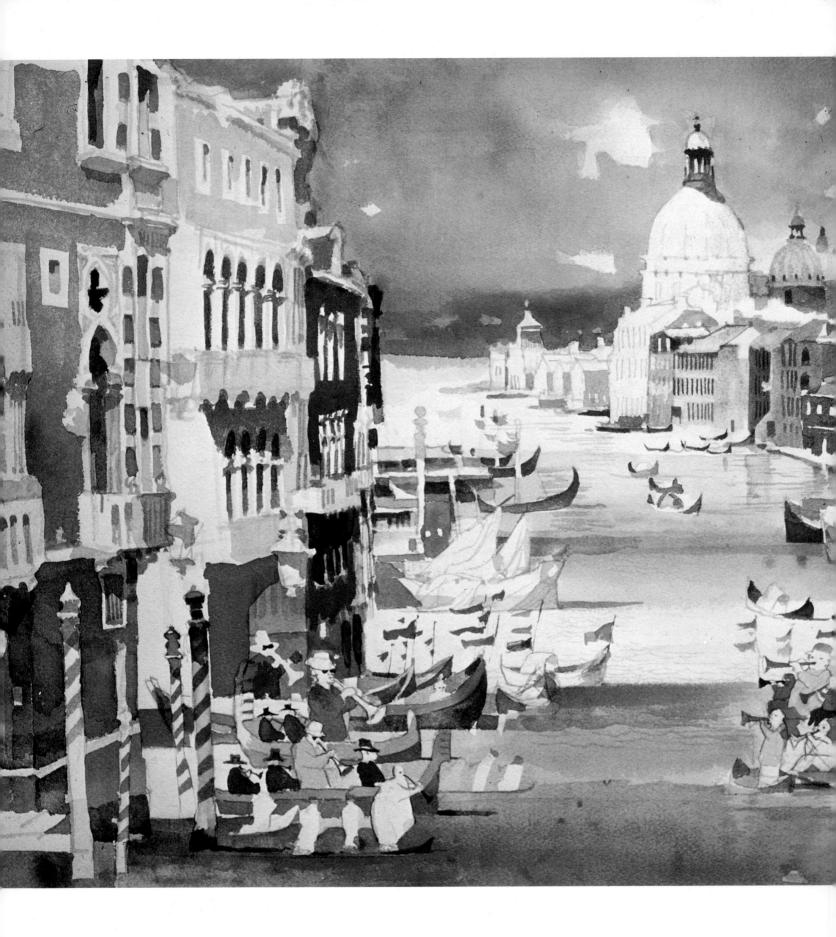

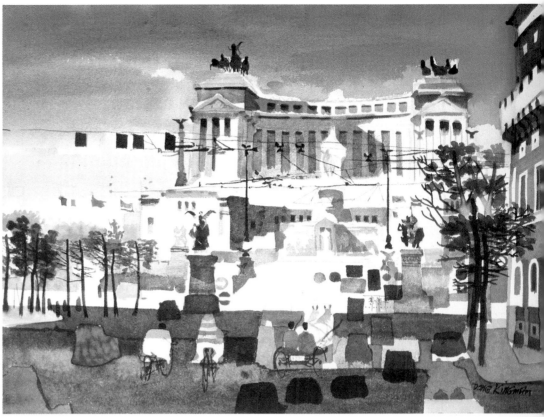

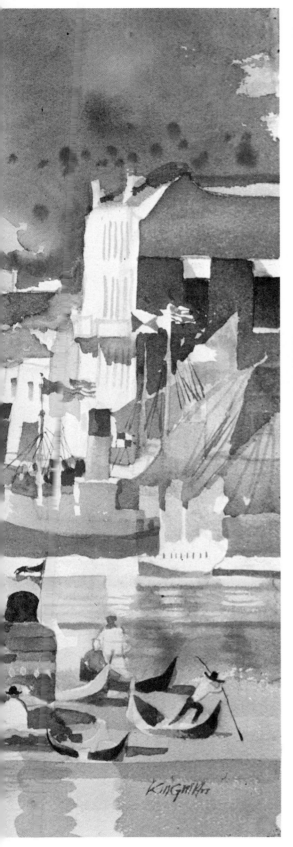

(Left)
VENICE
22 x 30 in. (56 x 76 cm)
Collection, Robert W. Sarnoff

Throughout the years, I have sketched all over Venice. Every subject in this city is fascinating to paint because its narrow streets and canals have been there such a long time and the walls and buildings have the wonderful texture of age. Painting the Grand Canal is especially fun for me because I can invent different kinds of activities in the waterways. In this watercolor, the tugboats and steamboats at the lower right-hand corner don't necessarily belong there; I added them to create a feeling that the scene is being invaded by outside elements.

(Above)
WEDDING CAKE, ROME
22 x 30 in. (56 x 76 cm)
Collection, Mr. and Mrs. Sheldon Tannen

The "Fatherland Altar," built by Mussolini, has so much gingerbread and so many tiers that people often refer to it as the "Wedding Cake." This picture was painted on location very early one morning, when the sun was just coming out and the traffic was still very light. I have learned that this is the best time of day to sketch in the streets of any city; not only are there fewer people about, but the contrasts of light and shadow add interest to any composition.

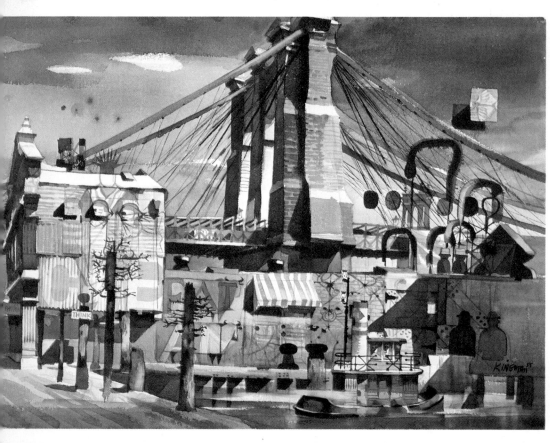

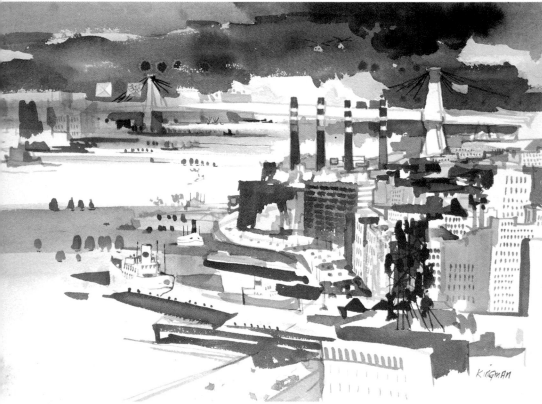

(Top)
SOUTH STREET BRIDGE
22 x 30 in. (56 x 76 cm)
Collection, Metropolitan Museum of Art

There's no such bridge as the South Street Bridge—this is actually the Brooklyn Bridge, which I painted from the Fulton Fish Market on South Street. When I painted this picture in 1955, the area was very run-down and dilapidated. It's a different story today. The neighborhood has been rebuilt and boasts the interesting South Street Seaport Museum, and nearby there are famous restaurants, shops, flea markets, and a large, ever-flickering electronic clock.

(Above)
LOOKING DOWN THE EAST RIVER
22 x 30 in. (56 x 76 cm)
Private collection

This picture was painted from the window of one of the tall buildings near the United Nations Headquarters in New York City, and in the background I could see the Williamsburg Bridge. The smoke stacks create a very strong vertical rhythm, which is one of the reasons I was inspired to paint this scene.

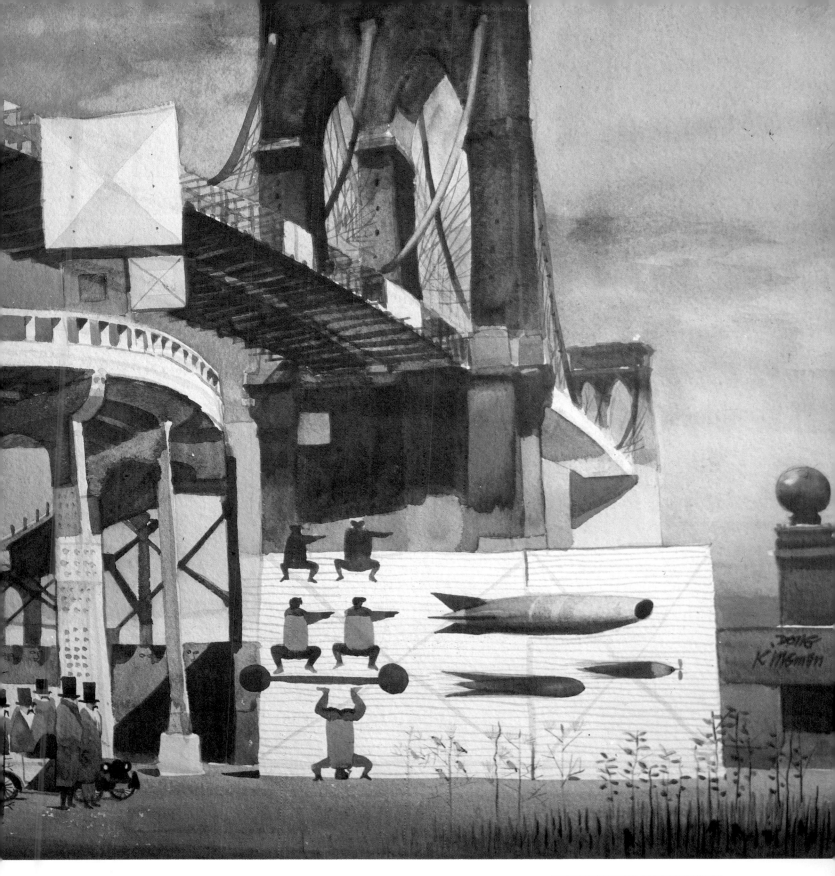

UNDER THE BROOKLYN BRIDGE
22 x 30 in. (56 x 76 cm)
Collection, Richard Shields

When I was sketching this picture on location, I was sitting under the shadow of the Brooklyn Bridge. It occurred to me that it would be wonderful to have different types of activities, instead of bums and waterfront characters, in the foreground. When I returned to the studio, I created my own circus act: a V-2 launching, with gentlemen in top hats looking on.

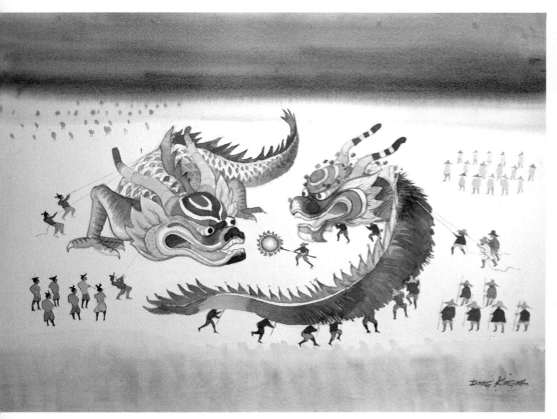

(Above)
TWO DRAGONS
22 x 30 in. (56 x 76 cm)
Collection of the artist

This picture was a study for *War of the Dragons* at right. The background is intentionally simple, as I wanted to focus my attention on the dragons and figures.

(Right)
WAR OF THE DRAGONS
22 x 30 in. (56 x 76 cm)
Collection of the artist

During the Chinese New Year celebration, the village clans or associations bring out their dragons to perform in the marketplace. Each clan has a particular color, shape, and design for its dragon as well as its own group of brave dancing athletes who try to outdo the others. This picture shows a conflict between two groups of dragon dancers, who seem to be getting ready for war. Some of the characters I created in the foreground symbolize this mood as well. I started this watercolor at Portsmouth Square in San Francisco's Chinatown. The square is a gathering place for retired men and women, mothers and children, Chinese chess players, and pick-pockets.

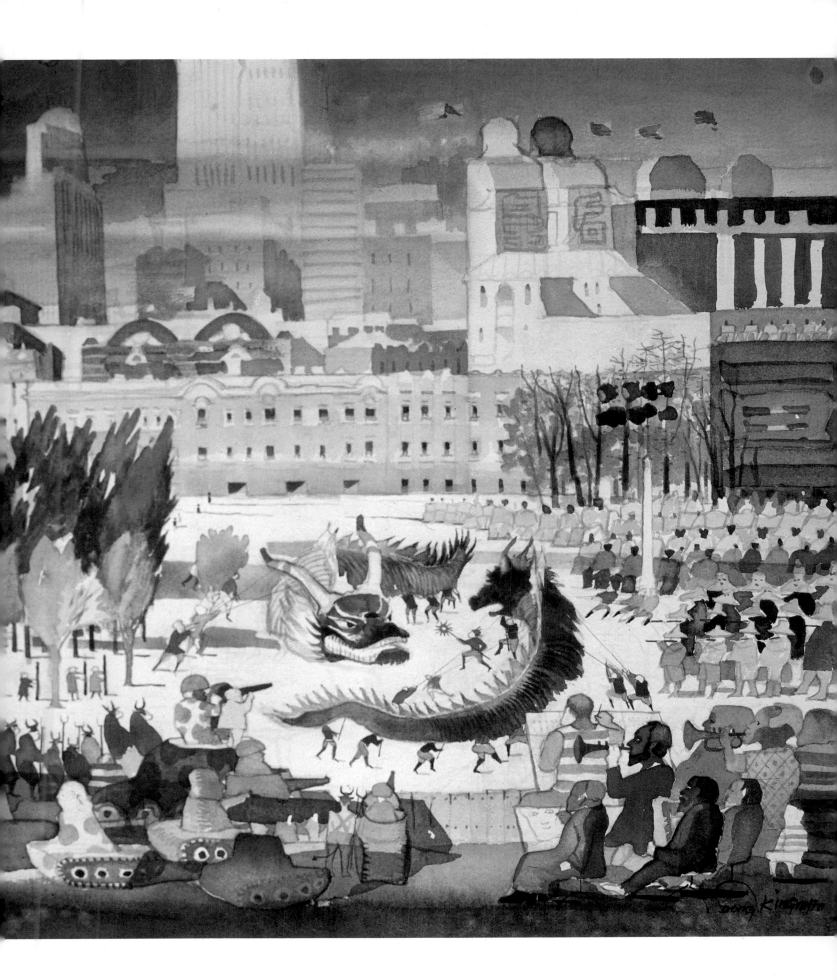

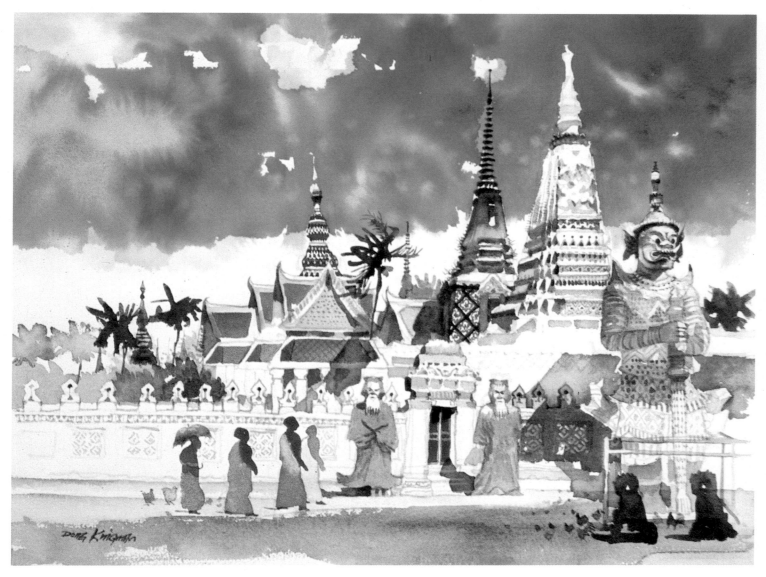

BANGKOK, A.M.
20 x 28 in. (51 x 71 cm)
Collection of the artist

Bangkok is in a tropical country, and it's hot year-round. The best time of day is early morning, around six A.M. In this picture, I tried to create a peaceful moment, with local people and orange-robed monks walking quietly in the streets on their way to work or prayer before throngs of tourists trespass their sacred temples.

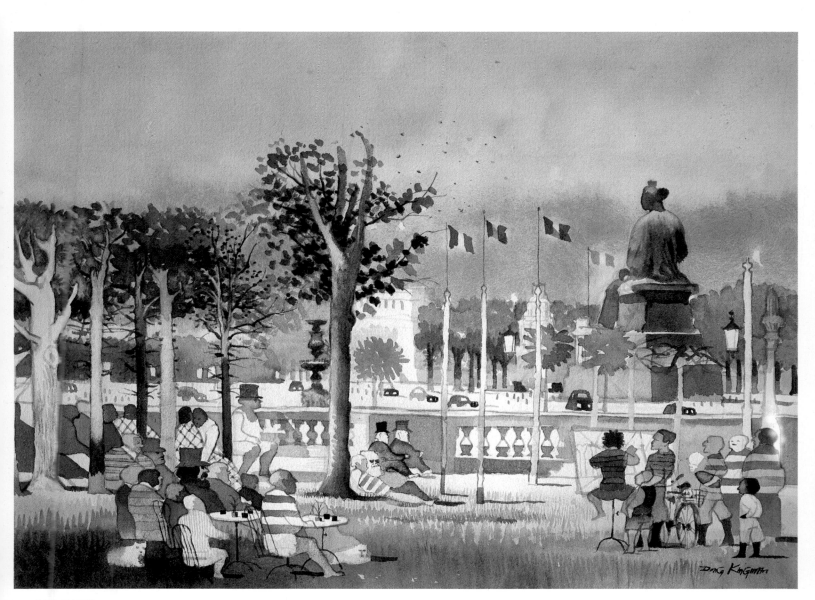

A.M., PARIS
22 x 30 in. (56 x 76 cm)
American Watercolor Society Award, 1978
Collection, Dong Kingman, Jr.

Morning is the best time of day for me, and
that's when I often do my best work. This
isn't necessarily the case all the time, but at
least my eyes are clear and my mind less
confused in the morning.

I was sitting in front of the Louvre one
morning when I started this picture (my
wife went inside the museum to look at the
masterpieces). Like most of my watercolors,
it was started on location but finished later
in the studio.

(Overleaf)
ABERDEEN
22 x 30 in. (56 x 76 cm)
*Collection, Charles and Emma Frye Art Museum,
Seattle*

When it comes to exotic scenes, there is no
place quite like Aberdeen, one of the show-
places of Hong Kong. At first sight, there
seem to be millions of junks and sampans
packed together, side by side, like sardines.
Located in the middle of this fishing village
are two floating restaurants decorated with
glittering neon lights and gingerbread Chi-
nese decorations. Hong Kong residents and
tourists alike visit these sea palaces at one
time or another, and it's a fun place to
sketch. I've tried to include a lot of festive
color and detail in this picture in order to
create the feeling of excitement and activity
that's characteristic of Aberdeen.

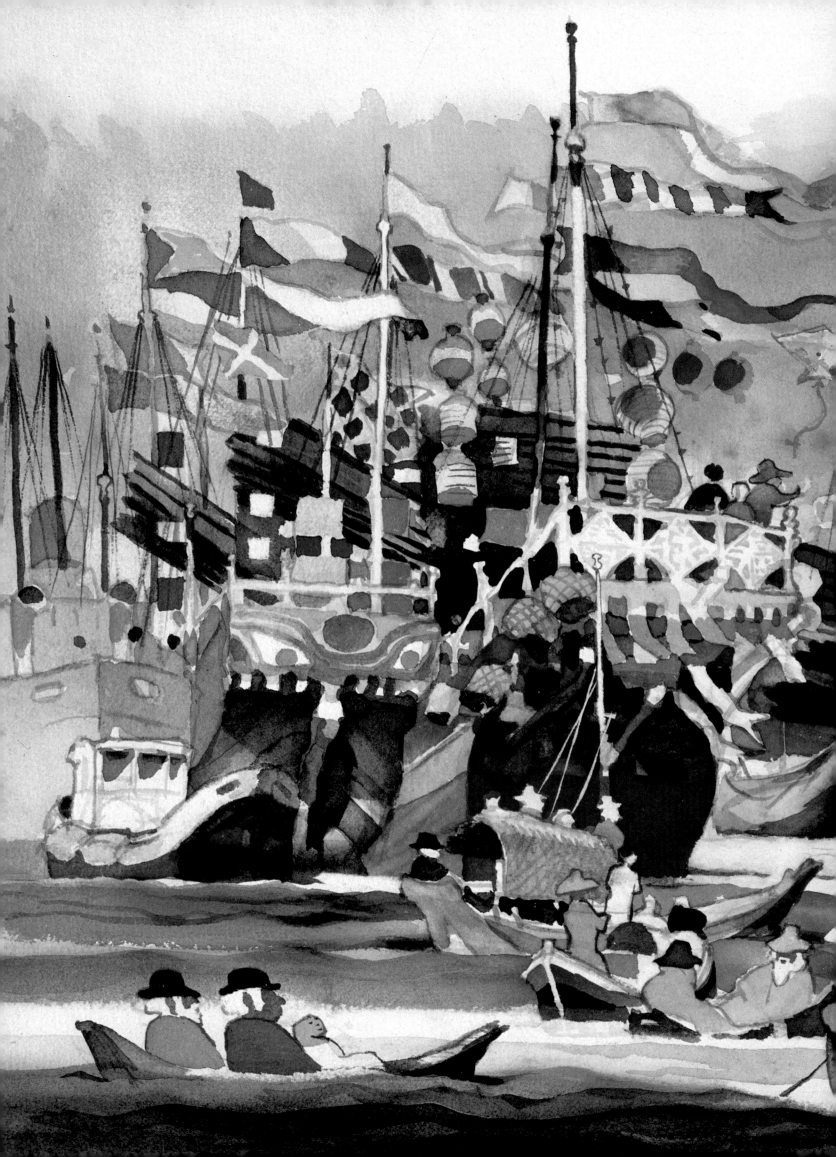

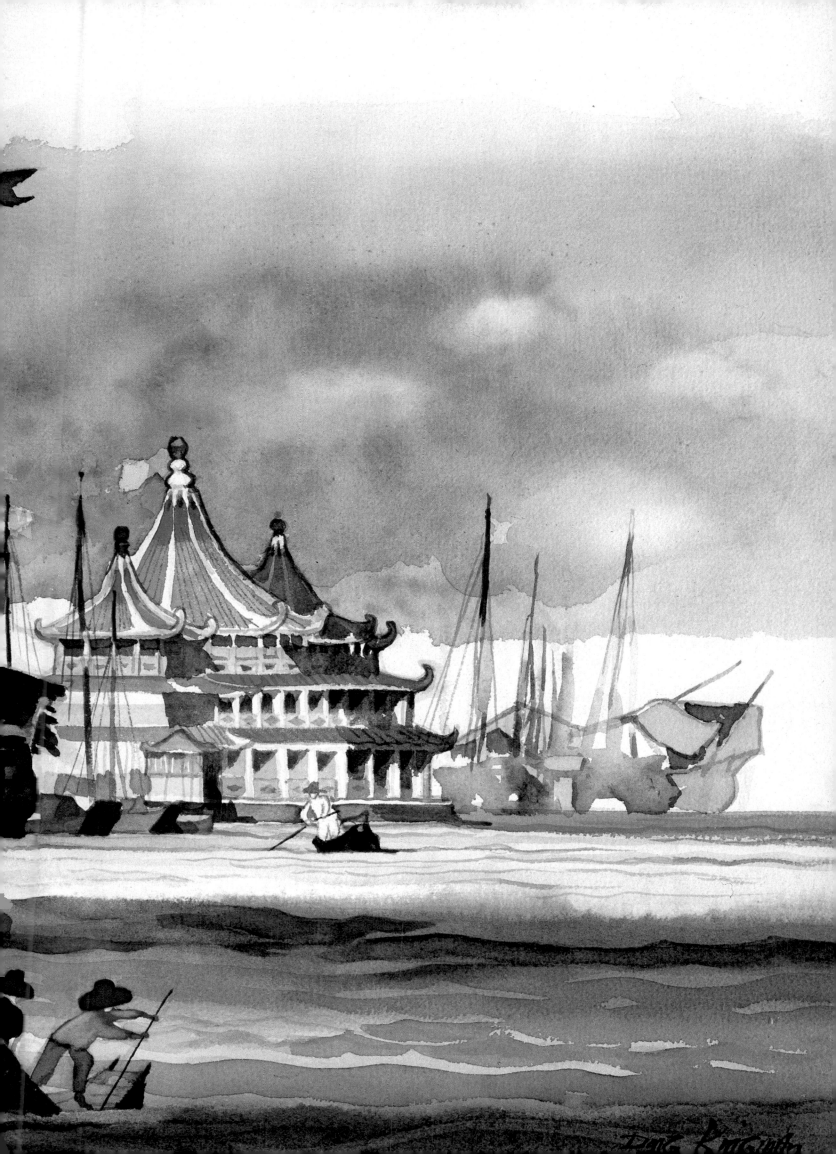

PENNSYLVANIA AVENUE, WASHINGTON, D.C.
21 x 18 in. (53 x 46 cm)
Collection, Rocky Aoki

When I was in the Army during World War II, I was stationed in Washington, D.C., pending orders to Kunming. Whenever I had free time during this period, I would go sketching outdoors. Years later, I created this watercolor totally from my memories. It shows a big parade taking place on Pennsylvania Avenue, suggesting an inauguration or the arrival of a circus in town. I left large areas of the paper unpainted in this picture, and this helped keep the colors clear and bright.

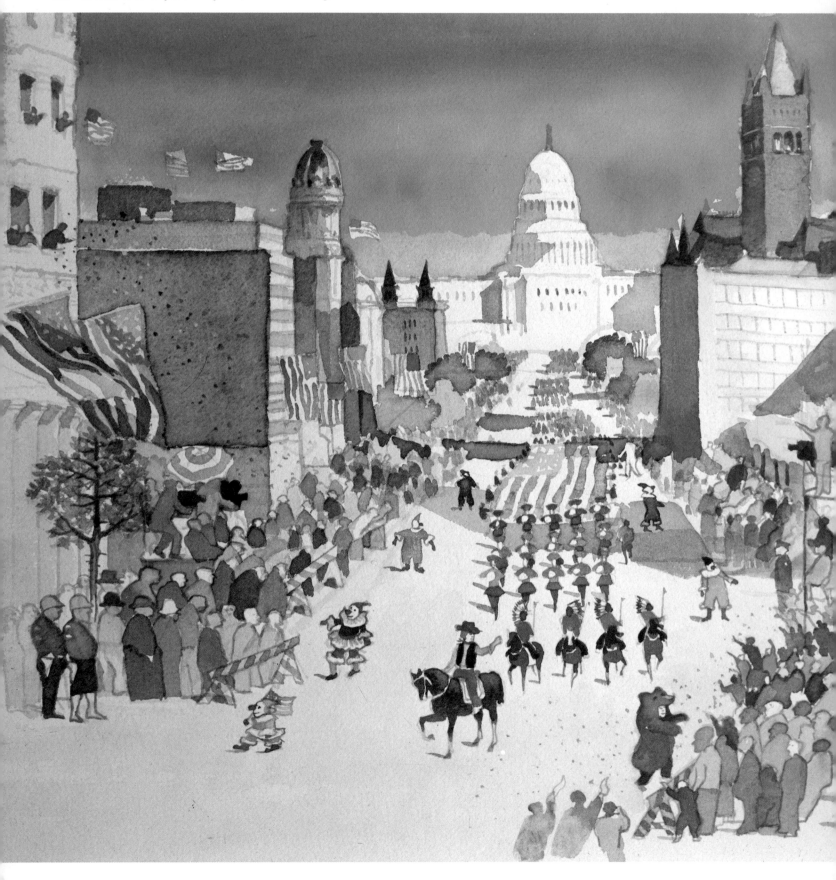

THE BIG PARADE
22 x 30 in. (56 x 76 cm.)
Collection, Mr. and Mrs. Burt Hause

I started this watercolor years ago, but I didn't finish it till much later—because my inspiration did not arrive till 1977. Originally, I painted the large building on the right-hand side and the building in the left foreground, leaving the rest of the composi-tion to be finished later. But it wasn't until 1977, when I was watching the inaugural march from Capitol Hill on TV and got the inspiration to create the big parade, that I was able to complete it.

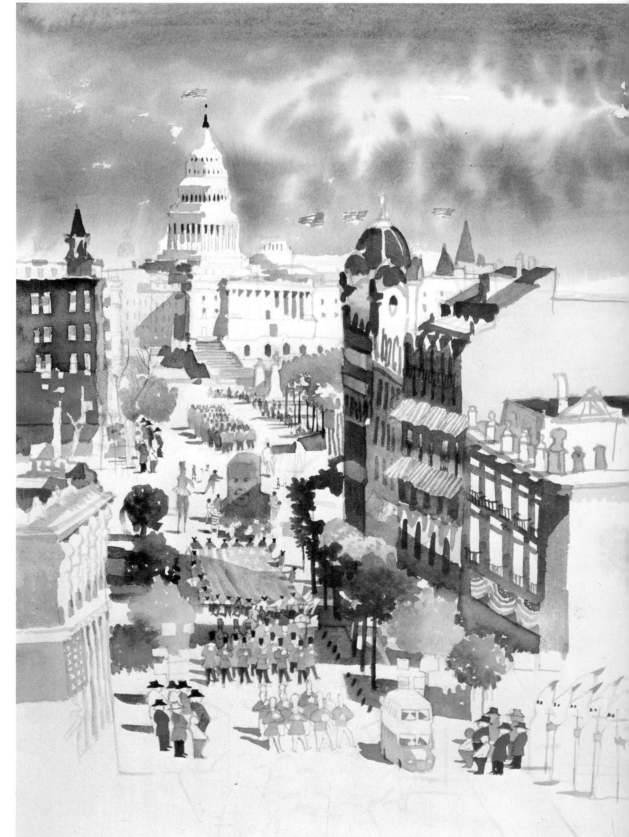

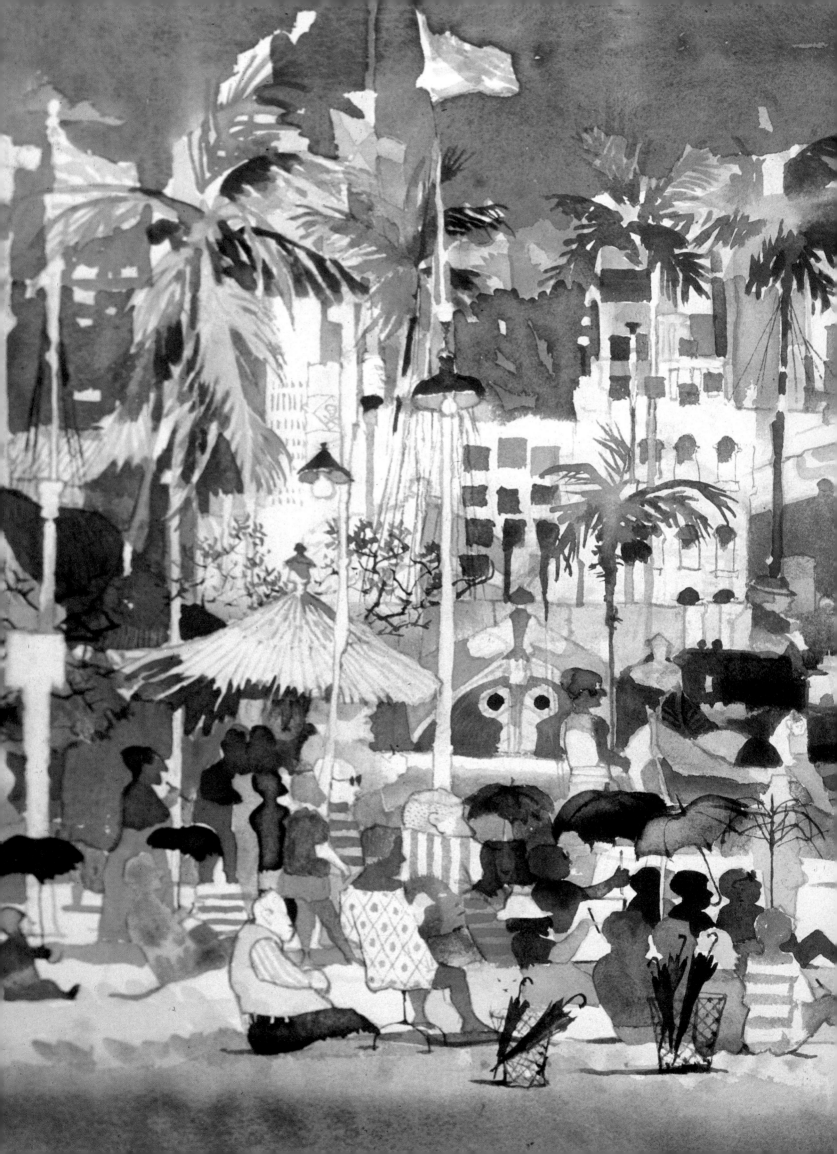

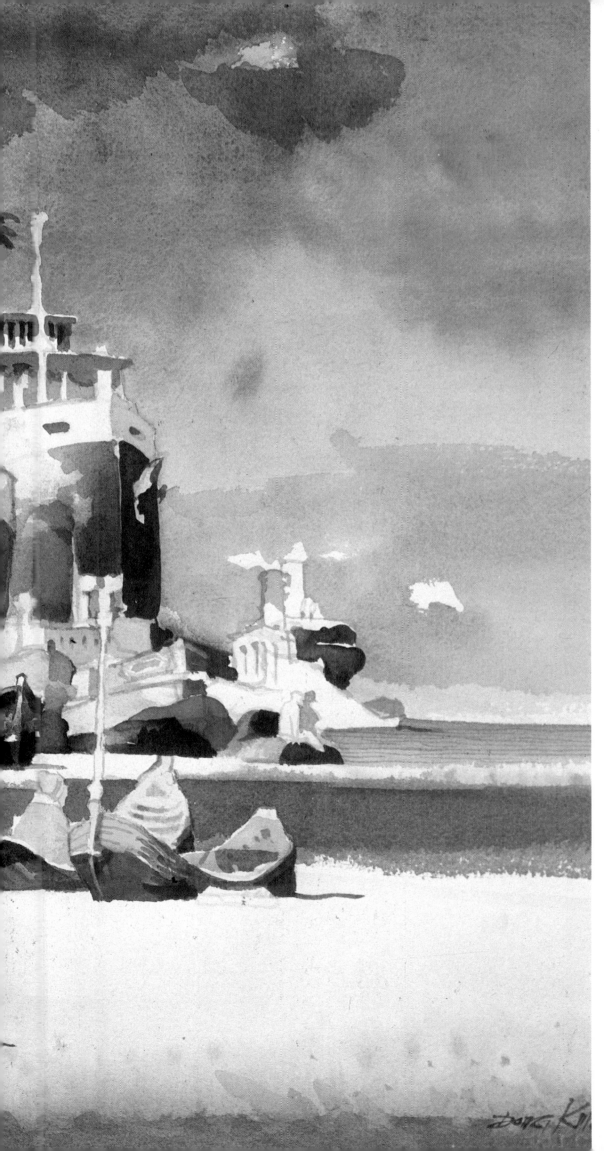

SHIPYARD VACATION
22 x 30 in. (56 x 76 cm)
Collection, Frank Woelke

I began this picture in Acapulco,
Mexico, when I was giving a paint-
ing workshop there. Near the hotel
was a beach which had an inter-
esting conglomeration of sun-
bathers. I started to sketch in part
of the background; then, as I al-
ways do, I finished the rest of it
back in the studio.

During the process of creating
this watercolor, I began to see a
mixture of people of different races
sitting on the beach, some with
dark skin, others with light com-
plexions. I added a few tugboats
and steamships to distract the at-
tention of the beachcombers. My
interest here was not so much in
the individual subjects, but rather
in the kaleidoscope of color and
rhythm, all falling into place in one
design.

131

PASSING THROUGH MONUMENT VALLEY
22 x 30 in. (56 x 76 cm)
Collection, Mr. and Mrs. James T. Wu

Generally, I am more at home painting city
subjects than landscapes, simply because I
was born and brought up in cities. When it
comes to painting landscapes, I always wish
I'd had an opportunity to understand the
subject better. One time I visited Monument
Valley and I was very impressed by its col-
ors and rock formations. We were passing
through and would be there only two days,
but I found an opportunity to paint it early
one morning when the sun was low and the
shadows were long. I decided that was a
perfect time to sketch the valley.

STORM OVER THE ACROPOLIS
22 x 30 in. (56 x 76 cm)
Collection, Mr. and Mrs. Frank Sinatra

I started this watercolor in a street in
Athens, and I sketched the Acropolis in the
background. Later on, in the studio, I pro-
ceeded to develop the foreground and mid-
dleground areas. There was a political
storm taking place in Greece at the time, and
it affected my thinking as I painted this pic-
ture.

(Overleaf)
CHUNG YANG KITES
22 x 30 in. (56 x 76 cm)
Collection, Mr. and Mrs. B. Le Roy Burnham

The ninth day of the ninth month on the
Chinese lunar calendar is a holiday called
Chung Yang. On this day, families take food
baskets to the top of a hill and picnic, and
children fly kites. I made my own kites dur-
ing my kite-flying days in Hong Kong. Some
looked like butterflies, birds, the moon with
two carps, dragons and centipedes. In this
picture I tried to show as little of the land-
scape as possible, emphasizing instead the
colorful kites against the sky.

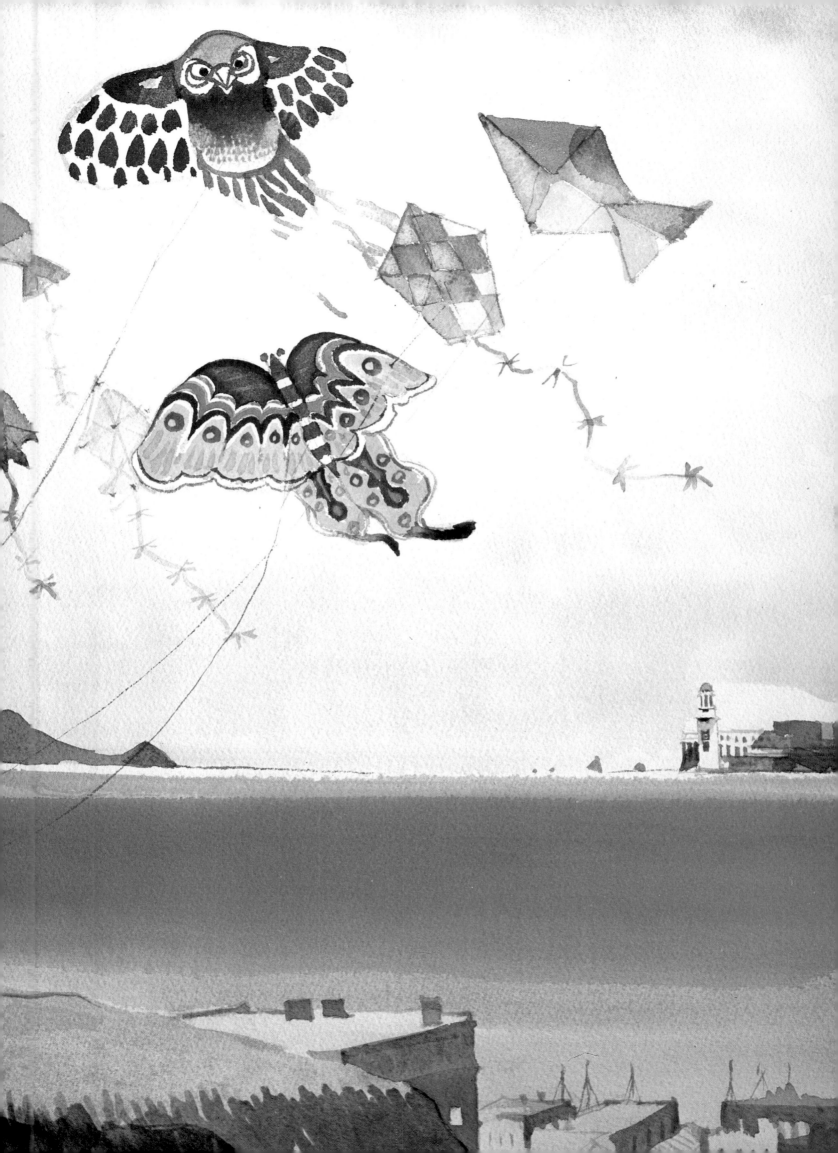

LOOKING UP AT NOTRE DAME
22 x 30 in. (56 x 76 cm)
The C. V. Starr Collection

I have sketched Notre Dame many times
and from many different views. I found this
angle, looking up from the lower level of the
riverbank, an especially interesting one. I
remember that when I painted this water-
color, there were sleepy-looking fishermen
along the bank and the slow-moving sight-
seeing boat, *Le Petit Mouche*, went by. I felt
very peaceful.

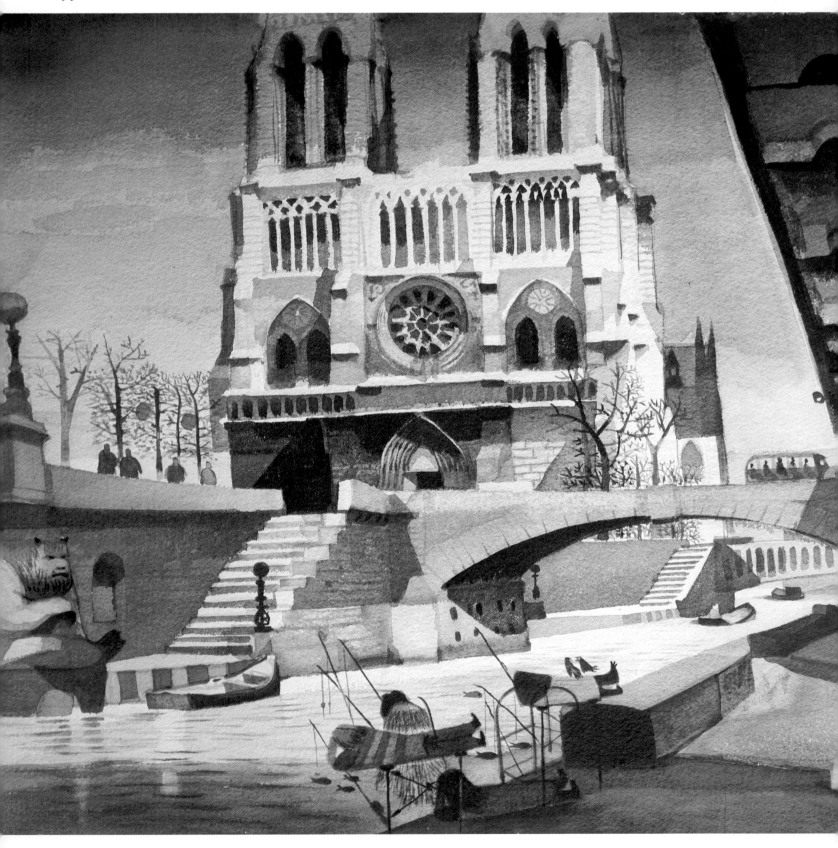

NOTRE DAME
22 x 30 in. (56 x 76 cm)
Collection, Serene and Irving Mitchell Felt

The Cathedral of Notre Dame is one of the most striking pieces of architecture in the world. There are always endless numbers of worshipers who come from all over the world to celebrate mass here every day. When I sketched this watercolor in 1962, the day was totally overcast. I've learned from long experience that when painting any kind of architecture, it's best to have sunlight and shadow on it, so I improvised the pattern of light and shadow on the building, as well as adding all kinds of people in the foreground.

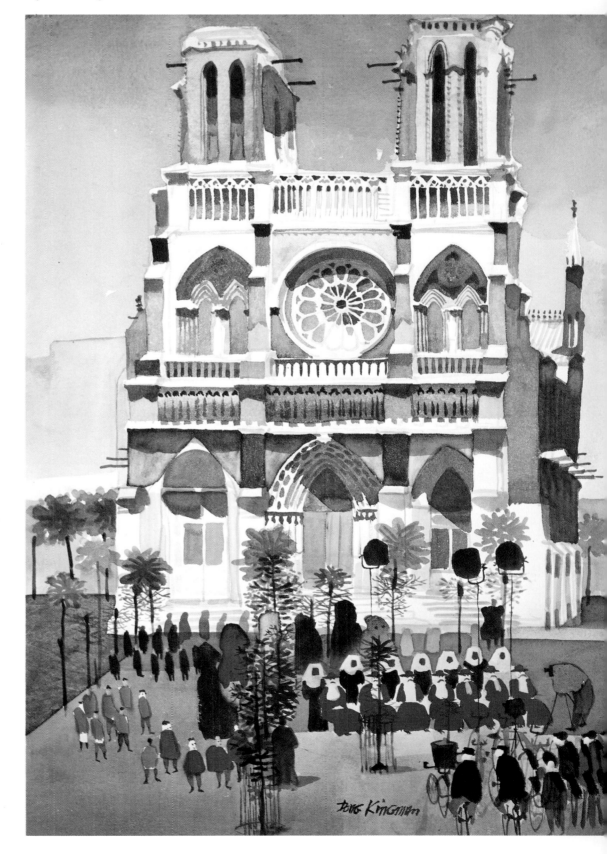

137

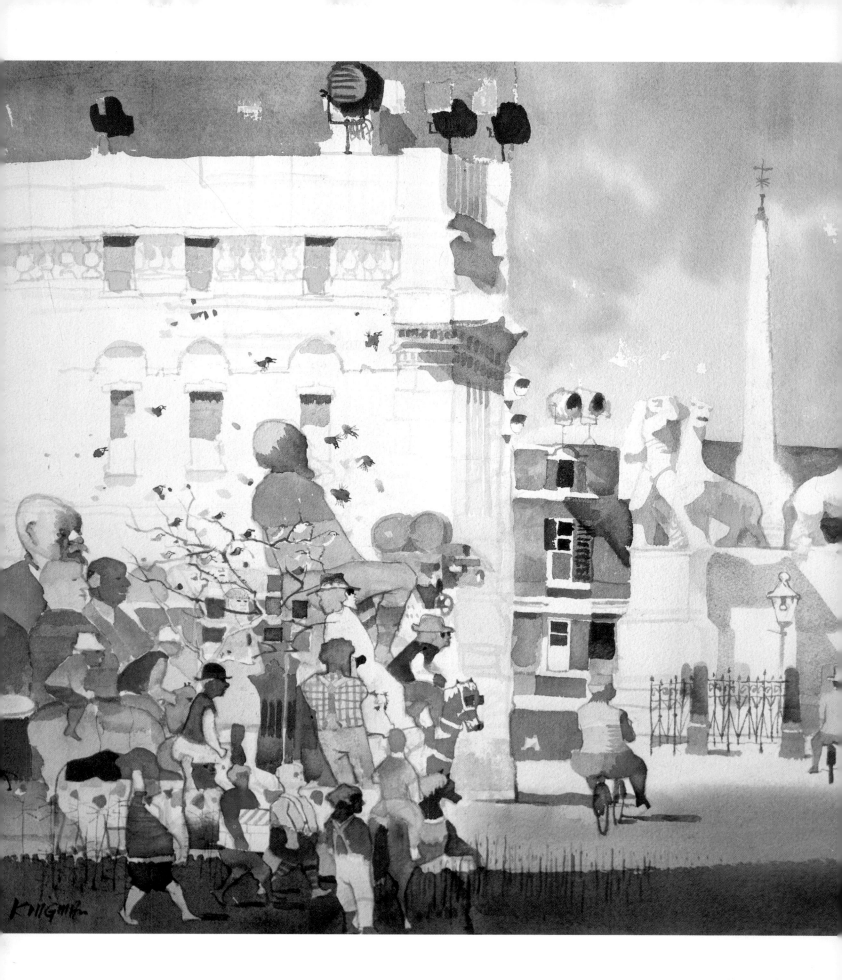

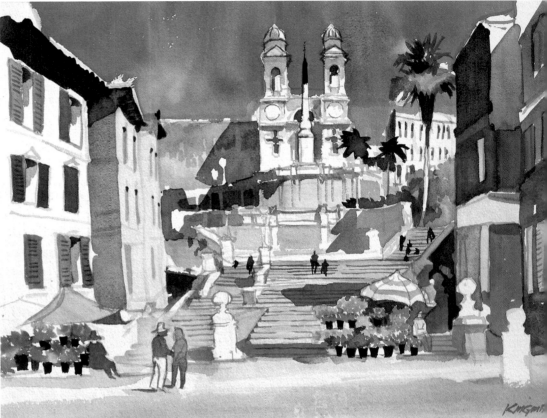

(Left)
HIGH NOON IN FOUR-HORSE SQUARE, ROME
22 x 30 in. (56 x 76 cm)
Collection, Helene Kingman

(Above)
SPANISH STEPS, ROME
15 x 22 in. (38 x 56 cm)
Collection of the artist

This watercolor depicts people making motion pictures in one of the squares in Rome. I have watched movie-making in many parts of the world—Hong Kong, Spain, Hollywood. Singapore, et cetera—and my artwork has been used in film productions such as *The World of Susie Wong, Flower Drum Song, 55 Days in Peking,* and *Lost Horizon.* One thing I have learned is that when it comes to set design, movie people like to make real buildings look phony and artificial sets look real. On the left-hand side of the picture, I've painted a group of people piling up on top of one another, in order to suggest how confusing making motion pictures can be.

I had painted in many parts of the world, but never been to Rome until my wife introduced it to me in the 1960s. Since then, I've sketched cities all over Italy many times.

Located in the heart of Rome amid narrow streets and heavy traffic, the Spanish Steps is one of the most famous tourist places. I found that the best time to sketch it was during siesta hours, between two and four in the afternoon. I took liberties with the sunlight and shadow in this picture in order to make it a better composition. This painting was subsequently reproduced on the cover of a Pan-Am Airways menu.

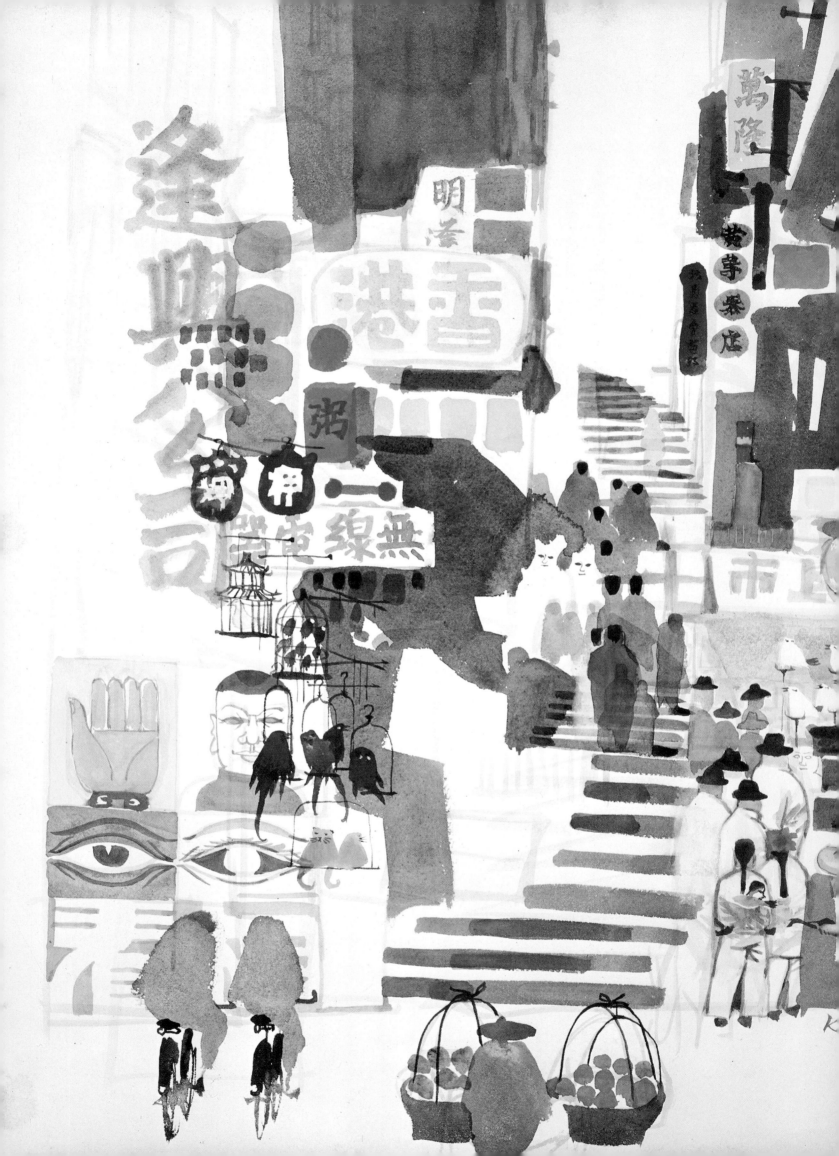

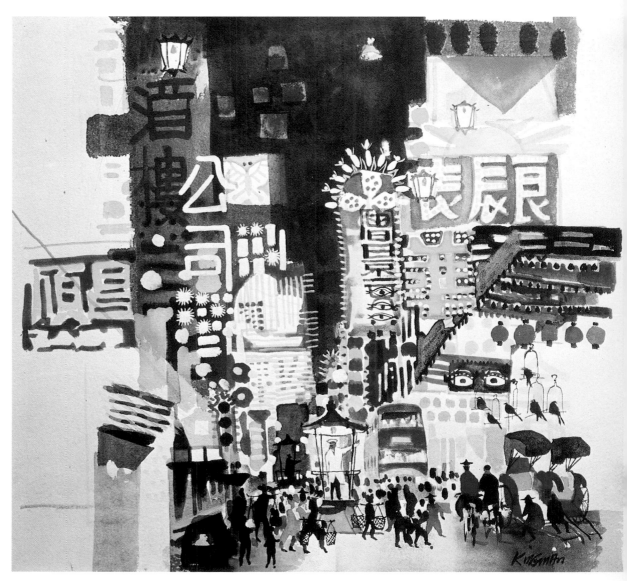

(Left)
HONG KONG
22 x 26 in. (56 x 66 cm)
Collection, Hong Kong Tourist Bureau

I painted this view of Hong Kong for the Tourist Bureau in 1965. Because it was intended to be reproduced as a poster, I departed somewhat from my usual style: I left much more of the white paper showing so that the colors would stand out crisply and the picture could be seen and recognized easily from a distance.

(Above)
NIGHT LIGHTS OF KOWLOON
22 x 22 in. (56 x 56 cm)
Private collection

Hong Kong is full of interesting detail, and I never get tired of painting its many moods. When I did this picture in the 1960s, I was intrigued by the busy streets and brilliant lights of Kowloon at night.

INDEX

Aberdeen, 126–127
Acrylics, 14, 20, 26, 32, 33
Additives to paint, 33
Airport travelers, sketch of, 26
American Artist, magazine, 18
A.M., Paris, 125
Amsterdam, sketch of, 36
Architecture, 17, 35
Art teacher: first, 12, 13; selecting an, 47
Artists at Work, Paris, 82–83; demon-stration, 78–83
Art training, 11–14, 38

Background, 34, 39; white of paper as, 14, 30
Bangkok, A.M., 124
Bangkok, sketches of, 24, 30–31
Barcelona Waterfront, Spain, 48–49
Base of Bay Bridge, San Francisco, 112
Behind the Cathedral, Mexico, 46
Bender, Albert, 18
Benihana restaurant, San Diego, sketch of, 43
Big Parade, The, 129
Blotting, to lift out pigments, 32, 41
Brushes: 27, 38, 39, 41, 43, 49; Chinese, 11, 26; sable, 26, 43, 49
Brush strokes, 12, 31, 32
Burchfield, Charles, 16
Busy Bay of Hong Kong, The, 33

Caen, Herb, quoted, 56
Calligraphy, 11, 14, 26, 38
Casein, 26
Celebration, Chinatown, 38
Center of interest, 37, 39, 49
Cézanne, Paul, 13
Chan Sun-Wen School, 11, 13
Chinatown, San Francisco, 60–61; dem-onstration, 56–61
Chinese traditional painting, 11, 13, 14, 16, 29, 30, 39
Chung Yang Kites, 133–135
City on the Golden Hill (Caen), 56
Cityscapes, 14, 17, 20, 29, 35
Color, 20, 29, 30, 32, 37; 39; for outdoors, 25, 29; for studio work, 25, 40; mixing, 25, 31, 43, 49; temperature, 49. *See also* Values
Colorful Junks, 100

Composition, 12, 20, 35, 39, 40, 41, 45, 49; design of, 17, 20, 29, 40, 49; simplifica-tion of, 12, 20, 29, 35; sketches, 35, 37, 39, 49
Critical reviews, 14, 18, 62
Cropping, 41

Day of the Iguana, 42
Demonstrations: *Artists at Work, Paris,* 78–83; *Chinatown, San Francisco,* 56–61; *Diamond Head, Honolulu,* 72–77; *French Quarter, New Orleans,* 68–71; *Grand Canal, Venice,* 84–89; *The Plaza in Central Park, New York,* 90–95; *Victoria Mountain, Hong Kong,* 50–55; *Yosemite, Late After-noon,* 62–67
Demonstration in the Park, 114
Design, elements of, 20, 29, 35, 39, 40, 49
Diamond Head, Honolulu, 76–77; dem-onstration, 72–77
Difficulties in painting, solving, 40, 46, 47
Dragon Boat Race, 101
Drawing table, 23, 30
Drybrush. *See* Technique
Drying process, 33
"Dry spells," 47

East End, London, 102
Egg tempera, 26
Equipment, 23, 27, 30, 33, 45, 90
Evaluation of picture, 40
Exhibitions, 14, 18, 23, 41

"Fatherland Altar," The, 119
Figures, 14, 34; style of, 17, 20
Finishing a painting, 29, 37, 39, 41
Fortune, magazine, 18
Fox & Morgan Art School, 12–14
Fragrant Harbor, The, 40
Frames, 33, 41
French Impressionists, 13
French Quarter, New Orleans, 70–71; demonstration, 68–71
Funny Art Class, A, 116–117

Gauguin, Paul, 13
Gouache, 14, 26, 32
Grand Canal, Venice, 88–89, 119; dem-onstration, 84–89

Great Wall, China, The, 106–107
Grosz, George, 16
Guggenheim Fellowship, 18, 68, 90

Happy New Year, 28
Harbor Structure, 113
High Noon in Four-Horse Square, 138–139
Hong Kong: 11–14, 17, 28, 40, 47, 50; dem-onstration, 50–55; sketches of, 20, 21, 41
Hong Kong, 140
Hong Kong Harbor, 100
Hong Kong Harbor, photograph of, 27; sketches of, 11, 32
Hong Kong in Moonlight, 22
Honolulu, demonstration, 72–77

Influences, artistic, 13, 16
Ink, 32
In the Forbidden City, 107
Kilimanjaro, sketches of, 35
Kuala Lumpur soccer game, sketch of, 16–17

Ladder Street, Hong Kong, 44
Landscape painting, 14, 25, 62; demon-strations, 62–67, 72–77
Lay-in washes, 39, 49
Lazy Afternoon, Hong Kong, 107
Life, magazine quoted, 62
Life-drawing classes, 12
Lifting, to remove pigment, 32
Light, for painting in studio, 23
Line drawing, to begin a painting, 38–39, 49, 57
Lingnan Branch School, 12
Location, painting on, 27, 29, 30, 34, 37, 40, 68, 78
Looking Down the East River, 120
Looking Up at Notre Dame, 136
Lun Yu ("Book of Confucius"), 13

Marin, John, 16
Maugham, Somerset, home in Pango Pango, sketch of, 29
Mats, 33, 40
Medium, choosing a, 12, 14, 20, 32, 46
Memory, painting from, 29
Methods, painting, 28–33

Metropolitan Museum of Art, 18
Mid-Autumn Festival, 104–105
Midtown Gallery, 18
Michener, James, 15
Mixed media, 41, 46
Mocambo Cafe, Taormina, 99
Museum of Modern Art, 18

Newsweek, magazine, 18
Near Westminster Bridge, London, 103
New Orleans, demonstration, 68–71
New York City, 12, 17, 18, 26; demonstration, 90–95
New Yorker, The, magazine, 18
Night Lights of Kowloon, 141
Notre Dame, 137

Oakland, California, 11–14, 17, 56
Oakland Tribune, quoted, 18
Oil painting, 12, 14
Old Mission, San Diego, 110–111
Omaha, 112
Opaque color, 26, 41, 46
Oriental heritage, 14, 16
Outdoor sketch class, 12, 13

Painting positions, sketch of, 27
Painting surface: position of, 23, 30, 31; preparation of, 30
Palette, 27, 31; of colors, 25, 43, 49
Paper, 27, 30–32; dry surface, 30, 32; preparing for work, 30; removing pigment from, 26, 32, 41, 43; size, 25, 41, 45; soaking, 30, 41; texture, 25, 32, 43; types, 25, 43; weight, 25, 43; wet surface, 30, 32; white of, 14, 25, 30, 39
Pango Pango, sketches of, 29, 47
Paris, 12, 78; demonstration, 78–83
Passing Through Monument Valley, 132
Pastel, 14
Peking Gate, 45
Pencil, 37, 38
Pennsylvania Avenue, Washington, D.C., 128
Philippines, sketch of, 18
Photographs, use of, 29, 39, 46
Plaza in Action, 108
Plaza in Central Park, New York, The, 94–95 demonstration, 90–95

Plaza Sitters, 109
Preliminary drawings, 35, 37, 40, 49, 50, 56, 62, 72, 78, 84, 90
Preserving pictures, 47
Puddles, in broad washes, 25, 30, 32

Rag paper, characteristics of, 43
Removing pigment, 26, 32, 41
Renoir, Claude, 13
Rhythm of a composition, 20, 49
Rickshaw men, Hong Kong, sketch of, 20
Rickshaw, Taiwan, 37
San Francisco, 11, 14, 17, 18, 30, 84; demonstration, 56–62; Art Association Annual Exhibition, 18; Art Center, 14, 18; demonstration, 56–62; Museum, 18
San Francisco News, quoted, 18
San Francisco Festival, 96–97
San Ho ("the Three Harmonies"), 35
San Marco Square, photograph of, 27
San Marco in White, 98–99
Scraping, to remove pigment, 32
Self-portrait, 9, 12
Shadow, 14, 29, 35, 49
Ship at Pier, San Francisco, 10
Shipyard Vacation, 130–131
Singapore, sketch of, 19
Size of work, 20, 23, 41, 45
Sketches, preliminary, 35, 37, 49; for demonstrations, 50, 56, 62, 72, 78, 84, 90
Sketching outdoors, 12, 14, 25, 27, 29, 30, 37, 40, 45
Soaking watercolor paper, 41
Soccer in Rio, 34
South Street Bridge, 120
Spanish Steps, Rome, 139
Sponge, 23, 26, 30
Still life, 45
Storing paintings, 47
Storm Over the Acropolis, 133
Street scene, 14, 20, 28, 29, 35, 44
Studio, 18, 20, 25, 29, 35, 37, 49; painting set-up, 23, 30; sketch of, 23; studies in, 39, 40
Styles, experiments with, 16, 18, 20
Subjects, 20, 29, 34; favorite, 35; finding, 29, 35, 45, 90
Sunlight, 14, 28, 29, 35

Sydney, Australia, surfing beach, sketch of, 39
Sydney Harbor, 15
Szetu Wei, 13, 47; sketch of, 12

Tai-chi, in Canton, sketch of, 25
Teaching, 12, 18, 34, 35
Technique: drybrush, 32; dry-on-dry, 32; dry-on-wet, 32; opaque, 26, 46; special, 32, 46; transparent, 14, 26, 32, 41, 46; watercolor, 18, 20; wet-in-wet, 30, 32; wet-on-dry, 32
Texture: paper, 25, 32, 43; picture, 20, 29, 31–33
"Three Harmonies," The, *(San Ho),* 35
Thurman Hewitt Painting Workshop, 84
Time, magazine, 15, 18
Tree Rows in Madrid, 115
Trinity College Church, 13
Two Dragons, 122

Under the Brooklyn Bridge, 121

Values: color, 25, 29, 31, 35, 37, 39, 40, 49; sketch for, 37, 49, 50, 90
Van Gogh, Vincent, 13
Venice, demonstration, 84–89
Venice, 118–119
Victoria Mountain, Hong Kong, 55; demonstration, 50–55
Viewfinder, 29

WPA Art Project. *See* Works Progress Administration
War of the Dragons, 123
Washes, 25, 26, 30, 31, 38, 39, 49
Water: clear wash, 26, 41; for painting, 25, 27, 31, 33, 37
Watercolor, as medium, 14
Wedding Cake, Rome, 119
Wet-in-wet. *See* Technique
Wetting, to remove pigment, 32
Works Progress Administration (WPA) Art Project, 18, 62
World War II, 18

Yosemite, Late Afternoon, 67; demonstration, 62–67

Edited by Betty Vera
Designed by Bob Fillie
Graphic production by Hector Campbell